The Universe History of
ART AND ARCHITECTURE

THE
TWENTIETH
CENTURY

Maurice Besset

Universe Books
New York

Published in the United States of America in 1988
by Universe Books
381 Park Avenue South, New York, N.Y. 10016

88 89 90 91 92 / 10 9 8 7 6 5 4 3 2 1

Printed in Hong Kong

Library of Congress Cataloging in Publication Data

Besset, Maurice.
[20. Jahrhundert. English]
The twentieth century / Maurice Besset.
p. cm. — (Universe history of art & architecture)
Translation of: 20. Jahrhundert.
Reprint. Previously published: Art of the twentieth century.
New York: Universe Books, 1976.
Includes index.
ISBN 0-87663-753-5 (pbk.)
1. Art, Modern—20th century. I. Title. II. Series.
[N6490.B4513 1988]
709'.04—dc 19 88-10912
 CIP

CONTENTS

New Structures, New Space

After 1900, the Art Nouveau wave in architecture quickly ebbed away. Although it had managed to produce a coherent visual language, its approach to form as an emotional response to a given situation or site, in which each solution was unique, was scarcely competent to tackle the real architectural tasks of the period. In the process of repetition, the eccentricity of Art Nouveau had little credibility (in addition, it was produced on an individual craft basis and was therefore expensive). What is more, Art Nouveau, rooted as it was in the applied arts, had always treated form in a purely decorative manner. With the exception of Antoni Gaudi (1852–1926), Art Nouveau architects were scarcely more concerned with softening the rigidly axial arrangements of academic tradition than was the Picturesque mode that had been flourishing in most Western countries since the Romantic era, culminating in the Arts and Crafts Movement. Indeed, one of the pioneers of a more open plan, Frank Lloyd Wright (1869–1959), was actually connected with the American variant of the Picturesque known as the "Shingle Style." He designed detached houses with wings radiating out from a central hall. Showy suites of rooms gave way to a less rigid, informal arrangement for the living quarters, which ensured a feeling of continuity and at the same time allowed for a wide range of variations in the flow of space. Wright's open-plan layouts are complemented by the fluid spatial structures of such architects as Ludwig Mies van der Rohe (1886–1969) in the 1920s (*Ill. 67*).

The moral requirement of a unified treatment of space and form that resulted from the new architectural programs and building methods was on the whole interpreted by European architects in a very different way from Wright. These lone wolves were perhaps united foremost by their clear awareness of the architect's social responsibility, though they did not all see this responsibility in quite the same light. For the Viennese Adolf Loos (1870–1933), for example, it involved a passionate search for logic in the social behavior of the individual, one that would be significant in all its manifestations. Peter Behrens (1868–1940), a German employed by big industrial firms, saw it as the need to coordinate all types of structures connected with machinery, in order to create an effective stylization of the industrial world. The French socialist Tony Garnier (1869–1948) went considerably further, giving the architect the major role in planning the "industrial town" of the future. In his early project for a *cité industrielle* (1901–4), Garnier had already formulated one of the basic principles of modern environmental planning: the fundamental unity of architecture and town planning. Meanwhile, others who championed a new building method recognized as binding the rationalist tradition that had raised "truthfulness" in construction and planning to the level of a First Commandment. This concept led them first of all to reject decoration outright (expressed by Loos in *Ornament and Crime,* 1908; see *1* and *4*); or, alternatively, to change its function, as did the Belgian Henry van de Velde (1863–1957), by using it to illustrate the interplay of forces that held the building together.

The obligation to be truthful at all times was also fulfilled, though in a different way, by Auguste Perret (1874–1954; *2*) and Walter Gropius (1883–1969; *5*). They made

a clear visual distinction between the supporting skeleton of reinforced concrete and the infill with no supporting function or the outer shell of the façade handled as a suspended "curtain wall." They thus took away architecture's former massive appearance and made it to a large extent transparent, recalling the iron-and-glass structures of the preceding century. The same effect was achieved in an even more subtle way in the luxury Palais Stoclet in Brussels (1910–11), which was designed by Josef Hoffmann (1870–1956), a pupil of Otto Wagner. Hoffmann bordered the individual cubelike components, which were grouped together in a richly articulated layout, with gilded metal, creating the impression of an ethereal arrangement of sheets of marble.

Perret, too, used truthfulness when he adopted the skeletal construction to put into practice his own concept of the open plan, which was fundamentally different from Wright's interpretation. He attempted to exploit to the full the possibilities afforded by a linear supporting structure that was also space-saving and flexible, creating an inner space that could easily be subdivided. The open plan is thus seen here from a practical standpoint. But this does not of course mean that Perret failed to accept his artistic responsibilities. These responsibilities were in fact first elaborated by Le Corbusier (Charles-Édouard Jeanneret, 1887–1965) in connection with the "free façades" of his 1920s' *machines à habiter* (*93*); his Dom-Ino houses of 1914, with their mass-produced, completely flexible dwelling units, are based on principles pursued by Perret.

The themes of the flexible ground plan and continuity between architecture and town planning, formulated shortly after 1900, together with a rejection of decoration and the reduction of the architect's vocabulary to basic stereometric forms, are symptoms of an intellectual outlook that was to play a large part in the evolution of a specifically 20th-century style. But the plans in which these features were expressed, and the few works that were actually carried out, were at first barely noticed by artists or by the general public; the more widespread reaction against Art Nouveau represented in essence a reapplication of Classicism and the homely Biedermeier or Early Victorian style.

The point is that at that time it was impossible to evolve from scratch a formal language that would fully express the architect's new feeling for space as long as the plastic arts did not supply any new suggestions. It was not until the advent of Analytic Cubism that help was at hand. And even then, World War I prevented its being carried over into architecture until the 1920s.

Toward Simplification in Painting*

In rejecting the academics' illusionistic space, all independent painters since Manet had been unanimous in believing that the two-dimensional picture surface, to which they gave unconditional primacy, could be respected only if in structuring their pictorial

* It is reported that Gustave Moreau once said to his pupil Matisse: "Your destiny is to simplify the painting."

space they allowed color to regain the decisive role to which it was entitled because they believed it to be the most innate quality in painting. But they had followed various paths in their efforts to achieve a pictorial space based solely on color. Thus, there were conflicting interpretations of what a picture really is. Painters such as Manet and Gauguin attributed the structure of a composition to the taut balance between a few large patches of color; the Impressionists and Neoimpressionists, and Cézanne in his later years, broke the picture surface up into small dots of color, their idea being to create a surface of uniform intensity. While the "Synthetists" believed that at least the basic structure of the painting should be rapidly comprehensible, the more analytically inclined painters who took over from the Impressionists sacrificed the legibility of the pictorial theme to the unity of the painted surface.

Both the idea of making a painting more difficult to read and the very concise handling of the pictorial structure (thus giving this structure greater power to impress itself on the memory) seemed to the painters of the turn of the century, who were involved in the problems raised by graphic art (book illustration, posters) and decorative art, to be equally effective means of intensifying the relationship between the painting and the person looking at it. This led them, among other things, to explore "pure," elementary ways of dynamic expression in painting or in graphic art (such as patches or strokes of color). In *The Kiss* (6), Edvard Munch (1863–1944) plays for maximum impact by strictly respecting the individual qualities of the material (wood) and the technique (cutting and staining). The contrast between the smooth, dark, rocklike patch of color and the graining of the ground conveys his message in the most succinct way possible; his intense image speaks of loneliness and the threat to the couple's happiness. By contrast, the couple in a frieze (7) by Gustav Klimt (1862–1918), although fused into a single entity in the same way, is "lost," dynamically speaking, in the ornamental, patterned background (which represents the Tree of Life). The repetition of spirals coiling in opposite directions, combined with the swirling patterns of the garments, gives a feeling of bewildering activity to the entire surface. Munch, by simplifying his already elemental means as far as possible, achieves an intensity of expression that could scarcely be greater, while in Klimt's frieze the accumulation of seemingly unrelated ornamental shapes and the expensive materials exercise a kind of seductive fascination that draws the spectator and evokes the couple's mood of rapture.

In both works, the dynamics of color and line achieve expressive ends. By contrast, in a painting such as *Le Luxe* (8), Henri Matisse (1869–1954) uses them purely for purposes of construction. Color and line neither are intended to express a discharge of tension (that is, as inherently expressive elements) nor are they played off against each other. And yet, the artistic creed that Matisse published a year later begins with the sentence: "What I am after, above all, is expression." A few lines later he defines expression in the following way: "To me the 'expression' lies less in the passion of a look or gesture than in the arrangement of my picture: the room that the bodies take up, the empty areas surrounding them, the proportions. Composition is the art of arranging

in a decorative manner the various elements which the painter uses to convey his feelings."

Matisse's demand for accuracy and "objectivity" in handling materials is in keeping with the idea being expressed at this time by the innovating architects. The stress is now on the rational element in the artist's activity. In this, Matisse creates a gulf between himself and the license recently (1905) adopted by the Fauves ("wild beasts") in their rebellion against the symbolism of Art Nouveau. They allowed their exuberant *joie de vivre* to burst out in an uncontrolled ("wild") explosion of color and rhythm. Immediacy of effects, which was as important to the great "simplifier of painting" (as Gustave Moreau called him) as it was to the Fauves, could not for Matisse be achieved solely on an emotional basis. Likewise Matisse rejected the regimented Pointillist method of breaking up the colored surface—a technique with which he himself had experimented for a time ("a purely mechanical means, corresponding to a purely physical sensation"). But he also differentiated strongly between intensity of color and mere gaiety in coloring (that is, a hasty translation of inner emotion by applying paint more with the hand than the head).

Yet Matisse did identify with the Fauves in his "striving for intensity of color without reference to the individual properties of the material being portrayed." The break with the "local tone" (or basic color) of the object being depicted, deriving from the view that color exists in its own right, represents a decisive step toward a "pure paint" attitude that ignored sensual stimuli from the external world, using color to produce a painting that was independent of its environment. The subjective impulse (*"l'émotion"*) expressed in the painting is not caused by the painter's emotional reaction to the world around him but is a pure creative urge, manifested in an autonomous visual object.

In this, the Parisian Fauves—Albert Marquet (1875–1947), Charles Manguin (1874–1949), Charles Camoin (b. 1879), Jean Puy (1876–1960), André Derain (1880–1954), Maurice de Vlaminck (1876–1958), Othon Friesz (1879–1949), Raoul Dufy (1877–1953), Georges Braque (1882–1963)—who emerged as a very loose group for the first time in 1905, differ widely from a contemporary group called Die Brücke in Germany—Erich Heckel (1883–1970), Ernst Ludwig Kirchner (1880–1938), Karl Schmidt-Rottluff (b. 1884)—and from the isolated North German artist Emil Nolde (1867–1956). Although these German painters used color just as freely as the Fauves, "expression" for them always involved the emotional or intellectual content of a painting. In paintings on related themes by Derain (*9*) and Nolde (*10*), for instance, the treatment can in both cases be described as lyrical, but in a completely different sense. Nolde's lyricism is the result of his emotional identification with the forces of nature which are, for him, an integral part of the landscape; Derain's composition is lyrical in so far as he remains aloof from his subject matter and uses it merely as a pretext for a composition that comes to life through the use of color that he has hit upon independently. His identification is not with nature, but with *color*.

On the other hand, an expressionist manner does not always derive from the almost mystical merging into the universe of nature to which Nolde aspired. It much

more often entails primarily—as in the case of the Brücke painters—a radically negative attitude, an almost desperate *no!* to the world around them, to the social or ethical order, and even to their own inner being. This emotionally charged rejection not only of specific life situations in which the painter is enmeshed but also of the human condition in general affects the Expressionists' choice of themes, for, unlike the Fauves, the Expressionists saw subject matter as an important point of departure for their art. Either they criticize social conditions, revealing man's debasement by his fellow-men or by his own instincts (in this, the Frenchman Georges Rouault, with his portraits of prostitutes and judges, comes close to the Brücke painters), or they betray a deep need to escape from temporal reality, a yearning to return to a state of nature that is free from "thou shalts" and "thou shalt nots." Yet in the work of Heckel, and even more in that of Kirchner, this conjuring up of the Garden of Eden is the opposite of the Romantic dream of a Golden Age and of the merry idyll that Matisse evoked on canvas in such compositions as *Le Luxe.* Their indictments of civilization end in avowals of barbarism. Compared with this, Gauguin's treatment of the primitive seems very conciliatory.

It was the rejection of conventional beauty (which Umberto Boccioni was later to transform into the theme of the *antigrazioso*) that led the Brücke painters to embrace the art of primitive peoples, with Nolde and Max Pechstein (1881–1955) even embarking on full-scale ethnological expeditions to the South Seas. This motivation in subject matter was diametrically opposed to that of the French painters, who were fascinated not by the primitive element in this type of art, but, quite the opposite, by what Picasso once called the "rational" element. In other words, they were concerned with the creative process, in which they thought they recognized a conceptual model that confirmed their own efforts to evolve a creative vocabulary that would not be hampered by the conventions of perception fostered by humanism.

The search for immediacy of expression that led the Fauvist painters to concentrate on the elementary pictorial components of color and line in Expressionist hands increased to a deliberately aggressive use of these means. Their primary goal was to break with viewing habits engendered by the perspective representation of space, since these enable the spectator to allot every single thing and every single person "its" own place and to keep it at a safe distance. In their attempt to do away with this distance between man and his environment, the Brücke painters did not get rid of the traditional image of space once and for all, as the Fauves did, and replace it with a new purely pictorial structure; instead, they distorted it just enough for the distortion to be felt as a deliberate attempt to shake people's feeling of security.

Thus, their use of primitivistic techniques (*13*) was intended to create effects of alienation. Felix Vallotton (1865–1925) and Edvard Munch (*6*) had already discovered the possibilities offered by woodcuts for expression in the concisest possible way. Now, by imitating the technique used in 15th-century German broadsheet woodcuts, the Brücke artists developed the woodcut into a medium that was fully in keeping with their artistic aims.

Freud and the Icons

The aggressive attitude of the Brücke artists was not the only strain of prewar Expressionism in Central Europe. The contribution of two Russian painters living in Munich and Murnau—Vassily Kandinsky (1866–1944) and Alexei von Jawlensky (1864–1941) —was equally important, and the work of a handful of artists in Vienna, namely Oskar Kokoschka (b. 1886) and Egon Schiele (1890–1918), was also significant. Both Kokoschka and Schiele were products of Art Nouveau, which continued to flourish for many years in Vienna, though they were not as strongly under its influence as was Gustav Klimt (1862–1918).

Kokoschka and Schiele experienced no less sharply than the Brücke painters the uneasiness concerning society and the self that can grow to such proportions that it produces severe psychotic disorders. But instead of reacting with a shout of accusation, they attempted to grasp it in all its complexity, in themselves and in the people around them (15, 16).

Whether or not an analogy may legitimately be drawn here with the founding of psychoanalysis by Sigmund Freud (1856–1939), this analytical attitude involved breaking up compact masses of color into a subtle interplay of nuances. An example here is the transformation of the Art Nouveau arabesque into a neurotically trembling line that is sometimes tortuous and intricate and sometimes more like fluid handwriting. It registers all the painter's emotional reactions to the figure he is portraying (and who is, essentially, an extension of himself) as if on a seismograph.

By contrast, neither Kandinsky nor Jawlensky was weighed down by feelings of decadence or by psychological intentions, or indeed by any ambition to rebel against the social order. They were linked to the French painters by their determination to make their color as vivid as possible. They saw color not as the carrier of message; rather, they endeavored to bring out its luminous power in its own right. In their pursuit of this aim, however, they did not follow Fauvist practice; instead, they covered the picture surface with thick and unbroken layers of color, which made it glow like enamel. This gave the paint itself a solidity and independence reminiscent of Byzantine mosaics. In Jawlensky's portrait (14), such an impression is reinforced by the uncompromising black outlines, which simplify the structure. This technique gives even small paintings a feeling of monumentality.

Discontinuity and Transparency of Form

While the Fauves and the Brücke painters were emphasizing the supremacy of color as the chief means for conveying the emotional content in painting, and were seeking to heighten the intensity of pictorial expression by a more aggressive tempo in their individual "handwriting," the significance of line was being peremptorily questioned. From 1908 onward, new and radical paths were being pursued in Paris by Georges Braque and Pablo Picasso (1881–1973), soon leading them to sever any links with representational reality, to which the Impressionists and Cézanne—and even Matisse— still adhered.

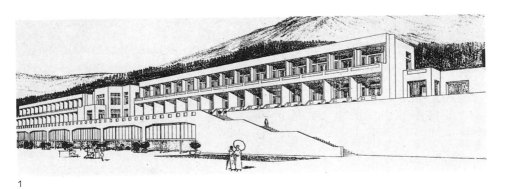

1

1 TONY GARNIER, TUBERCULOSIS SANATORIUM. From the Cité Industrielle. 1901–4. Drawing
for an unexecuted project.

Picasso and Braque rejected external form as perceived by observation, which is influenced by nonartistic factors, in order to reveal instead the inner structure of objects. They depicted them in a two-dimensional pictorial space, which they acknowledged as the only reality that is binding to the painter. But the inner structure of a figure, object, or landscape is revealed as a spatial structure only when we are not limited to a view taken from a single angle, but instead are offered more information than we can infer from the most poetically drawn outline.

Now, if several complementary views can be fused together to create a synthesis, then the new formal entity, corresponding as it does to each individual view, can be broken down into simple basic components, and by combining these elements, we can reactivate the knowledge that we have previously acquired from the object itself. To allow this reconstruction, the system of forms must enable us to switch from one view to another freely and fully—in the case of a figure, from profile to full face, for instance. The idea is not to indicate the stability of form, modified by the changes it undergoes in the ebb and flow of visual perception, as it was with Paul Cézanne. Instead, mutually exclusive aspects of form are contrasted in the visual experience, making the form transparent, so that the inner structure of the object is revealed. It is this structure that shines forth like filigree from Braque's and Picasso's Analytic, or early phase, Cubist paintings (1908–11).

This step—the development of Cubism—was to have incalculable consequences. The Renaissance concept of space, which presupposed that all spatial elements were homogeneous and measurable, and which had seemed highly questionable since Post-Impressionism or earlier, now lay in ruins. And with it disappeared the concept of the object as a clearly defined body displacing space. Space, object, and viewer became a single entity. Or better still, as a space-time reality, the object was once again lodged in the viewer's imagination, not in his concrete perception. Thus, Cubism represents a decisive step in the progression of modern art toward conceptualization.

11

For Braque and Picasso, and still less for Juan Gris (1887–1927), mere dissolution of form was not the goal. The inner structure of an object could be fully understood only if its outward shape, which was stamped on it by chance and convention, was replaced by a synthesis of its elementary components; only then could it definitely be integrated into the spatial structure of the painting. But this synthesis presupposed a completely new working method, which we can call montage, since what it really involved was studying the elements that had been isolated by analysis, selecting the ones that belonged to the object's pictorial structure, and then rearranging them.

The analytic Cubists made use of "geometry" (the surface fragments into which they broke up the overall form correspond more or less to elementary geometric figures; their aim was to expose inner structures. They thus introduced intellectual motifs, like those of elementary form or construction, that are also useful in other creative spheres—particularly in architecture.

Real Space

The example set by painters who turned away from external shapes in order to analyze objects structurally was soon followed by certain sculptors. They reduced the fixed volumes with which sculpture had always been concerned to the same type of "open" systems. For instance, in two heads executed in 1913 (*23*) and 1915 (*25*), Alexander Archipenko (1887–1964) and Naum Gabo (b. 1890) started out from the assumption that, say, a cube can be construed not only as a solid body cut off from the surrounding space by its six walls, but also as the open spatial figure that results from the planar cross formed by three squares intersecting at right angles. The outer space infiltrates the figure from all directions and it thus enters into a new relationship with its environment. This change of significance is clearly visible in a work such as Henri Laurens' (1885–1954) *Head* (*26*), which is conceived as an "open" spatial structure, on the model of Braque's and Picasso's 1912–13 compositions. The space with which this structure is intimately bound up is not the painter's two-dimensional space, but the multidimensional "real" space in which the viewer himself moves. The traditional type of sculpture—that is, the type that remains alien to its surroundings despite being "realistic"—becomes an object that incorporates the concrete space in which we live. Painters had abandoned the perspective plane by 1913 (*41, 42*) and, in so doing, had placed their pictures in "real" space, having since 1908 considered them as independent "objects." (Cubism subsequently came up with the concept *tableau-objet*.)

Compared with the relative simplicity of the principle of transposition on which Archipenko's hollow sculptures are based, the complex system of forms into which Raymond Duchamp-Villon (1876–1918) translated a horse's head as early as 1914 (*24*) seems quite impossible to unravel. In this piece, the individual anatomical shapes are

2 AUGUSTE PERRET, APARTMENT HOUSE, Rue Franklin, Paris. 1903. Ferro-concrete.
3 FRANK LLOYD WRIGHT, WILLITS HOUSE, Highland Park, Illinois. 1902.
4 ADOLF LOOS, STEINER HOUSE, Vienna, seen from the garden. 1910.
5 WALTER GROPIUS and ADOLF MAYER, FAGUS FACTORY, Alfeld an der Leine, Germany. 1911.

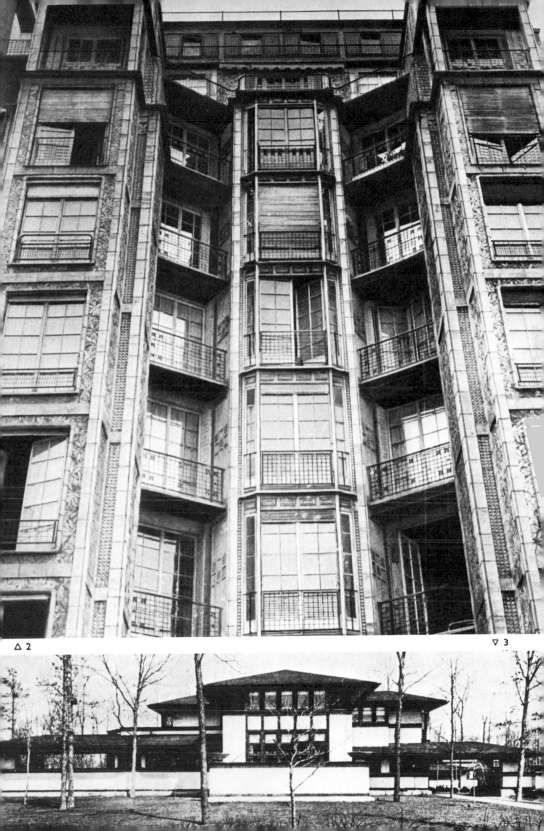

△ 2

▽ 3

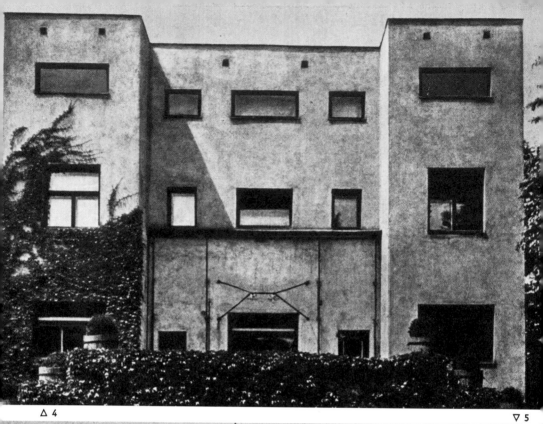

△ 4

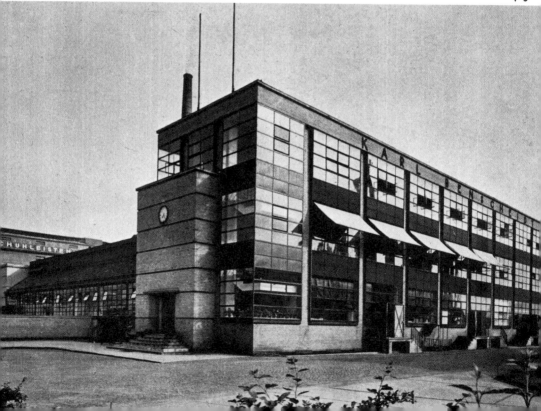

▽ 5

integrated to form dynamic partial units. They are subjected to such a radical process of translation that we are left without any structural plan at all, though the cypherlike structure that emerges is comparable to some compositions by Picasso dating from the "hermetic" phase of Cubism (1911–12).

Movement I

One of the most urgent tasks facing the new art, now that it had parted company with customary representational ways of thinking and was instead committed to modern forms of thought and experience, was that of conveying movement. It was obvious that the problem of depicting moving bodies must be posed afresh and that it would be approached from various different directions, starting with the purely physical angle. From Renoir, Toulouse-Lautrec, and even the calm Seurat (*Le Chahut*) to Sonia Delaunay's (b. 1885) *Bal Bullier* and the *Bal Tabarin* paintings by Gino Severini (1883–1966), by way of Matisse's *Dance* and Nolde's Oriental dancing girls, the hot rhythms of cabaret dances or exotic southern folk dances take over from the figures of classical ballet who were being analyzed so objectively by Degas. Even Matisse tells us that while working on his huge dance scene (a distant "foredancer" of Action Painting), he actually executed some steps from the Catalan *sardaña* that had inspired him to paint it in the first place.

For the painters who produced Fauvist, early Expressionist, or Futurist work, then turned to Futurism, the human body caught up in the rhythm of the dance or some form of sport—it could even be their own body—represented a way of focusing with great immediacy the excitement and inner tension they were trying to express. But the main source of movement that confronted them, and very concentrated movement at that, was the rhythm of machines and engines—*the* hallmark of the new century. There was the rapid movement of cars, underground trains, elevators, steam engines, airplanes; and then there was the rapid change in one's whereabouts that these allowed one to make; and the frenetic tempo of life in big towns, throbbing to the rhythm of flickering electric signals and neon-lit advertisements—the tempo whose praises were sung by such poets as Filippo Marinetti, Guillaume Apollinaire, and Blaise Cendrars.

The Futurists felt that this omnipresent movement nullified any attempt to describe things or people properly because it caused a constant mutual interpenetration of all objects, circumstances, and movements in a single, overall experience of the world: "simultaneity." What the painter had to capture was *dinamismo,* the inner dynamics of objects, people, and situations, their *compenetrazione* (penetration) and *simultaneità* (simultaneity). But such experiences are no longer purely visual ones.

The Futurists were the first artists—at least, in theory—to demand that the experience of the world around us as a simultaneity of movements, sounds, and smells be expressed in a new *Gesamtkunstwerk,* or total work of art, which would appeal to all the senses equally. Their attitude was quite different from that of the Cubists. The Cubists dissolved the object into its surroundings on the basis of an objective, impersonal analysis of its structure, with the aim of reconstructing it, whereas both the starting

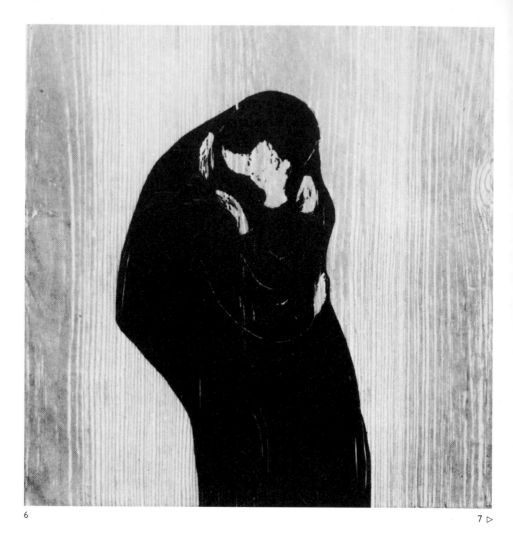

6

6 EDVARD MUNCH, THE KISS. 1897. Woodcut.
7 GUSTAV KLIMT, THE KISS. 1909. 44.7 × 44.7 cm.
Musée des Beaux-Arts, Strasbourg. Sketch for
a mural painting in the Stoclet House, Brussels.
8 HENRI MATISSE, LE LUXE. 1907. Oil on canvas.
210 × 138 cm. Rump Collection. Statens Museum for Kunst, Copenhagen.
9 ANDRÉ DERAIN, SHIPS IN THE HARBOR. 1910.
Oil on canvas. 70 × 90 cm. Private collection,
Berne.
10 EMIL NOLDE, AUTUMN CLOUDS. 1910. Oil on
canvas. 73 × 88 cm. Kunsthalle, Bremen.

point and the goal of the Futurists were subjective and emotional. They wanted to
convey with total immediacy the state of excitement caused by the process of becoming aware of the dynamics of a situation. They did not break open compact forms
and allow the surroundings to penetrate them because they wanted to reveal the object's
inner structure, but because the form is always perceived only very dimly. "The new

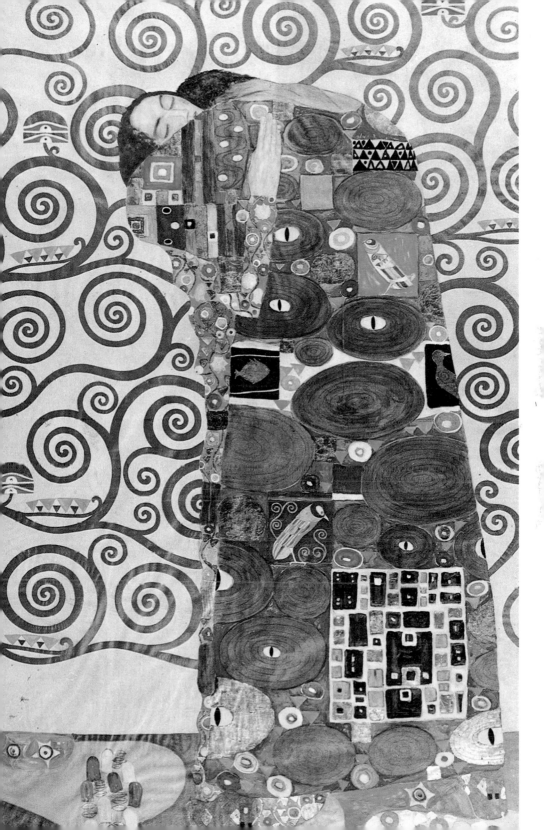

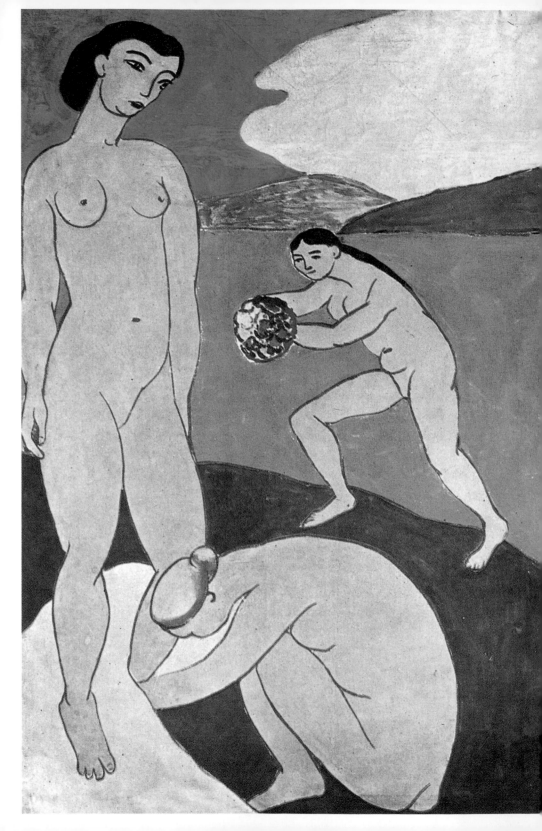

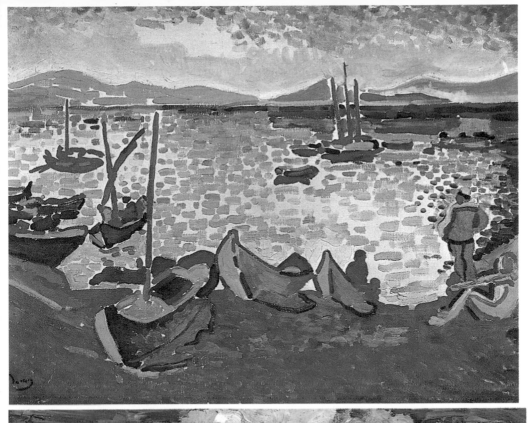

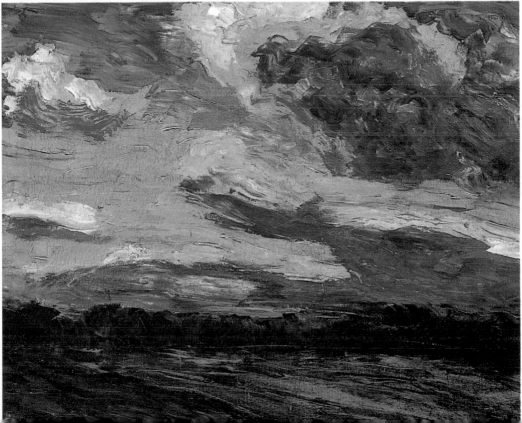

11

12

11 ERNST LUDWIG KIRCHNER, NUDE IN THE
STUDIO. 1910–11. Oil on canvas. 93 × 94 cm.
Nationalgalerie, Berlin.
12 GEORGES ROUAULT, THE SMALL OLYMPIA.
1906. Watercolor. 55.5 × 63 cm. Rump Col-
lection, Statens Museum for Kunst, Copen-
hagen.
13 ERICH HECKEL, SELF PORTRAIT. 1917. Wood-
cut. 369 × 296 cm. Folkwang-Museum, Essen.

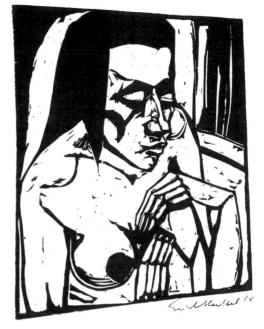

13

sculpture," wrote Umberto Boccioni (1882–1916), "will illustrate the atmospheric planes
that cut across objects and join them together. Let us herald the absolute and complete
abolition of the finite line and closed sculpture. Let us break open and enclose the
environment in it." A comparison of Boccioni's *Striding Figure* (*29*) with Duchamp-
Villon's *Horse's Head* (*24*) is a clear illustration of the fundamental difference between
the Futurist and the Cubist concept of open form.

Marcel Duchamp's (1877–1968) approach to the problem of movement was very
different from the subjectively expressionistic attitude of the Futurists. He interprets
his *Nude Descending a Staircase* (*28*) as "an organization of kinetic elements, space,
and time illustrated by means of the abstract representation of movement." "But,"
he adds, "we must not forget that if we fix our gaze on the movement of a form
through space for a specific length of time, we enter the realm of geometry and
mathematics, just as if we were to build a machine to produce this movement. If I want
to show an airplane taking off, I try to show what it does, I don't turn it into a still
life." Thus movement is not experienced lyrically as a *dinamismo,* as an uncontrollable
force, but is examined objectively as the way in which a mechanism functions. The
structural changes that space is liable to undergo as soon as one of its components
is set in motion are not accounted for by hieroglyphs devised by magic and intuition,
but by "diagrams of force" calculated and constructed on scientific lines. In this way
figures and objects forfeit the last shreds of identity and independence allowed them

by the Cubists. The problem of visualizing movement thus leads to the question of an object's existence as potential subject matter for a painting.

But in using a technique for reproducing the movement of his *Nude* that was inspired by the "chronophotography" of Etienne-Jules Marey (1853–1904)—a physiologist of movement who used a multi-exposure camera with moving plates—an ancestor of the film camera—and was therefore not strictly artistic, Duchamp challenged the traditional concept of a painting as an ultrapersonal creative product utterly different from work produced by scientific and technical graphic processes. The many members of the general public who were horrified and outraged by the painting in Paris in 1912 and at the Armory Show in New York in 1913 may perhaps have had some inkling of this.

Light and Color

In the work of Braque and Picasso we could object to the fact that piecing together fragments of an object and setting them in a space without depth makes it virtually impossible to introduce movement into the painting. In the same way, many painters found it utterly incomprehensible that a basic fact recognized by the Impressionists —the identity of light and color—should apparently be ignored by the Cubists. The light that allowed Impressionist still lifes to glow palely out of the half-dark remained colorless in Cubist hands. In the "hermetic" paintings they produced between 1910 and 1912 (*21*) the warm/cold resonance they had inherited from Cézanne paled to a virtually monochrome interplay of various grayish shades. Painters like Jacques Villon, Fernand Léger, Roger de La Fresnaye, and particularly Robert Delaunay (who in the years 1910–12 emerged as the leading figure in the Cubist group) refused to admit that transparency in space must be bought at the expense of color.

In his early work Robert Delaunay (1885–1941) had paid homage to strong coloring, generally applying color in the Neo-Impressionist manner to create an impastoed, mosaiclike effect. Then, through his wife, Sonia Terk, he became familiar with the equally strong glowing colors that she had made her speciality, as had Kandinsky and Jawlensky.

Yet Delaunay was interested in Analytic Cubism because it seemed to offer him the opportunity to reduce the importance of the picture plane by articulating the picture space in a more varied way than if he were reveling in pure color. But when this optimistic painter with a strong interest in structure tried out the Cubist fragmentation of form in paintings of townscapes or buildings, he came to believe that the effect was "destructive," and he soon abandoned it. He did adopt the Cubists' use

14 ALEXEI VON JAWLENSKY, WOMAN'S HEAD AGAINST RED BACKGROUND. 1913. Oil on cardboard. 68.8 × 49.9 cm. Bayerische Staatsgemäldesammlungen, Munich.

15 OSKAR KOKOSCHKA, EMIGRÉS. 1916–17. Oil on canvas. 95 × 146 cm. Bayerische Staatsgemäldesammlungen, Munich.

16 EGON SCHIELE, SELF PORTRAIT. 1911. Historisches Museum der Stadt Wien, Vienna.

14

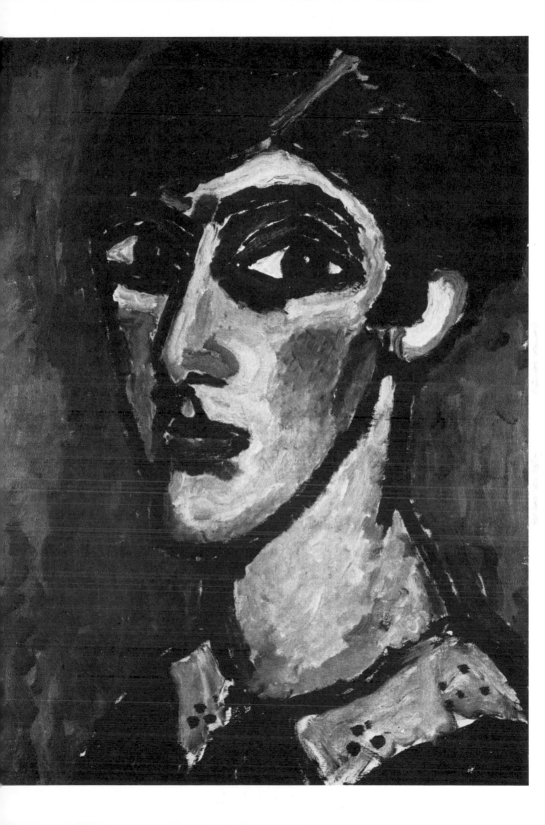

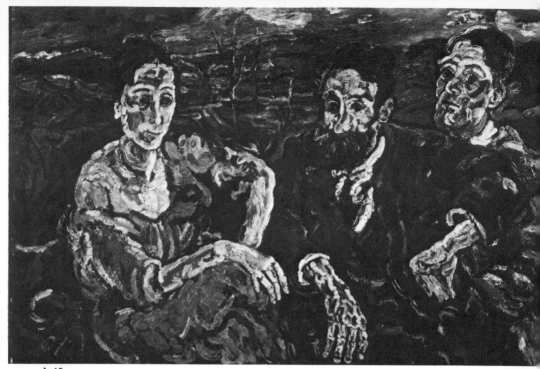

△ 15

▽ 16

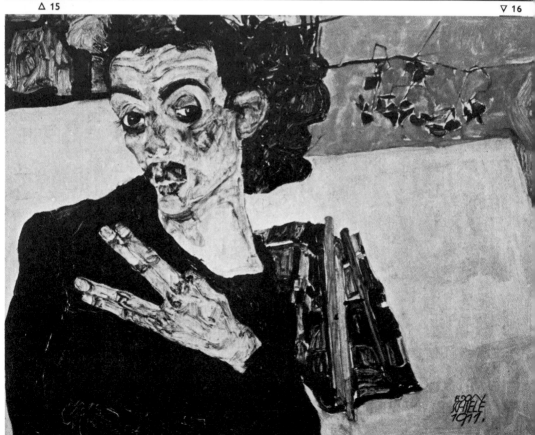

of faceted structures that sometimes mirror light and are sometimes translucent, except that he extended them into a grid of verticals and horizontals dividing the picture plane into a system of uniform areas of color and light. In his *Window* series (*32*) the repeated cell structure of the cityscape merges with the grid pattern, revealing the colored texture of the light. Shapes like the gathered curtains and the distant silhouette of the Eiffel Tower are merely suggested, as a counterpoint to the rectangular grid-structure. Light refraction has replaced the breaking up of forms as the primary analytic technique, displaying color in all its abundance.

But this technique of dematerializing objective reality altogether presupposes not only the transparent effect achieved by Cubism but also a purification of color, which was not possible without a return to the experiments begun by the Impressionists. By covering the picture surface with a uniform network of blobs of color, which worked against the differentiation of form by giving the entire surface equal weight, the Impressionists created a vibration that propagated in the space between the picture and the person looking at it. The stippling technique used by the Neo-Impressionists provided a quasi-scientific explanation for this attempt: if one looks at two comple-mentary dots of color simultaneously, the vibration actually originates on the retina, at least in theory. The same technique was employed by the Italian Divisionist painters. Gino Severini, who moved to Paris permanently in 1906, took over this technique, as did the other Futurists. Severini tried to combine it with the Cubist technique of fragmentation, seeking to allow light to act not merely as a vibration but as a kinetic element in the process of *compenetrazione* (*31*).

A painter like Delaunay could not accept this solution. His aim was not to portray light and its effects but to reproduce the actual moment of seeing, as the stimulating effect of light on the retina, and thus as pure dynamics. "Seeing is movement," he said. Even the grid texture of his *Windows* soon began to annoy him, since it still contained elements that prevented the light/color from expanding freely. He therefore invented his rotating circles, which carried this dynamic principle over into the surrounding space. From these circle he and his wife evolved a rhythmic principle for large-scale compositions. His art was christened Orphism by Guillaume Apollinaire.

Delaunay's phrase "Seeing is Movement" was re-echoed in the 1960s in the work of many painters. They took literally the ubiquitous demand—now growing ever louder—for overthrowing painting as outdated, since it was a surface covered with a fixed system of carefully arranged colors and shapes. Bearing in mind the viewer's mobility, they did not attempt to define the effect of color on the picture surface, but instead allowed the form to be perceived unsteadily in space. For instance, in his *Physichromies* (*35*), Carlos Cruz-Diez (b. 1923), a Venezuelan, uses thin strips of colored rhodoid arranged perpendicularly to the picture plane to intercept the note sounded by the narrow stripes or lines of the background, thus letting it radiate out into space, so that the color effect changes as the viewer changes his position.

A careful study of a *Hammamet* watercolor by Paul Klee (*33*) and a later still life by Jacques Villon (*34*) gives a good idea of the possibilities inherent in a combination

of the fragmentation of shapes practiced by the Cubists and an exploration of the effects created by light and color. Both paintings are virtually devoid of representational suggestions; only a few vague pointers within an abstract basic structure give any hint of the physical subject matter that motivates them. But these clues are far from being without significance, since they clearly reveal the painter's intention. Thus, Villon (1875–1963), by taking a handful of superimposed sheets of paper as the pretext for his composition, demonstrates his wish to examine, under objective conditions, so to speak, the "layered," unfathomable space in which the Cubists built up their still lifes. This objectivity allows him to create a highly transparent effect. But at the same time, it means that he remains closely dependent on space that is visually experienced (which the Cubists admittedly never abandoned), implying that the relationship of the viewer to the content of a painting is linked to the viewer's perception of "real" space. However ethereal Villon's colors, then, they are presented as "actual" colors, rooted in reality.

Klee (1879–1940), on the other hand, uses his *Motif from Hammamet* because it can be transformed—in the manner of Delaunay's windows—into a faceted, afocal structure that gives a new meaning to the picture space. Since there is no longer any link with a spatial structure derived from visual experience, the picture surface becomes a screen onto which shapes are projected. They group themselves not into a more or less skillful "pictorial" reconstruction of this experience, but into something resembling a childlike sign language. In this new spatial context even the coloring seems to have been freed from any kind of practical content and thus regains an elementary significance. It is not even, as in the Villon painting, a final transformation of certain natural colors encountered in daily experience; it, too, is a projection of pure spiritual content.

From 1920 onward, Klee became involved on a systematic basis with the theme of a chessboard, which he saw as an "elementary" rhythmic principle. He explored the possibilities it offered for creating elementary arrangements in the field of color and in this way created an important precondition for the development of what is known

17 PABLO PICASSO, HARLEQUIN. 1908–9. Gouache on paper. 62 × 47.5 cm. Kramàr Collection, Narodní Galerie, Prague.

18 PABLO PICASSO, LOVES AND BOWL OF FRUIT. 1908. Oil on canvas. 164 × 132.5 cm. Kunstmuseum, Basel.

19 GEORGES BRAQUE, VIOLIN AND JUG. 1910. Oil on canvas. 117 × 73.5 cm. La Roche Donation, Kunstmuseum, Basel.

20 GEORGES BRAQUE, MANDOLIN. 1910. Oil on canvas. 73 × 60 cm. Tate Gallery, London.

21 PABLO PICASSO, TORERO WITH GUITAR. 1911. Oil on canvas. 65 × 54 cm. Kramàr Collection. Narodní Galerie, Prague.

22 JUAN GRIS, GUITAR AND FLOWERS. 1912. Oil on canvas. 112 × 70 cm. Museum of Modern Art, New York.

23 ALEXANDER ARCHIPENKO, HEAD. 1913. Bronze. Saarlandmuseum, Saarbrücken.

24 RAYMOND DUCHAMP-VILLON, HORSE'S HEAD. 1914. Bronze. Musée National d'Art Moderne, Paris; Museum of Modern Art, New York.

25 NAUM GABO, CONSTRUCTION OF A HEAD. 1915. Wood. Height, 45 cm.

26 HENRI LAURENS, SAINTE TÊTE D'HOMME. 1918. Wood. 15 × 17 cm. Arp-Hagenbach Collection, Kunstmuseum, Basel.

17

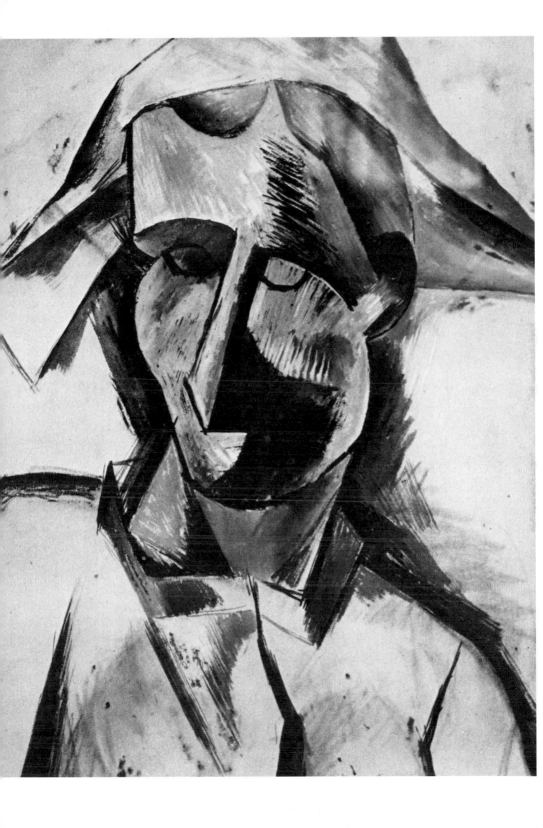

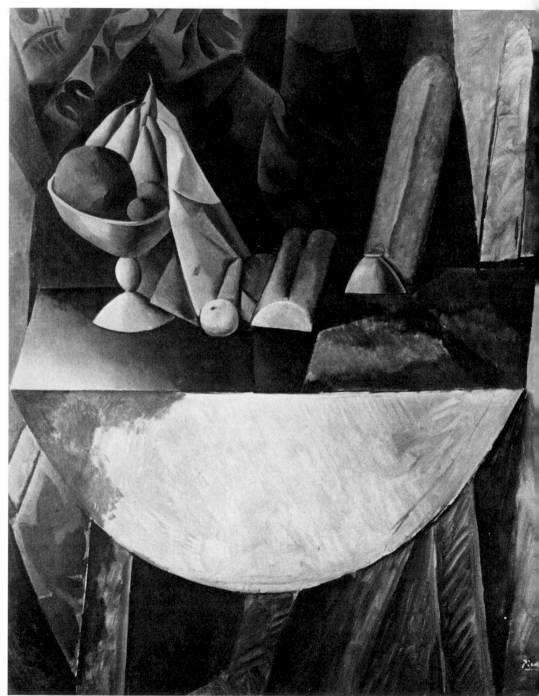

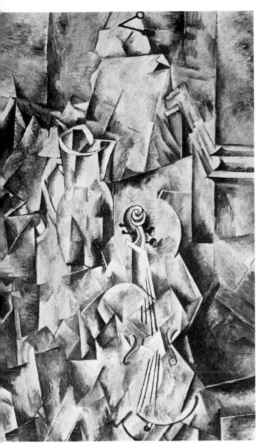

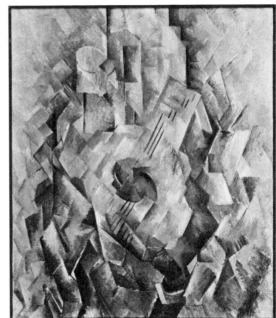

△ 19 ▽ 21

△ 20 ▽ 22

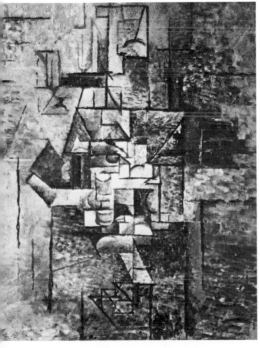

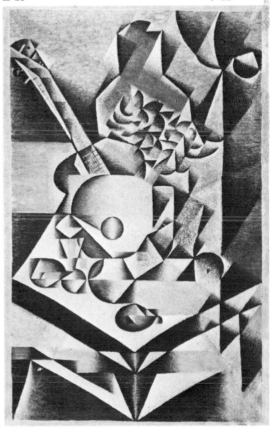

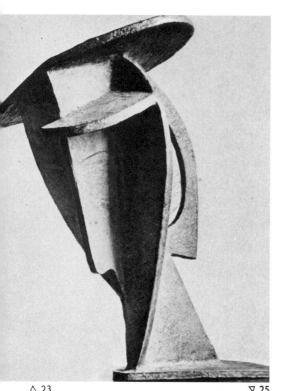

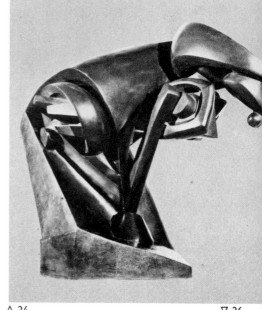

△ 24

△ 23 ▽ 25 ▽ 26

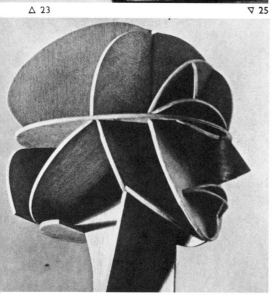

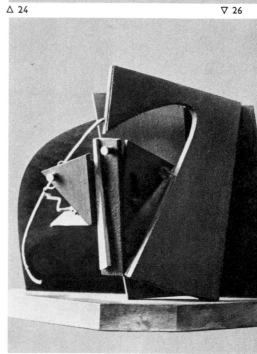

as serial art. As many paintings from his Tunisia visit show, he seems, as early as 1914, to have sensed the significance of the changeover to an afocal picture structure —unlike the German Blaue Reiter Expressionist Franz Marc (1880–1916), who also adopted Delaunay's technique of faceting in some of his paintings, but soon abandoned it in favor of dramatic composition schemes (37).

Thus the experiments made between 1905 and 1912 with the main picture components of color, form, movement, and light led rapidly but logically to the interpretation of these components in a new way. The Fauves, for instance, made color autonomous, while the Cubists made form transparent. The omnipresence of *light* proclaimed by the Orphist Delaunay enabled painters to interpret space as an expansive and dynamic fluid element instead of a static, measurable reality or an atmospheric reality. Each of these new discoveries meant that the object lost more and more of its substance. For many painters (though there were some important exceptions, such as Matisse and Léger), the essence of the object was no more than an unstable spatial constellation, or simply a momentary modulation of light. The only reality of painting was then the element, around which a painting free of objects could be constructed. In such a painting there was only one object—the actual picture. But certain lines of thought, such as those followed by Marcel Duchamp, were already pointing to the conclusion that this shift of reality must also lead to a break with the traditional concept of the relationship of the artist to his work, and the relationship of his work to society and the world around him.

"Lyrical Explosions"

At this period, painters experienced rhythm not only through dancing or machines or through the general tempo of modern life, but also through music. Quite a few painters, including Braque, Matisse, Kandinsky, and Klee, played musical instruments. They also had contact with various composers—Kandinsky was a friend of Schoenberg, for instance—and went to concerts. From the time of Post-Impressionism onward, music had represented a model and a challenge for painters. Gauguin had already claimed that painting's ideal goal was the "purity" that in music could affect man's moods. Painting would achieve this only if it stopped being literary and descriptive and instead used "purely painterly methods." Subsequently, painters became interested in such specifically musical means as tone and rhythm, which they saw as equivalents of color and line. But they were also interested in the science of harmony and composition. The abstractness of music served as a model: It was able to transpose the sounds of nature into patterns of sound that were far removed from nature. Painters were also impressed by the precision that musicians had attained in defining their abstract tools. This precision allowed them to explore ever newer avenues of harmonic expression with an almost scientific certainty, which painting—groping about in the half-dark of imprecise theories—was still incapable of achieving.

The analogy between music and painting was taken quite literally by Vassily Kandinsky (1866–1944). The painter's task, as he saw it, was to express the "inner sound" of

objects. He therefore classified his paintings as "impressions," "improvisations," or "compositions." He saw the art of the future as a synthesis of painting and music to create an abstract spectacle in which shapes and colors would not stand in a fixed relationship but would move about in a constant interplay of fluid interrelationships governed by music.

In Kandinsky's *Composition No. IV* (*36*), which is, in effect, bisected by the two roughly vertical bars while at the same time firmly held together by a curving shape that is reminiscent of the swelling contours of a mountain, irregular shapes—not blots!—and free-form lines suggest, on the left, a clash between hordes of warriors brandishing lances, and on the right, the peace of a cemetery with two towering tombstones. Thus, a hint of subject matter is dimly visible, somehow unreal and yet definitely there, as in Cubist paintings, but it is drawn from an imaginary world—the world of heroic sagas—which is as far removed as it possibly could be from the prosaic and unassuming world of Cubist still lifes. But, most important of all, it interprets the essence of music in a completely different way from Analytic Cubism. For the French painters, music is made visual through a type of sublimated geometry, which suggests structural solutions as the artists experiment with the picture space, while Kandinsky's concept of "inner sound" gives greater prominence to the subjective, as opposed to the technical, expressive content. Cubists see rhythm as a means of arranging and measuring the composition; Kandinsky exploits its expressive and dynamic qualities. The treatment of the graphic element, in particular, suggests that what we have here is gesturally expressive art. Kandinsky's linear treatment also shows his role as a mediator between Art Nouveau and Action Painting. "The line, the stroke is a force that cannot either deny its nature or escape its fate—lines, notation of gestures: that's where the miracle comes in," wrote the Belgian painter, architect, and decorator Henry van de Velde. In the same way, Kandinsky felt that every stroke records release of psychic energy, set free by the awareness of the "inner sound." This led straight to what became known in the 1950s as Abstract Expressionism.

Kandinsky was not the only painter to record inner movements in a more or less abstract way. In view of his close collaboration with Franz Marc (1880–1916) in the Blaue Reiter group, it is tempting to compare *Composition No. IV* with Marc's *Animal Destinies* (*37*). It is striking that whereas Kandinsky's choice of title points only to the (musical) form of his work, Marc's gives the actual content of the painting, which is related to the theme on which he had concentrated for several years—animals

27 KASIMIR MALEVICH, THE KNIFEGRINDER. 1912. Oil on canvas. 80 × 80 cm. Yale University Art Gallery, New Haven, Connecticut.

28 MARCEL DUCHAMP, NUDE DESCENDING A STAIRCASE, 1. 1911. Oil on cardboard. 95 × 60 cm. Arensberg Collection, Philadelphia Museum of Art.

29 UMBERTO BOCCIONI, FORMES UNIQUES DE LA CONTINUITÉ DANS L'ESPACE. (Also known as STRIDING FIGURE.) 1913. Bronze. Height, 112 cm. Galleria d'Arte Moderna, Milan.

30 GIACOMO BALLA, SPEED OF A CAR + LIGHT + SOUND. 1913. Oil on canvas. 130 × 87 cm. Kunsthaus, Zurich.

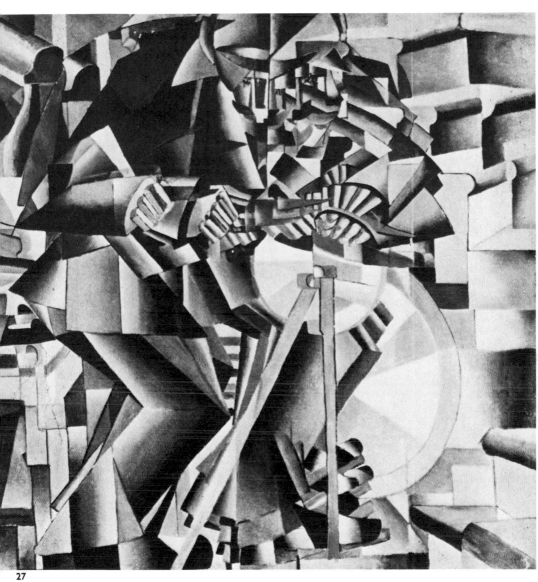

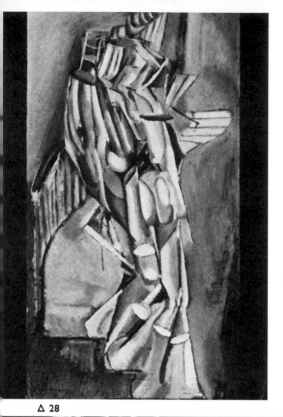

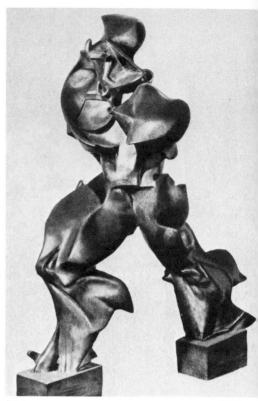

△ 28

△ 29

▽ 30

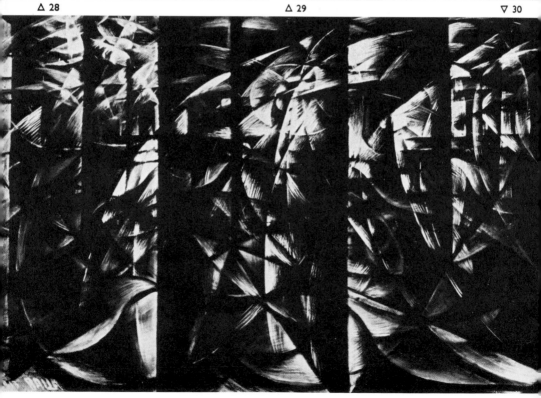

as a symbol of man's lost harmony with the forces of nature. Although this theme seems to be on a more cosmic scale than Kandinsky's epic poem, the moment of drama seems to be hinted at in a more precise, more human way than in Kandinsky's painting.* It seems closer to reality, in spite of the fact that the individual structure is un-recognizable. However expressive Kandinsky's unmistakable signature, his painting appears sovereignly impersonal compared with Marc's.

Even more striking than the arching shape that links the two halves of *Composition No. IV* is the lack of any lighting effect. This allows the structure to exist not as a transient sequence of two incidents or episodes but—as in icon painting—as a timeless coexistence of two states that are diametrically opposed to each other. By contrast, the rapid eruption of rays transposes Marc's painting into a temporal sphere that is not definable in terms of calendars or clocks, but is experienced unequivocally as a "moment," and into a space that, although not measurable, is still experienced as real. In order to heighten the dramatic effect, Marc attempts to enrich his realistic depiction of light by means of the "bundle of rays" used by the Futurists. He adopts this because of its symbolic strength and to underline or reinforce Delaunay's dissolution of the pallid beam of light into a multicolored interplay of complementary colors. This, however, resulted in a certain lack of clarity, to which even Paul Klee objected.

Dynamic forms of expression that virtually do away with recognizable individual objects altogether are also found in the work of artists who are not concerned, as Marc is, with drama, but who want to conjure up "lyrical explosions" in their paintings. (This is the term used by the Italian painter Alberto Magnelli [1888–1971] for a whole series of pictures of 1918.) A good example here is František Kupka (1871–1957), known as Frank Kupka after his emigration to Paris in 1895, whose swirling com-positions are reminiscent of the Baroque roofs of the churches of his native Bohemia. The Russian Rayonist painters Mikhail Larionov (1881–1964) and Natalia Goncharova (1881–1962) also professed their faith in the Futuristic ray of light—the term "Rayonist" comes from the French *rayon,* meaning "ray" or "light" beam. Like the Futurists, Larionov used this beam of light half symbolically and half realistically (*38*), and he also made it support an abstract theory of painting; by 1915, however, he had virtually abandoned abstractionism and worked principally in stage design.

The series of large compositions, some as large as 65 square feet, painted by Francis Picabia (1879–1953) after a visit to New York, reflecting his impressions of the American way of life (*39*), are more enigmatic. The dynamic force they convey is not on a cosmic scale; rather, it represents the energy of a modern city and of the men who live in it and are influenced by it. It is true that the shapes swirling through these paintings as though caught up in a frenzied rhythm suggest clearly outlined, hard-edge structures with smooth surfaces, but they seem almost more original than the ones that float through Kandinsky's compositions. They are not based on biological, figurative, or even mechanical structures, like those in other paintings by Picabia

* In *Rückblicke* (1913), Kandinsky indicates that "battle" is the theme of his painting.

executed in the same year. In his use of shapes unrelated to known objects, we can detect both an attempt to eliminate any possibility of association—thus allowing the rhythm to act alone—and, by showing that "anything can stand for anything," to reduce *ad absurdum* the efforts of the Cubists to define pictorial analogies on the basis of a quasi-scientific analysis of "real" form. The choice of abstract shapes can thus be seen as an early manifestation of the art of the Absurd—also known as anti-art, the pioneers of which were to be Picabia and his friend Duchamp. Certain elements can already be recognized in Duchamp's *Nude Descending a Staircase* (28).

The *Tableau-Objet*

We could almost say that with his *Interior with Eggplant* (40) Matisse (who, according to Braque, was irritated by the contemporary Cubist experiments) wanted to demonstrate to his younger colleagues that he could build up the pictorial space synthetically without necessarily rejecting color, not only within the narrow confines of a still life but in a large-scale interior scene as well. Out of the abundance of visual components, Matisse picks out contrasting patterns of bright, unexpected colors therefore, and assembles them in such a way that the interlocking of a few sectors of surface, all of which are given equal emphasis, is enough to express complex spatial relationships in two-dimensional terms. Two decades earlier, the French group of painters called the Nabis (Bonnard, Vuillard, Vallotton, Maurice Denis) had begun to use the ornamental patterning of wallpaper to construct the closed space of their intimate interiors. On occasion, on the model of Japanese colored woodcuts, they had also introduced the checked pattern of a dressing gown or a woman's dress so that it looked as though the piece of material had been stuck flat to the wall, rather than draped around the contours of a human body. Their figures, therefore, have the effect of silhouettes cut from colored paper. Matisse uses such an idea here by placing a rectangular piece of material with a black-and-white floral motif against the screen right in the middle of his picture. This rectangle is not real material, of course, but it has been copied with such painstaking care that there is no doubt whatsoever that a *trompe-l'œil* effect is intended. Matisse does not link his piece of fabric to any supporting shape. Instead he allows it to float independently in space, and in so doing, he challenges the arrangement suggested by the other wallpaper cuttings. These are also painted in a flat manner, but they are associated with shapes identifiable as spatial areas.

31 GINO SEVERINI, DYNAMIC FORMS. 1912. Oil on canvas. 100 × 73 cm. Galleria Nazionale d'Arte Moderna, Rome.

32 ROBERT DELAUNAY, WINDOW. 1912. Gouache on canvas. 45 × 37 cm. Musée de Peinture et de Sculpture, Grenoble.

33 PAUL KLEE, MOTIF OF HAMMAMET. 1914. Watercolor. Dötsch-Benziger Collection, Kunstmuseum, Basel.

34 JACQUES VILLON, PAPIERS. 1923. Oil on canvas. 38 × 46 cm. Galerie L. Carré, Paris.

35 CARLOS CRUZ-DIEZ, PHYSICHROMIE 317. 1967. Rhodoid and wood. Private collection, Paris. 3▮

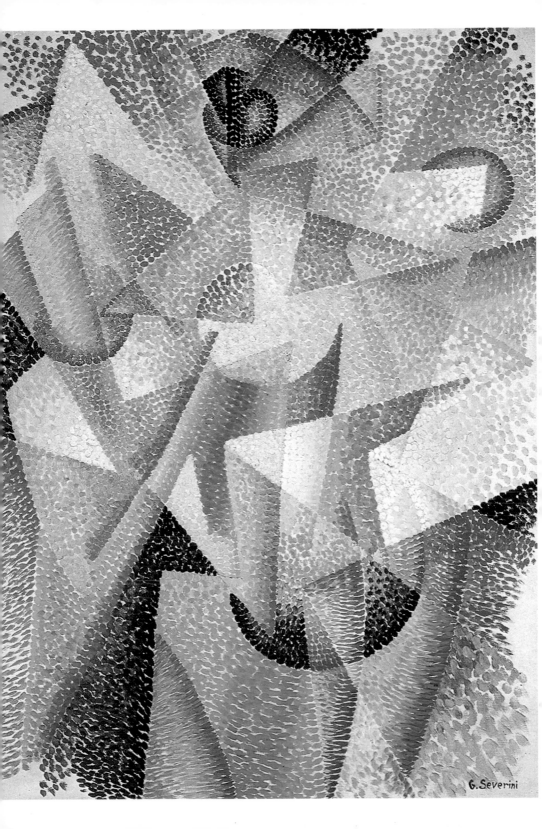

G. Severini

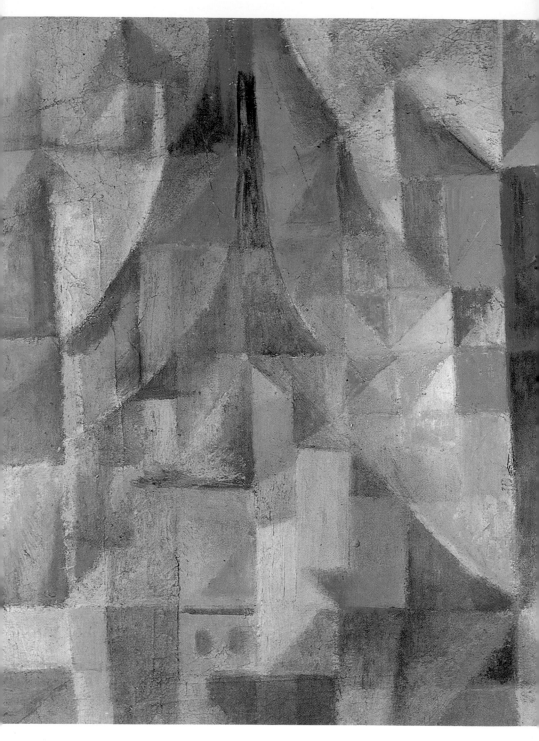

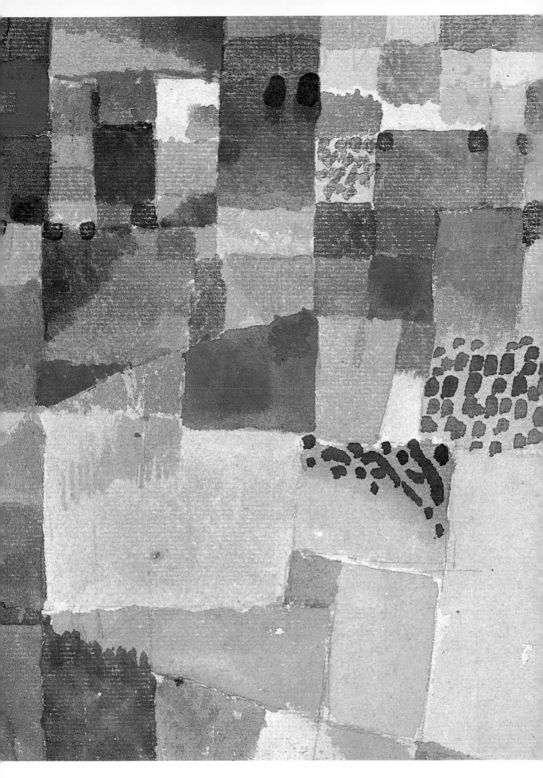

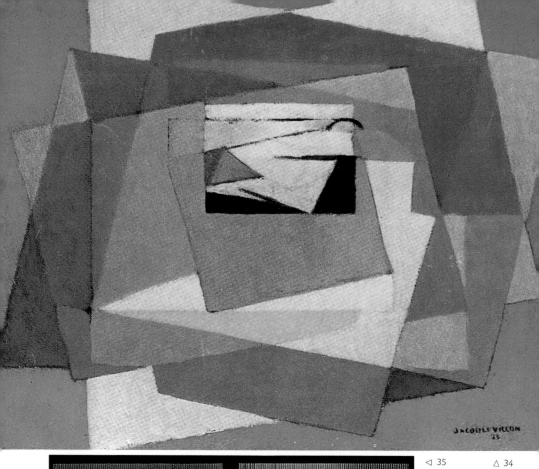

At the same time, the Cubists were taking the process of dismantling the image of reality much further. Indeed, they claimed the right not only to reject the description of reality in the traditional way—according to illusionistic conventions of representation (in this, they diverged from their predecessors from Manet to Matisse)—but also to reconstruct it freely from scratch, rather than recasting it according to purely visual criteria. At issue was not the artistic quality of the individual shape or material, but, rather, the specific nature of the intellectual act that sought and affected the relationship of these elements, creating pictorial analogies of the object that originally served as the pretext for the painting.

Yet this radical formulation of the artist's claim to freedom tacitly includes the possibility of interpreting the creative process in a way that suppresses the fixed and traditional relationship between real and represented form, between real and represented space, even between picture and object depicted, and between a picture and its environment. Like an abstract painting, a painting depicting an object is not only an image of the object but is an independent reality in its own right, belonging to the real world but at the same time calling it into question.

The first thing to go was the frame, which relinquished its importance as a barrier between the space in the picture and the space surrounding it (*21*). The standard rectangle disappears and the picture surface that had been delimited by the frame is merely a working area onto which forms can be projected. If, as in Braque's *Bach* (*41*), real materials are included in the composition—first newsprint, then bits of wallpaper, pieces of lace, and so on—then the picture plane no longer necessarily delimits the picture surface; the construction moves outside the picture plane, into the surrounding space, just as it has stepped out of the frame. The result—as in Picasso's *Guitar* (*42*) —cannot be described as a painting, as a relief, as a piece of sculpture, or even as an abstract construction. Like the original article or pretext, it is an object that can be held in the hand. We have already seen that Analytic Cubism led sculptors to produce related structures.

In the earliest *papiers collés,* newspaper, wrapping paper, and wallpaper were used, apparently not only because they were "more real" than oil painting, but also because they had been pre-prepared by another hand—or, more precisely, by a machine—using impressions produced by printed characters or stencils. The artist rarely touched them up; rather, he built them into his composition as a sort of reference or quotation from outside, exploiting the fact that they were often roughly cut and crudely made. These references generally consist of pictorial or verbal stereotypes that are unlikely to be thought of as "creations"—commonplace wallpaper designs, newspaper headlines, song titles, cigarette packs, labels, and so on. In this way, reality and, indeed, triviality—raw and "untreated"—enter what was once the sacred realm of the picture, with its carefully protective frame. The polemical intention is unmistakable: Picasso's *Guitar* casts an ironic look at every *Still Life with Musical Instruments,* including his own variations on the theme, and at the guitar itself. Art was seen as equally valid when created from the best, still very cheap, or even worn-out, secondhand materials, or from ready-made

structures that are normally considered esthetically worthless, or even kitsch, as from such materials as beautifully prepared oil paint or bronze, hallowed by tradition.

By destroying the perspective spatial image, the Analytic Cubists brought about a crisis in the classical concept of the object. Their use of collage led them to review the traditional methods of the artist, but they also went further, questioning artistic concepts that were still extremely rigid, from the difference between (two-dimensional) surface art and (three-dimensional) spatial art to the interpretation of the actual act of artistic creation. This "crisis of means" led to a crisis in painting, indeed to a crisis in the idea of art in general.

Anti-Art

The collages that the German artist Kurt Schwitters (1887–1948) produced from 1918 onward consisted exclusively of worn-out materials fished out of the dustbin. Schwitters' passion for anything that had been used by other people's hands and trampled on by other people's feet was almost an obsession. It is true that the designs underlying his assemblages are strongly reminiscent of Expressionism, and also of Constructivism, but he apparently had no urge to express anything or even to construct anything. He did not intend his beloved "junk" as a symbol of anything, or as an artistic "analogy" to anything. It is there in its own right.

Yet Schwitters' rehabilitation of this unorthodox, discarded material was not, in fact, an anti-art gesture. For many other artists, however, the process of handling the materials objectively—handling them as what they were, not conventionally, as imitations of other things—represented first and foremost a way of unmasking the "art lie." Even before the War, Boccioni had put forward his theory of *polimaterico,* the multimaterial work of art. "A sunrise is announced," said Picabia. "What we get is a mishmash of oil and pigments." Words, in the form of titles, are a good way of unmasking things. In 1921 Picabia used bits of a tape measure for an (ironic) depiction of a tree. But he gave this collage the literal, "objective" title *Centimeter* (not *Tree*). The same effect can also be achieved the other way around—for instance, from the title *Novia* we might expect an image of a girl, but we are shown a drawing of a machine (*44*). "The subjective part of my work is in the title," wrote Picabia. "The actual picture is objective."

In 1917 Duchamp tried to exhibit his first ready-mades in a setting appropriate to works of art. He stressed over and over again that he did not hunt out these objects —urinal, bottle rack (*47*), snow shovel, and so on—to juxtapose them with recognized art objects and thereby show that they were "beautiful as well." "The choice [of

36 VASSILY KANDINSKY, COMPOSITION NO. IV. 1911. Oil on canvas. 160 × 250 cm. Kunstsammlung Nordrhein-Westfalen, Düsseldorf.
37 FRANZ MARC, ANIMAL DESTINIES. 1913. Oil on canvas. 195 × 263.5 cm. Kunstmuseum, Basel.
38 MIKHAIL LARIONOV, MAY NIGHT. 1911. Gouache. 37 × 50 cm. Nationalgalerie, Berlin.
39 FRANCIS PICABIA, PHYSICAL CULTURE. 1913. Oil on canvas. 89 × 116 cm. Arensberg Collection, Philadelphia Museum of Art.

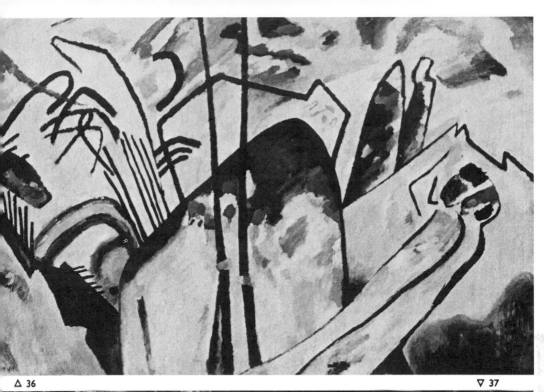

△ 36

▽ 37

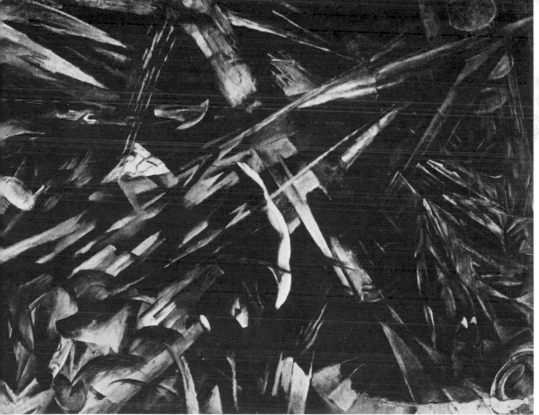

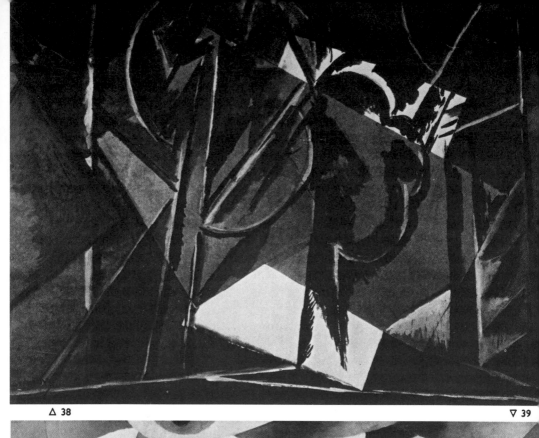

△ 38

▽ 39

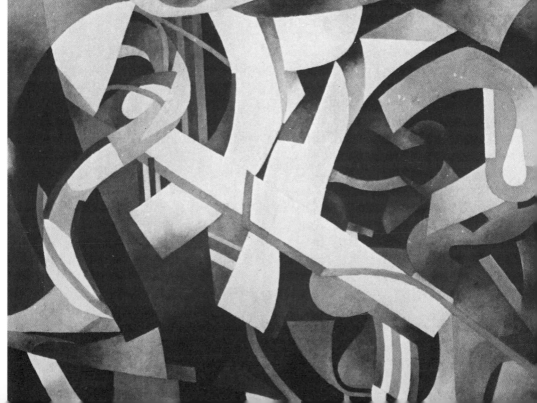

these objects]," he said, "always depended on a reaction of visual indifference. Taste —good or bad—played no part." What the ready-made questions is the esthetic assessment of any type of content and of any type of formal treatment. No counter-values are put forward; indeed, implicit in the whole concept is the idea that all objects are totally valueless. The gesture of displaying the articles is what counts, not the objects themselves; they remain a matter of indifference.

Thus, when these ready-mades were put on show they represented an early form of the Happening—of art as an event in itself. Duchamp remarked: "I very soon realized how dangerous the arbitrary repetition of this form of expression could become, so I decided to limit the production of ready-mades to only a few pieces each year."

But if an artist's work can be criticized because it is not made to serve a practical purpose, any product or object can be similarly criticized because it, too, does not fulfill a practical purpose. A good example here is Man Ray's *Gift* (*48*), bristling with nails, which clearly anticipates the objects produced by the Surrealists.

The presence of the machine confronted the artists with a whole range of problems. As early as 1911, Picabia was speaking of the "abstraction of mechanics." In the same year he and Duchamp attended a performance of Romain Roussel's play *African Impressions*. This contains a detailed description of how a "painting machine" works, which was no doubt what led Duchamp to paint his *Nude Descending a Staircase* in the style of the closest real-life equivalent, Marey's chronophotograph (*28*). After this work, Duchamp gave up painting altogether and concentrated on designing imaginary mechanisms, notably *The Bride Laid Bare by Her Bachelors, Even*, which he worked on from 1913 to 1921. And in 1913, influenced by a visit to the United States, Picabia produced his *Poems and Drawings From the Daughter Born Without a Mother* meaning the engineers' daughter, the machine. These were followed by "mechanoid" compositions that created a sensation and influenced Max Ernst and others. In these, the machine itself was treated ironically, which takes us straight to Jean Tingucly's absurd machines that autodestruct (*170*).

Mass production, a system based on rigid division of labor and standardization of procedure, leads from the theoretical working plan and experimental costings via the working drawings to the assembly line—the business of actually putting the machine together (and publishing directions for its use). This process assures a complete anonymity of form that makes the subjectiveness of an individual "creative" style both presumptuous and irrelevant. The systematic methods used in machine manu-facture and the impersonal element in the finished structures now became a model for artists. They began to see romantic genius and an emphasis on the individual in artistic expression as two of the lies with which bourgeois humanism had driven their generation down the road to mass destruction through war. Montage, which was to become one of the most important means of expression for the revolutionary anti-art movement ("Art is dead ... Long live Tatlin's machine art!") gave the collage more objectivity. It transformed the meaning of the collage by choosing a new material, press photos.

Beginning in 1918, the Berlin Dada artists Johannes Baader (1876–1955), Hanna Höch (b. 1889), Raoul Hausmann (b. 1886), and John Heartfield (Helmut Herzfelde, 1891–1968), most of whom were intent on political or revolutionary action, were particularly enthusiastic in their systematic exploitation of the possibilities opened up by their recent invention of the technique known as photomontage. Newspaper photographs, like the scientific action photos of Marey or of Eadweard Muybridge (1830–1904), were devoid of artistic ambition; mechanically produced, they were intended as an objective source of information. By way of montage it was possible to combine non-related objects; and through changes of the angle of view and variations of scale, the montage could convey either an impression of incongruously fortuitous arrangement or a precise didactic meaning. Such compositions were made by Höch, Hausmann, and Schwitters in Germany and by Vladimir Mayakovsky (1893–1930), poet of the Revolution, and Alexander Rodchenko (1891–1956; 46) in Russia. The propagandist or didactic photomontage, which was quite different (and later), was used mainly by John Heartfield and El Lissitzky (1890–1941), a Russian. These artists did not restrict themselves to news photos, but used the latest advances in photography and film technique, such as double exposure and fade-ins. In the second half of the 1920s, photomontage became one of the most common methods of disseminating political propaganda or commercial advertising—indeed, for visual communication in general. The technique known as typo-photography, which the Hungarian László Moholy-Nagy (1896–1946) taught during the 1920s at the Bauhaus (the important German art school at Weimar, and later at Dessau), represented an interesting attempt to integrate image and word. The influence of photomontage, in fine as well as commercial art, can be traced long before Pop Art burst upon the scene in the late 1950s. Examples are Fernand Léger's famous *Mona Lisa with a Bunch of Keys* (1930) and the graphic work of Willi Baumeister (1889–1955).

The Manikin

When applied to the human figure, collage and montage—together with their three-dimensional variant, known as assemblage—led to the emergence of such amazing structures that public opinion rejected them virtually unanimously as a willful degradation of man. Yet the critical attitude that led to the creation of the *Kunstfigur* (the term was originated by the German painter Oskar Schlemmer, 1888–1943) was not primarily anti-human, and cannot properly be interpreted as an arbitrary act. The new attitude emerged as a result of a series of experiments that had led to a reinterpretation

40 HENRI MATISSE, INTERIOR WITH EGGPLANT. 1911. Oil on canvas. 212 × 245 cm. Musée de Peinture et de Sculpture, Grenoble.
41 GEORGES BRAQUE, BACH. Paper collage. Kupferstichkabinett, Öffentliche Kunstsammlungen, Basel.

42 PABLO PICASSO, GUITAR. 1914. Collage. 95 × 66 × 19 cm. Artist's estate.
43 KURT SCHWITTERS, DISJOINTED FORCES. 1920. Collage, montage, and oil on cardboard. 106 × 86.5 × 9 cm. Huggler Bequest, Kunstmuseum, Berne.

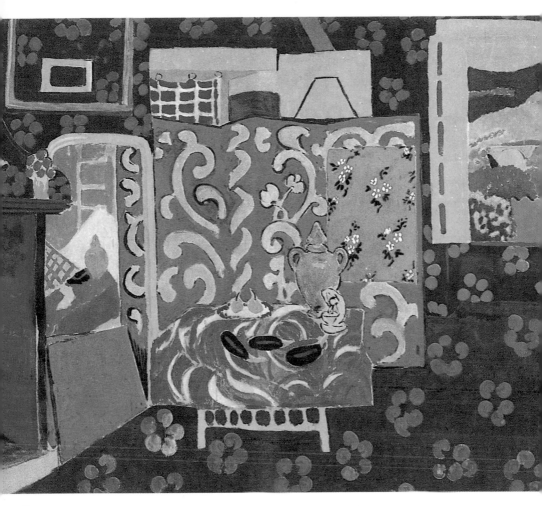

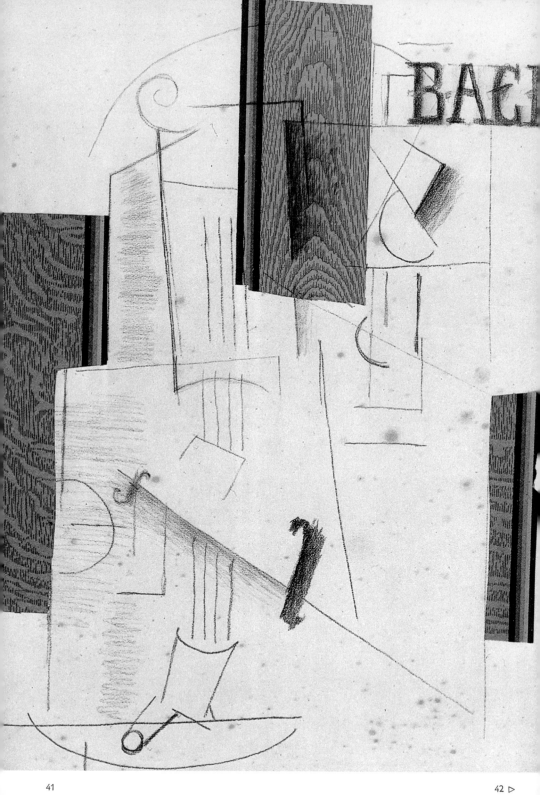

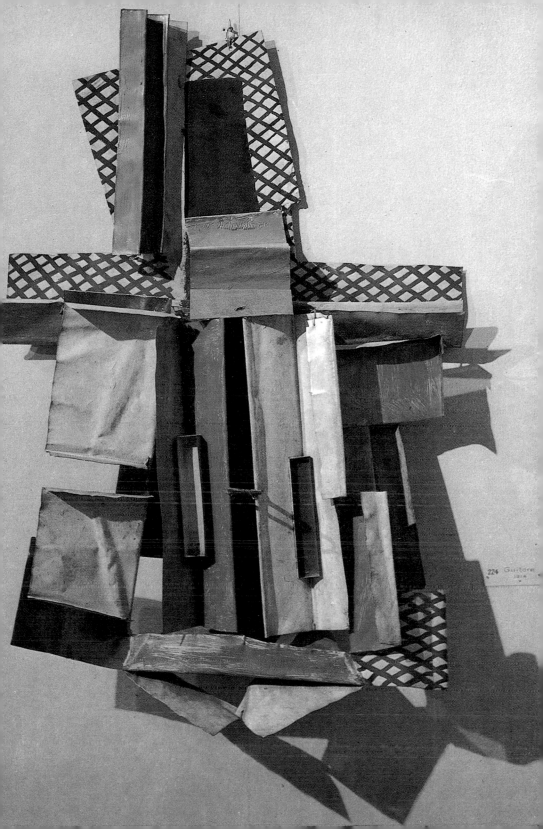

224 Guitare
1914

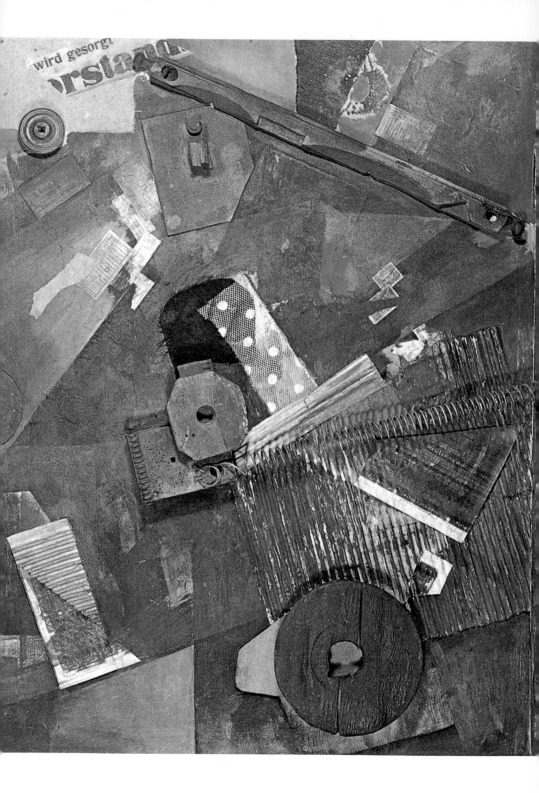

of the methods used for representing form. By studying African masks, certain artists had established that vivid expression and a good "likeness" in reproducing a figure could be obtained just as effectively by grouping together a series of basic shapes (such as Léger's "tubes") or, on the other hand, schemas for montages (as in Picabia's "mechano-morphic" work). These schemas could be used either in a purely pictorial manner, as in Léger, or in a spirit of parody, as in Picabia, to produce likenesses of human forms and behavior.

A combination of the collage principle with the mechanistic metaphor underlies the large number of Dada portraits produced by Picabia, Hausmann, Grosz, Ernst, Lissitzky, and many others. In these portraits the pictorial analogies of Cubism are modified to represent ironical or allegorical substitutes for the real thing. On the other hand, the robot (itself a son of that "motherless daughter," the machine), which made its first appearance in Léger's war pictures, is once again closely related to the jointed doll that appeared in several places simultaneously before World War I. For sculptors such as Duchamp-Villon or Archipenko, it was rather like primitive sculpture—exclusively an instrument or model for studying form. But Giorgio de Chirico (b. 1888), from the outset attributed to the *manichino* the significance of the "faceless man," with whom he had become acquainted in the metaphysical novel *The Man Without a Face* by his brother Alberto Savinio. In the manmade environment in which de Chirico sets his figures—urban landscapes and backgrounds that look like open-air stage sets—the jointed doll is seen to be made up not of anatomical components but of the tools of the geometrician and the surveyor—of the same elementary geometric shapes that create the unnatural environment (*49*). Thus, the unity of space and figure is expressed symbolically, by means of a traditional and naturalistic technique that ignores virtually all the achievements of modern painting. Even the eerie poetry that emanates from de Chirico's metaphysical artificial figures is quite different from the expressionistic sarcasm of most post-Cubist collages. The poetic aura of his paintings found a strong echo in the work of, among others, Max Ernst (b. 1891), whose first series of etchings, entitled *Fiat Modes* (1919), was influenced by de Chirico's Ferrara paintings. Ernst gave a particularly grandiose interpretation, both grotesque and cosmic, of the artist's manikin in his *Ubu Imperator* (1924). Another artist influenced by de Chirico is George Grosz (1893–1959); an untitled painting of 1920 (in Düsseldorf) interprets the faceless man as modern man robbed of his individual features by the anonymity of capitalism and degraded to the status of a robot—a somber *pittura metafisica* (as the style of de Chirico and his followers was called), without the metaphysics.

It is true that the influence of de Chirico, and also of Léger, had something to do with the emergence of Schlemmer's "art figure"; this concept, however, is based on Schlemmer's initial analysis of the relationship of the figure to the surrounding space, which he systematically developed while he was at the Bauhaus. Schlemmer does not examine these relationships from an awareness of the interpenetration of form and

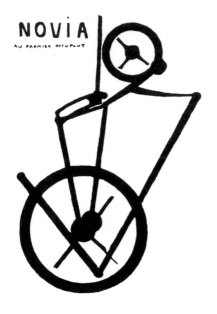

391

NOVIA
AU PREMIER OCCUPANT

44

44 FRANCIS PICABIA, TITLE-PAGE OF THE PERIODICAL *391* (No. 1, 25 January 1917). Bibliothèque Nationale, Paris.

45 RAOUL HAUSMANN, HEAD "THE SPIRIT OF OUR TIME." 1919. Wood, leather, and metal. 32 × 23 cm. Hausmann-Prévot Collection, Limoges.

46 ALEXANDER RODCHENKO, THE TROGLODYTE. Photomontage, Mayakovsky Museum, Moscow.

47 MARCEL DUCHAMP, BOTTLE RACK. 1914. Height, 64.2 cm. Present whereabouts unknown.

48 MAN RAY. GIFT. 1921. Present whereabouts unknown.

49 GIORGIO DE CHIRICO, HECTOR AND ANDROMACHE. 1917. Oil on canvas. 90 × 60 cm. Gianoli Mattioli Collection, Milan.

50 FERNAND LÉGER, SOLDIERS PLAYING CARDS. 1917. Oil on canvas. 129 × 193 cm. Rijksmuseum Kröller-Müller, Otterloo.

51 JACQUES LIPCHITZ, SEATED FIGURE. 1925. Onyx. 55.8 cm. Marlborough Gallery, New York.

52 OSKAR SCHLEMMER, ABSTRACT FIGURE, STANDING. 1921. Bronze. Height, 107 cm. Collection of Frau Tut Schlemmer, Stuttgart.

53 PABLO PICASSO, SEATED FIGUR ON THE SEASHORE. 1930. Oil on canvas. 163.5 × 129.5 cm. Guggenheim Fund, Museum of Modern Art, New York.

space, as Boccioni does in his *Striding Figure* (*29*); rather, he categorizes the pictorial components as constructive elements, anatomical elements, rhythmic elements, and so on. In his *Abstract Figure, Standing* (*52*)—one of the few three-dimensional sculptures he produced—he attempts to combine the various interpretations of the figure in a single synthetic structure which, although completely open, does not, like Boccioni's, appear to encompass the surrounding space but remains the active radiant center of that space.

As with de Chirico, Schlemmer always sees this space as the geometric, structured space of architecture—or, more precisely, as a stage. Schlemmer was himself a gifted dancer; he became very closely involved with ballet conception, sets, and costumes for *Triadic Ballet* (1916–1922) and was in charge of a stage workshop at the Bauhaus from 1923 on. He dressed the dancers, who in performing a ballet reveal the inner structure of space, in costumes that did not characterize them in psychological, social, or historical terms, or indeed in any other terms, but

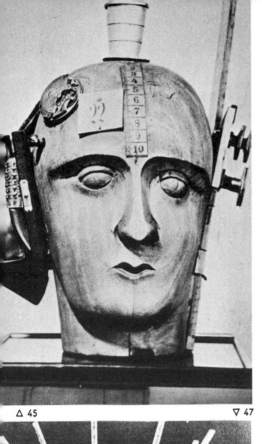

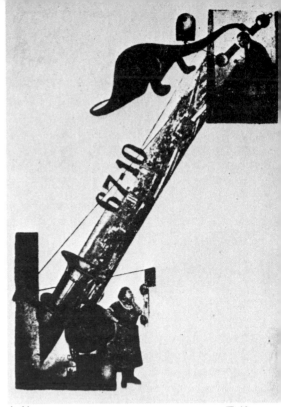

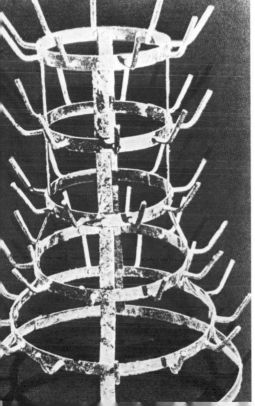

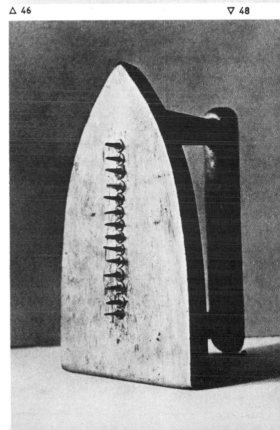

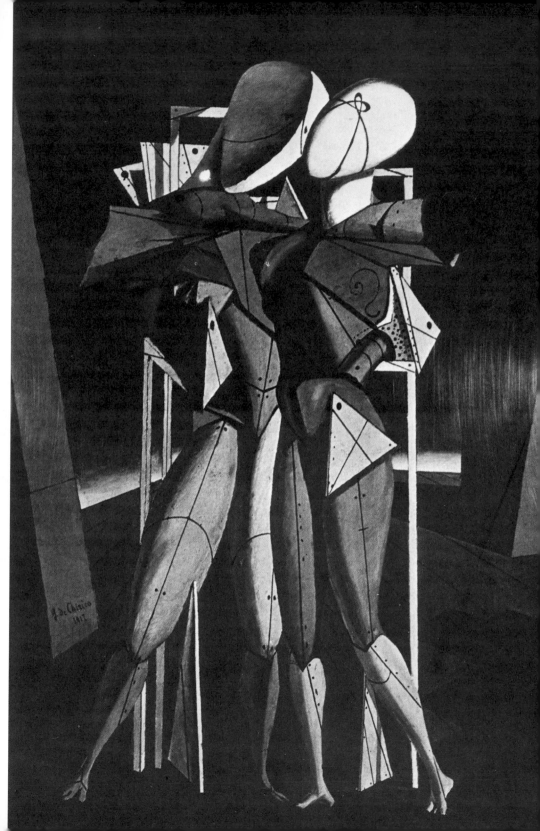

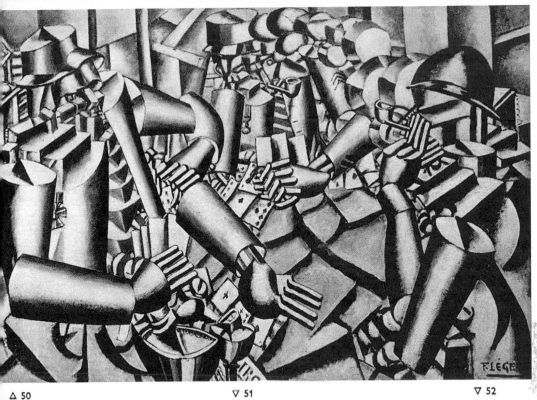

△ 50

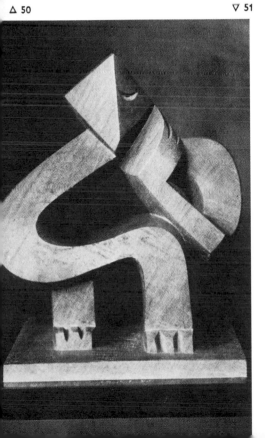

▽ 51

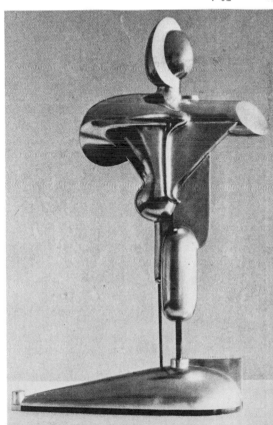

▽ 52

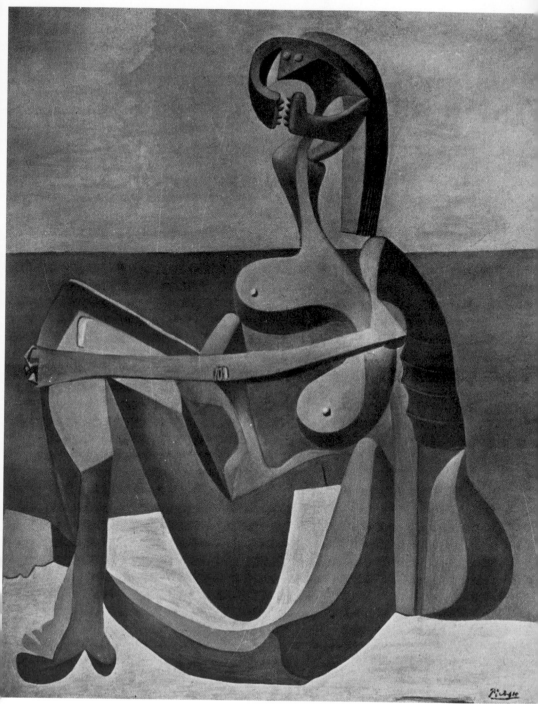

transformed them into stylized geometric figures. Related attempts to depersonalize the protagonists by the use of costume and of masks to distort their voices are found in the armorlike pasteboard structures worn by the Zurich Dadaists to recite their simultaneous poems at the soirées given at the Cabaret Voltaire; in the Cubist constructions in which Picasso dressed the Managers in Jean Cocteau's ballet *Parade* (1917); a little later, in Léger's costumes for Rolf de Maré's ballet *The Creation of the World* (1922); and, as early as 1912–13, in costume and dress designs by Sonia Delaunay. Depersonalization meant more than a stylistic adaptation of the figure to its environment (the anti-naturalistic and anti-illusionistic stage set); costumes concealing the natural shapes of the performers, which prevented them from making natural gestures, reinforced the depersonalized acting style that Gordon Craig had demanded of actors as early as 1905. Thus, the manikin, or "art figure," takes its place in the progression from Craig's supermarionette to acting automaton. In the "heroic experimental theater" organized by Ferdinandov and the "industrial poet" Tchertchenevitch, the "pathetic clown" moves like an automaton, his diction imitating the rhythms of the machine, but he is still a human being. Lissitzky's plans for staging Khrutchenik's opera *Victory Over the Sun* (1920) had the director guiding mechanical figures electromechanically. As in Raoul Haus-mann's *Head* (45), the theme of the puppet is combined with that of the machine. The puppet reappears in the marionettes of Sophie Taeuber (later Taeuber-Arp, 1889–1943) for *König Hirsch* (*King Stag*, 1918)—bodies again propelled by outside forces—and in Alexander Calder's circus figures (from 1926). In Picasso's *Seated Figure on the Seashore* (53), the puppet idea seems to be behind the virtually disembodied limbs and forms freely moving in space, which are reproduced so faithfully, in *trompe-l'œil* fashion, that the figure resembles a piece of Cubist sculpture that has been taken apart so unambiguously that we could reassemble it with ease. But unlike the components of de Chirico's figures, Picasso's individual shapes are not identical with recognizable objects. They are loosely derived from pre-Dadaist collages, including those made by Picasso himself as early as 1913, just as clearly as from the transpositions of form practiced by the Cubist sculptors, again under the influence of Picasso; a good example of this transposition is Duchamp-Villon's pierced sculpture *Horse's Head* (24). But the composite structures produced by Picasso between 1927 and 1930 are radically different even from such totally remodeled figural structures as the *Seated Figure* (51) of 1925 by Jacques Lipchitz (1891–1973) and Alberto Giacometti's sculptured figures of 1925–27. For while the Cubist variations on the human figure are based on an analytic process that is controlled by the artist in all its phases, Picasso's anthropoid structures, in spite of their mineral or wooden hardness, seem to record phases in a process of regression that reduces all living forms from a state of anatomical precision and variety to an amorphous plasticity. It is this instability in the genetic structure of the figure that makes Picasso's metamorphoses so eerie; and it is also this that entitles them to be called Surrealist.

54

54 ANTONIO SANT'ELIA, DRAWING FROM THE CITTÀ NUOVA. 1913–14.

55 ERICH MENDELSOHN, EINSTEIN TOWER, Neubabelsberg, near Potsdam. 1919.

56 MICHAEL DE KLERK, EIGEN HARD, housing estate, Amsterdam. 1917.

57 LYONEL FEININGER, UPPER WEIMAR. 1921. Oil on canvas. 80 × 100 cm. Boymans van Beuningen Museum, Rotterdam.

58 LUDWIG MIES VAN DER ROHE, SKYSCRAPER, Friedrichstrasse, Berlin. 1919. Design for a competition.

59 RUDOLF BELLING, TRIAD. 1919. Bronze. 90 × 78 cm. Saarland-Museum, Saarbrücken.

60 WALTER GROPIUS, MONUMENT TO THE FALLEN (Kapp Putsch, Weimar, March 1920). 1921. Concrete.

61 GEORGES ROUAULT, THE THREE JUDGES. 1925. Oil on canvas. 64 × 98 cm. Zumsteg Collection, Zurich.

62 CONSTANT PERMEKE, OVER PERMEKE. 1922. Oil on canvas. 150 × 195 cm. Permeke Museum, Jabbeke, near Bruges.

63 ERNEST BARLACH, THE CLIFFS. From the sequence called *The Metamorphosis of God*. 1920. Woodcut.

Architecture and Expression

The organic unity of all created form, particularly architectural form, that was so strongly emphasized by Art Nouveau remained a central theme for a number of architects right down to 1925. The call for rationalism made in reaction to Art Nouveau (see pages 6–7), which was both constructivist and neoclassical, and the Cubist analysis of form had clearly failed to influence them. To this tendency belonged the architects of the Amsterdam School (56), who aspired to flowing but at the same time strongly rhythmic forms and eliminated the right angle; the German painters and architects belonging to the Frühlicht ("morning light") and Gläserne Kette ("glass chain") groups, including the brothers Bruno (1880–1938) and Max Taut (1884–1967), Hans Scharoun (1893–1972), Otto Bartning (1883–1959), and Hans Poelzig (1869–1936), with their dreams of fantastical community buildings; and, last but not least, Erich Mendelsohn (1887–1953). Even the Bauhaus was considerably influenced by this development in its early phase (1919–23), as seen in Walter Gropius's Sommerfeld House (Berlin, 1921) and Lyonel Feininger's woodcut for the Bauhaus Manifesto of 1919, *The Cathedral of Socialism*.

The concepts of biological growth and continuity of form, symphonic structure, and the symbolic nature of architecture took precedence over such catch-alls as construction,

geometry, function, and proportion. Instead of a balance between weight and support, the ideal and goal was now movement with an upward thrust or movement stretching out into space. Steel or concrete structures were used not to give more light to the inner space or to make the architectural mass seem transparent, but to allow colored light to stream in—a mystical half-light evoking the interior of a cathedral. (Curiously, only the arch-rationalist August Perret ever managed to create a genuine "light-space" of this kind, in his concrete church at Le Raincy, outside Paris, built in 1922–23.)

Priority was given to two themes: the high-rise structure and the vast centralized building. The high rise grows organically out of the ground as a sort of crowning point to the city (55) or shoots up into the sky, as in Mies's designs for glass sky-scrapers (58). It is possible that Mendelsohn's war drawings variations on the theme of the industrial or cultural super-building of the future—and Mies's earliest postwar sketches are partly based on the fragmentary views of the *città nuova* (54) invented by the Futurist architect Antonio Sant'Elia (1888–1916), which expanded Garnier's thoughts on the *cité industrielle* to a monumental scale. In the cavernlike inner space of the centralized building, the anonymous crowd shares a cultlike experience; momentarily, it is a self-aware community. The building may be a house for social functions (*Volkshaus*), as drawn up by Bruno Taut and Hans Scharoun, or a festival hall or theater, exemplified by Hans Poelzig's designs for rebuilding

3 ▷

the Grosses Schauspielhaus in Berlin (1919) or for a festival theater in Salzburg (1920–21). Max Berg's circular Century Hall in Breslau (1913) had in large part anticipated this concept. An amazingly short road led from these projects to the monstrous plans of the Nazi architects, such as Albert Speer's circular hall for the Nazi Party (in his design for the reconstruction of Berlin).

Faceted glass now took on an almost mystical significance. Sharp-edged and transparent, indestructible yet seeming to dissolve in the light, it radiates shimmering colors on to everything around it. For instance, the richly articulated layout of Mies's glass skyscraper (58) is intended to intensify the effect of the reflected light on the faceted façade. In his town- and seascapes (57), the painter Lyonel Feininger (1871–1956) combines refracted light and shapes (in which echoes of Cubism can be found) with the dynamic radiating lines of Futurism, and with the distortion of the spatial structure and the emphasis on aggressively acute angles that are characteristic of the later Brücke painters in Berlin. In architecture, stage design, and graphics there arose a style that might be called Caligarism, after the famous sets for Robert Wiene's film *The Cabinet of Dr. Caligari* (1919), in which the rapid changes from light to shade and the sudden refraction of light rays or the axis of a form create broken rhythms, as in Gropius's *Monument* (60). In sculpture the German Rudolf Belling (1886–1972) and the Czech artist Otto Gutfreund (1889–1927) go beyond Archipenko's and Boccioni's experiments and break up the figure completely, so that it is now conceived solely as a rhythmic movement, as in Belling's *Triad* (59).

The Block

Other artists tried to produce strongly expressive sculptural works the other way around, by reducing the figure to what we might call the "archetypal block." Early examples are the *Kiss* of Constantin Brancusi (1876–1957), *Caryatids* by André Derain (1880–1954) and Amadeo Modigliani (1884–1920), Ernst Barlach (1870–1938) with his mystical figures that are so strongly influenced by 15th-century art in Germany, and Käthe Kollwitz (1867–1945), with her working mothers who literally exist only in bulk. A similar tendency can be found in the work of a large number of other painters, most impressively perhaps in that of the Frenchman Georges Rouault (1871–1958), whose violently accusing voice made itself heard after the war in a monumentalizing treatment of the figure that is reminiscent of Byzantine mosaics or Romanesque stained glass (61). But the stylization is more often based on a geometric treatment of form, as in the work of the French-born Marcel Gromaire (b. 1892) and the Belgian painter Constant Permeke (1886–1952), who was the leading figure in the movement known as Flemish Expressionism. (62).

The Search for a Unified Style

Even though the Cubists fragmented form and emphasized the spatial element to such an extent that the object survived only as a mere phantom or a parody, they still clung firmly to it. As a result, even before 1914 many painters were reproaching them

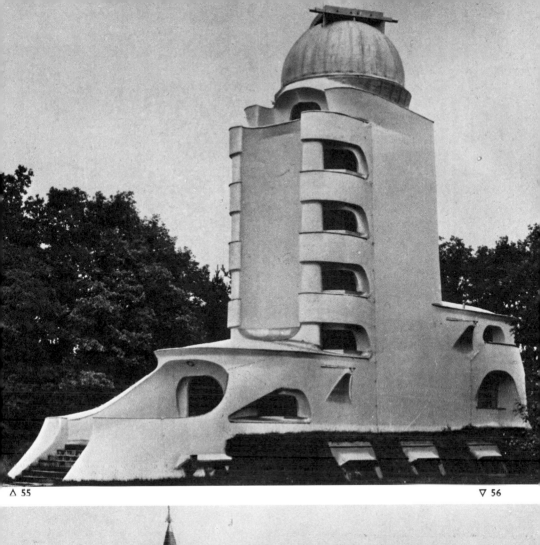

△ 55

▽ 56

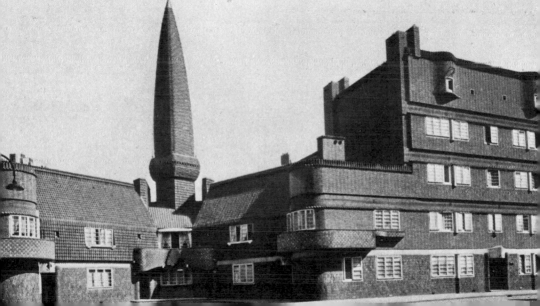

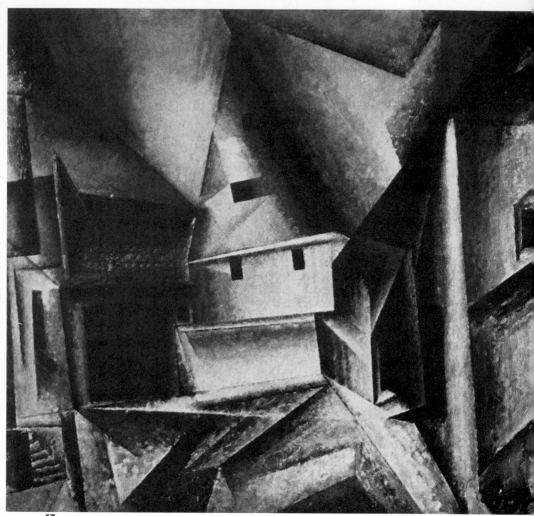

57

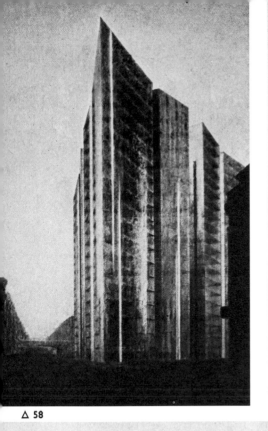

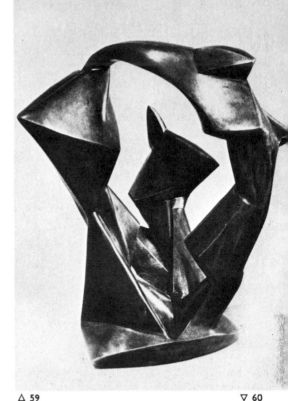

△ 58 △ 59 ▽ 60

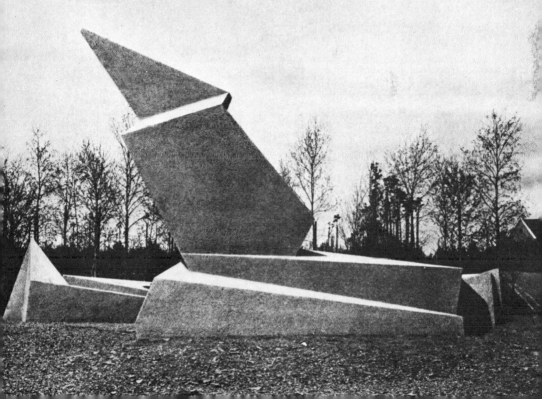

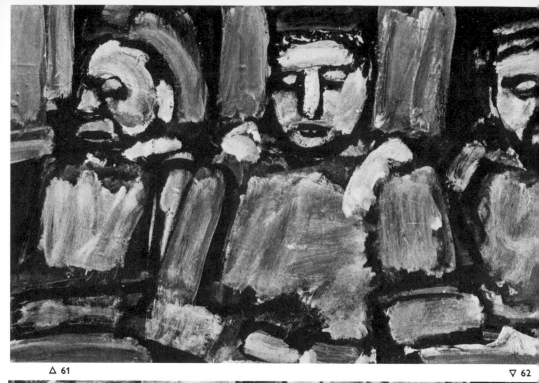

△ 61 ▽ 62

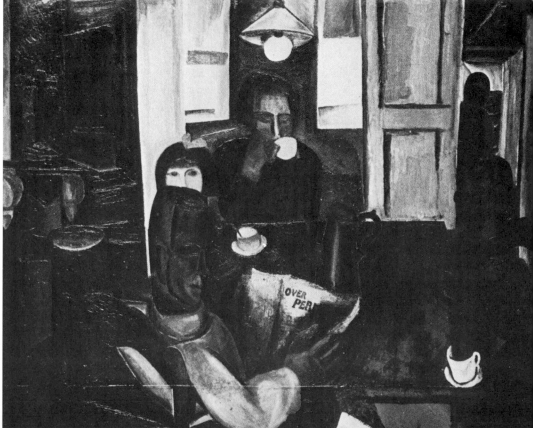

for not logically following through their analysis of form to the point where the basic components of the picture structure would emerge objectively, in their own right, and without the alien pretext of the object. Only if the representational theme is eliminated can a painting become what the Cubists were in fact trying to produce—an autonomous object, a *tableau-objet*. The first artist to do this type of "objective" painting was Delaunay, who in 1912 made the sole object in his paintings the dynamics of light perception (*front cover of book jacket*). Piet Mondrian (1872–1944) attempted to adopt the same concrete approach. In his paintings of 1913–17, he undertook a systematic examination of the pattern produced by screening and made this the dominating element of the picture.

According to Mondrian, the only way to make a painting autonomous is to treat it purely for what it is—as a vertical plane. Any suggestion of an illusory treatment of space—whether or not it is in perspective—must go. There is no question of our looking at the painting from various viewpoints. It must not offer any "views." It must be without focus ("afocal"). To achieve this, uniform components are distributed as evenly as possible over the picture surface. That is why at first, so long as he needed the support of an external theme, Mondrian chose subjects such as trees, scaffolding on the sides of buildings, or the sea billowing around a pier. These subjects were particularly suited to two-dimensional treatment, since they consisted of meshlike structures with repeating elements that could be conveyed with the minimum of geometric figures (*64*). In his paintings on the theme of the wall, the small square of color first used by Cézanne, which pales to a colorless reflecting bit of mirror-glass in Cubist art, then returns to its original brilliance in Delaunay's windows, undergoes one last transformation before it disappears completely in the cellular geometric surface screen.

Mondrian did not abandon altogether the temporal element the Cubists introduced into painting with their multifocal treatment. In his series of pier and sea pictures he creates a "fourth dimension" with an open system of vertical and horizontal strokes, fragmenting the continuous trellis-work of his wall-theme paintings.* These allow our eyes to roam completely freely over the picture plane with no privileged viewpoint. In some compositions painted in 1918 (*66*) Theo van Doesburg combines Mondrian's plus-sign with colored rectangles in such a way that they are not framed by the black grid pattern on all sides but only on two sides. In this way the picture plane creates a dynamic effect of movement (Van Doesburg's use of the so-called fourth dimension), however clear and firm the grid. Our gaze is not allowed to stop at any specific point; it is propelled by the various kinetic impulses that emanate from the

*During the years of Cubism and thereafter, the term "fourth dimension" was in vogue for "temporality," the famous "space-time" element. Mondrian and the Stijl artists admitted that it was possible to introduce such a fourth dimension without actually beholding the third dimension (space), since the eye needs time to "read" the plane surface of the picture.

painting's pictorial structure. Incidentally, Klee, too, wrote in 1920: "Space too is a temporal concept."

We cannot be sure whether or not Van Doesburg was influenced in this work by Wright's open layout, with which he was familiar. At any rate, in the view of this founder of the movement known as De Stijl, the return to unity of style presupposed a good deal of interchange between the various different branches of art. But there is no question that Mies's concept of spatial continuity, on which his design for country house is based (67), is equally indebted to the work of the American architect and the Dutch painter. From Wright's prairie houses he takes over the idea of a plan radiating from a central core. But the way he leaves the individual spatial areas open, achieving a dynamic unity in the overall layout that cannot be experienced without wandering through all the rooms, is strongly influenced by Van Doesburg's use of four dimensions. A similar combination of Neo-Plastic principles (that is, principles of Mondrian's painting) with the elements from Wright's repertoire can be seen in the front elevation of a design by J. J. P. Oud (1890–1963) for a factory (69).

In the heyday of Neo-Plasticism, Mondrian reduced the number of pictorial elements—bars and color areas—to the absolute minimum and did the same with the number of colors he used (65). All that is left are the three primary colors, red, blue, and yellow, in addition to the colorless black and white. Only one square area is framed by the grid on all four sides. All the other segments are intersected by the edge of the picture, which means that they remain open on at least one side. These areas on the edge of the picture vary considerably in size, but they are contained between the central square and the square outline of the canvas in such a way that they appear to be a part of other squares that continue beyond the edge of the painting. The gridlike structure seems to be part of an infinite but flexible screen-pattern made up of "active" verticals intersecting with "passive" horizontals. Mondrian sees this as a metaphor for the structure of the world. The mobility is no longer purely optical and restricted to the actual painting; symbolically, it refers to the mood of meditation that the painting inspires in us as we look at it. Although the way in which the individual elements are related to the format of the painting is very precisely defined, the frame has no significance as a means of dividing the picture off from its surroundings. In Mondrian's view, and in Van Doesburg's, the picture is a germ-cell within a geometric reorganization of our environment.

64 PIET MONDRIAN, COMPOSITION NO. 6. 1914. Oil on canvas. 88 × 61 cm. Slijper Bequest, Gemeentemuseum, The Hague.

65 PIET MONDRIAN, COMPOSITION. 1922. Oil on canvas. Rothschild Collection, New York.

66 THEO VAN DOESBURG, COMPOSITION XIII. 1918. Oil on panel. 29 × 30 cm. Stedelijk Museum, Amsterdam.

67 LUDWIG MIES VAN DER ROHE, DESIGN FOR A COUNTRY HOUSE IN BRICK. 1923. Unexecuted project.

68 THEO VAN DOESBURG and CORNELIUS VAN EESTEREN, ARCHITECTURAL DESIGN. 1923.

69 JACOBUS JOHANNES PIETER OUD, DESIGN FOR A FACTORY, Pumerend, Holland. 1919.

64

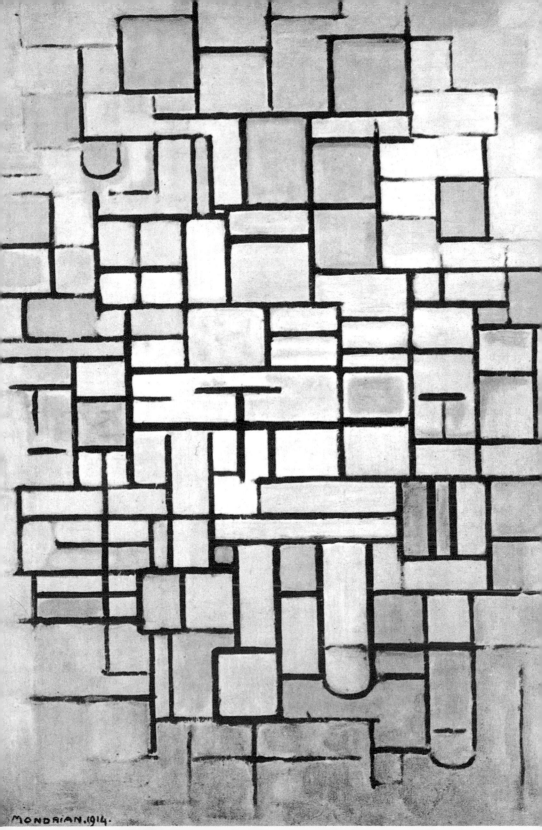

MONDRIAN. 1914.

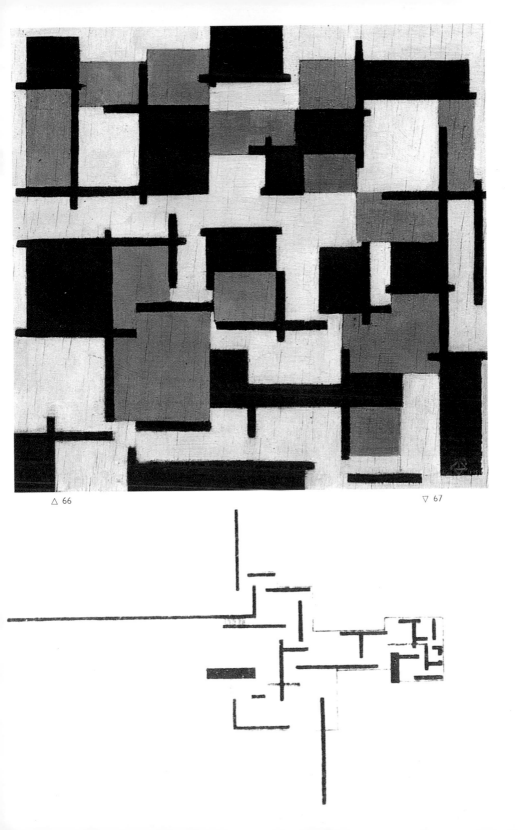

△ 66 ▽ 67

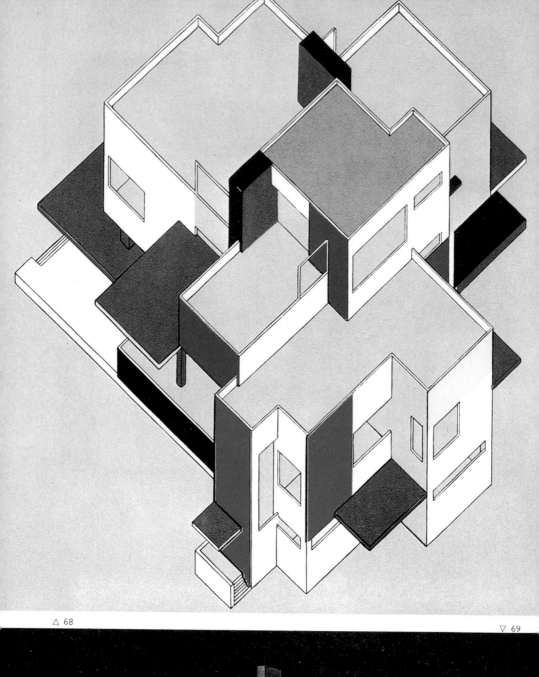

△ 68

▽ 69

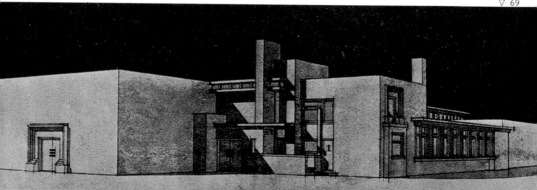

But if Mondrian understood this "new plastic art" in an almost mystical sense, to Van Doesburg, who also took part in the Dada movement from 1920 on, the "cultivation of elements" chiefly meant an opportunity to lay the foundations for anti-art in objective terms. Van Doesburg also sees how it can be applied to shaping the environment, in a more concrete way than Mondrian; he sees it as a practical collaboration between painter and architect, but definitely not in the usual way. After experiments with Oud, he embarked in 1923 on an experiment with Cornelius van Eesteren (b. 1897) that involved an exchange of roles: the painter produced a plan and the architect tested it to see whether or not it could be put into practice. Although the designs that resulted from this collaboration (68) were not immediately realizable, they are important in the history of architecture in that they represent the first attempt—together with Le Corbusier's houses—to translate into architectural terms new discoveries being made in painting and sculpture concerning the elements of form.

Floating

The methods used by Kasimir Malevich (1878–1935) were even more drastic than those of the Dutch painters, for in his *Black Square* (70) he apparently went so far as to empty the picture of content altogether. However, the black square is no more the subject of Malevich's painting than Duchamp's ready-mades are still lifes. Malevich proposes this square, this negation of form, color, and movement, as a full stop to the whole range of previous developments in art, which buried "pure artistic feeling" beneath mere trivialities. In so doing, however, his aim is not, like Duchamp, to announce that all artistic activity is absurd: "The square," he writes, "was not an empty square; it merely showed how excited I was at having broken free from the object." The "zero point of art," as he called the square, was the point of departure for a new abstract art known as Suprematism.

Malevich interprets Suprematism as "the absolute supremacy of pure artistic expression," which is guaranteed only if the picture is "purely pictorial" and "unrelated to nature in any way." He chooses geometric shapes because they are abstract—that is, because they are as far removed as possible from objects and as closely related as possible to the "purely pictorial substances" which he sees as the ideal mode of expression for Suprematist painting. In order to make his painting dynamic he creates tension first by off-center designs, then by arranging these shapes around a "dynamic axis" that departs slightly from the vertical. This dynamic axis was to become a commonplace of early geometric abstract art.

But from this radical simplification Malevich swung back toward an increasingly complex pictorial structure (72); his progress was thus exactly the opposite of Mondrian's. Although all the shapes are still abstract, the picture gradually stops existing solely in its own right and becomes a symbol for a spatial event that cannot be described any more precisely but is clearly experienced on a cosmic scale. There seems to have been a lively interchange of ideas between Kandinsky and Malevich in the period 1918–22. The Suprematist composition schemes that brought

the unruly "breakthrough" period (1910–14) under control and produced a serene floating feeling were also the determining factor behind Kandinsky's work during his Bauhaus period (1922–33).

But it was not only Kandinsky's example and teaching that made the Suprematist motif of the suspended equilibrium of abstract geometric shapes or bodies the esthetic creed of the Bauhaus. Suprematist ideas also played a central part in the work of László Moholy-Nagy (1895–1946), a Hungarian who, as a Bauhaus instructor, 1923–28, had a decisive influence on their development. Moholy-Nagy, true to his materialist anti-art ideology, linked the idea of floating, plus that of transparency, to the possibilities offered by modern materials and technology in relation to opacity and freeing objects from the force of gravity (73). Compared to Malevich's compositions, which are totally removed from time and physical reality, Moholy-Nagy's paintings appear almost illustrative in their sublimation of the filigree structure of modern constructions that had already been exalted by the Futurists (machines) and the Expressionists (faceted glass).

As early as 1914, a quite different approach had led Paul Klee to get rid of gravity by giving the picture an afocal structure (33): floating results here from the structure itself. Since the method he used to analyze elementary pictorial means led him to give precedence to the line over the plane,* the grid that underlies his many chessboard compositions dating from 1918 to 1930 takes its undeniable dynamism from an impulse basically opposed to that of Mondrian's mobile grills. For Klee, the meshes pucker, thicken or slacken, expand or retract, according to the line's "mood," with the color sometimes underlining this. The variable strength of the line produces stresses that are further strengthened by sudden changes of direction (148). *Floating* (75) belongs to a small group of works painted about the same time Klee left the Bauhaus (where he taught from 1920 to 1931). In these he takes up some of the themes that were currently fashionable there—floating, transparency, objectivity—and treats them ironically.

* For Klee, as for Kandinsky, the plane results from shifting a line laterally, exactly as the line results from the dynamic of a point moving along a straight or curved trajectory. He regards both line and plane as basically dynamic elements.

70 KASIMIR MALEVICH, BLACK SQUARE. c. 1913. Oil on canvas. 106 × 109 cm. Russian Museum, Leningrad.

71 KASIMIR MALEVICH, SUPREMATIST COMPOSITION, WHITE ON WHITE. 1918. 79 × 79 cm. Museum of Modern Art, New York.

72 KASIMIR MALEVICH, KOMPOSITION IN YELLOW AND BLACK. 1916–17. Oil on canvas. 70.5 × 72.5 cm. Russian Museum, Leningrad.

73 LÁSZLÓ MOHOLY-NAGY, COMPOSITION VIII. 1924. Nationalgalerie, Staatliche Museen, Berlin.

74 VASILY KANDINSKY, IN BLUE. 1925. Oil on canvas. 80 × 110 cm. Kunstsammlung Nordrhein-Westfalen, Düsseldorf.

75 PAUL KLEE, FLOATING. 1930. Oil on canvas. 84 × 84 cm. Paul-Klee-Stiftung, Kunstmuseum, Berne.

76 HANS RICHTER, PRELUDE (PRÄLUDIUM). 1919. Detail from scroll.

77 EL LISSITZKY, THE WOLKENBÜGEL, project for a skyscraper in Moscow. View looking toward the Kremlin. 1924.

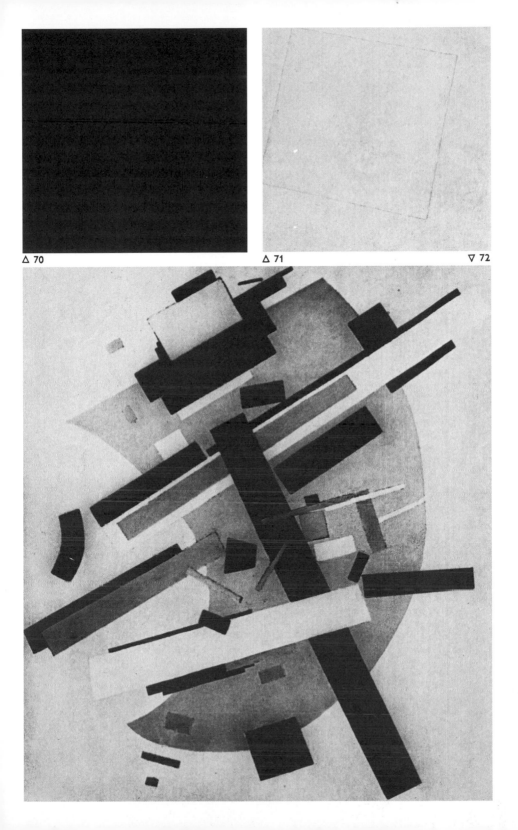

△ 70　　　　　　　　　　　　△ 71　　　　　　　　　　　　▽ 72

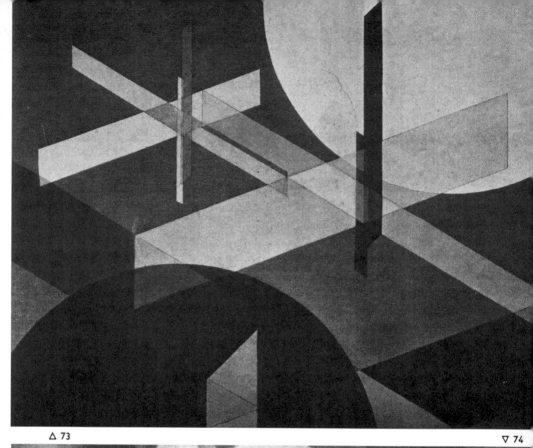

△ 73

▽ 74

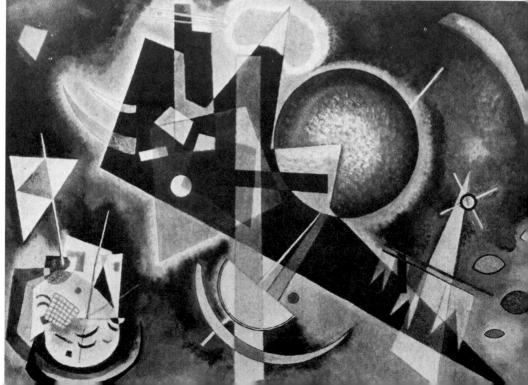

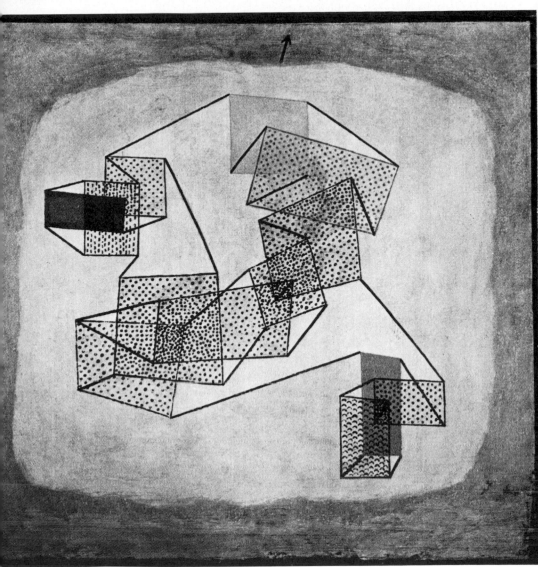

△ 75

▽ 76

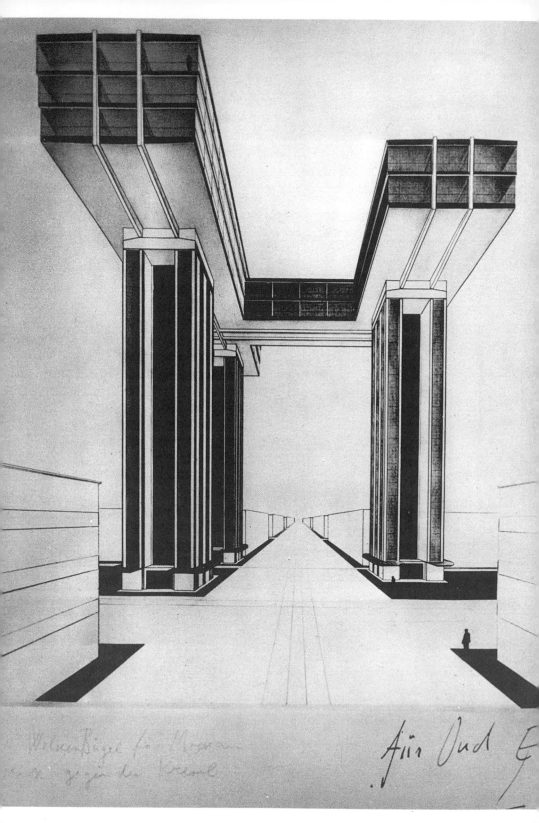

Like Moholy-Nagy, Hans Richter and El Lissitzky belonged to artistic circles where the idea of limiting the artist's activities to the picture, in isolation, was considered totally old-fashioned. Richter (b. 1888), for instance, a German who was at one time a member of the Zurich Dadaists, and later settled in America, moved from the static easel-painting to the fluid cinema screen, believing that with film he could express the space-time element that, according to all members of the abstract avant-garde, remains a feature of all forms. With the Swedish artist Viking Eggeling (1880–1925), following up some experiments with painted picture scrolls in 1919 (76), he produced the first abstract films. In these, basic geometric shapes are varied, transformed, and combined like the theme of a musical movement. Lissitzky called his own abstract paintings (*"Prouns"*) of 1921–23, "a station for changing trains from architecture to painting." We should not see this merely as a reference to the graphic techniques that Lissitzky borrowed from technical diagrams and used alongside those of traditional painting. More important, he was pointing out that the space in his *Prouns* is not infinite cosmic space, but the delimited concrete space of architecture. He was therefore saying that the shapes themselves are not empty abstractions, but structures that correspond to the spirit and potential of modern building technology and that they can actually be carried out. Malevich had earlier used his flat, Suprematist compositions to make first three-dimensional structures and then architectonic plans (for instance, his *Architektona* and *Planit* houses), but paintings were still paintings and buildings were buildings. When we come to Lissitsky, however, paintings stop being only paintings and become architectural designs, just as the blueprint takes on the importance of a picture in its own right. We are reminded of what Van Doesburg called his "counter-compositions" (68). Yet Lissitzky's plan for a skyscraper (77) is both more concrete (an office building that would bridge a specific intersection in Moscow) and more utopian in spirit. The suggestion of floating and transparency is not made by purely artistic means—distribution of color, overlapping planes, and so on—as it is in the work of Van Doesburg. Instead the designs were intended to be carried out in concrete terms, although they required the use of building techniques that were not yet available. Suprematist abstraction here enters on a remarkable alliance with the determination of the Constructivists to integrate the new reality of modern technology.

A New Spirit

Like Mondrian, many French artists reproached Picasso and Braque for making their analysis too easy. Although they did fragment the structure to the point where the object was as formless as they wished it to be, they did not go so far as to remove differentiation between an object and its environment. This criticism is implicit in the work of Juan Gris (1887–1927), who gives the whole of the surface of his paintings a rigid geometric texture (22, 79); Albert Gleizes (1881–1953) formulates it explicitly. Gleizes represents the socio-esthetic utopian outlook that says the function of art is to unmask the lies perpetuated by the bourgeoisie and their creature, the big city, to prevent the masses from being seduced. In a series of large compositions (*Bruising the Corn,*

1911–13, and others), he advocated "simultaneity of themes" as against the Cubists' "simultaneity of views." This alone, he felt, was fitted to symbolize the solidarity of men united in collective action. But after the war his concept of a socially effective art became more abstract. The art he envisaged was now based on geometric shapes and mathematical proportions (*80*), and he was later to imbue it with religious symbolism.

The Purist painters Amédée Ozenfant (1886–1966) and Le Corbusier (Charles-Édouard Jeanneret, 1887–1965) commented much more brusquely on Cubism by taking Gris's demand for intellectual discipline to extremes. They recognized the movement's historical importance, but criticized it for lacking the severity that was absolutely essential if concepts such as structure and geometry were to be invoked. They saw this severity as the chief hallmark of the "new spirit." (*L'Esprit nouveau* was the title of the review they edited from 1920 to 1925.) They claimed that from 1913 onward the Cubists had gambled away their very definite achievement (fragmentation to make objects transparent) in their allegedly synthetic phase, which was in fact purely decorative (*78*). They had thus misunderstood the significance of this phase for a more spiritual approach to the image, which the Purists, along with Kandinsky, Mondrian, and Gleizes, believed to be a requirement of modern painting. But unlike the abstract painters, they did not aim to achieve this spiritualization by eliminating the object. Instead, they aimed to transform it into a *pur objet plastique*. Their first move, therefore, was to give it back its identity as a *continu plastique* (*81*). They thus restored the unity of the image, which was potentially endangered by the new independence won for the object, in spite of its inclusion in geometric compositions. Their method was to use "marriages of shapes" in which the object's characteristic outline is given not only the function of linking object to object and form to form but also, most important, that of linking the positive form of the object to the surrounding space, which is conceived as a negative form (*82*).

Le Corbusier elaborated these "marriages" into exceedingly complex compositions, which were always dynamic, however rigorous the structure (*83*). They strikingly resemble the interlocking spatial designs for his famous "machines for living" (*machines à habiter*), which were produced somewhat later (*93, 94*). The transparent and dynamic effect created by the image results from the almost clockwork precision with which the forms interlock, and the entire surface of the picture is activated by means of a constant fluctuation in the direction and tempo of the movement, with the space expanding and the form becoming concentrated. Yet because Le Corbusier exercises strict control over the way the picture's mechanism functions, he deliberately keeps tight rein on the tempo of this "machine for seeing"—for it is quite clearly modeled on a machine.

Le Corbusier's paintings suggest a less rapid tempo than Léger's earliest mechanical landscapes (*84*). Beginning in 1913, Léger explored movement in a tense and wholly abstract series called *Contrasts of Forms*. Then, in his "tubist" paintings and drawings, he begins to express movement mechanistically, with the figure appearing as a robot pure and simple (*50*). In the landscapes, however, the figure reappears in an environ-

ment that, like itself, has the unmistakable stamp of the machine all over it. The painter has created the effect of the omnipresence of the machine less by turning organic forms (people, animals, and trees) into mechanized (or geometric) shapes than by his simultaneous use of a mixture of "mechanical elements" (this was the title of many compositions produced at about this date) scattered over the painting. Later on, Léger abandoned this simultaneous treatment (which required the dissection of the object) in favor of a montage technique. In this way, he could not only respect the continuity of forms, in the Purist sense, but could also bring out their identity in an emblematic and monumental way—for instance, by not reproducing objects to scale. An example of this is his *Still Life with Ball Bearing* (86), a forerunner of the use of hypergraphics by Pop artists in the 1960s.

In the Europe of the 1920s a large number of artists seem to have adopted an approach to form, machine, and image that is more or less related to that of the French Purists. Examples are Victor Servranckx (1897–1965), a Belgian, with his abstract compositions that remind us of Léger; Alexander Bortnyk (b. 1893); and a Russian émigré Sergei Charchoune (1888–1972), whose work is closer to that of Ozenfant; and, of course, Oskar Schlemmer, who made no secret of his admiration for Léger. But the artist most strongly influenced by Léger was Schlemmer's friend Willi Baumeister (85). Baumeister shares the enthusiasm of Léger and Delaunay for machinery and sport, for the combination of representational and abstract geometric forms, and for treating the human form as a robot, whereas the mixture of painting and sculpture in his early reliefs ("sculpto-paintings"), his use of processes borrowed from draughtsmanship, and his sporadic use of photomontage link him with the Constructivist painters of Central and Eastern Europe.

Suprematist motifs rather than Purist ones predominate in the work of the Polish founder of Unism Wladislaw Strzeminski (1893–1952), who kept to purely visual effects in his almost monochrome paintings (deriving from his methods of paint application), as he sought to pass beyond form in the manner of Malevich. But his fellow Pole Henryk Berlewi (1894–1967) gave such effects another meaning by using the mechanical dot screen of photographic printing plates (87). By means of this non-Dada return to a mechanical technique, he approached the Purist attitude to the machine, which is totally alien to any type of anti-art tendency.

Construction: Romantic and Objective

The analysis of elementary geometric figures as practiced by the Cubists and the Post-Cubists did not merely help architects to evolve a coherent system of forms that allowed them for the first time to fulfill the moral demand for clarity and truthfulness made by such pioneers as Wagner, Loos, Perret, and Garnier. More fundamentally, the artists' use of collage and montage to rescue the artwork from represented space and to set it in the real space of experience encouraged a radical reorganization of the intellectual categories of architecture.

The point is that there is not much distance between montage and "construction";

and the first artist to bridge it is Vladimir Evgrafovich Tatlin (1885–1953). The montages he saw at Picasso's studio in 1913 inspired his "counter-reliefs"—unframed three-dimensional objects hung in corners or suspended from the ceiling instead of hanging on the wall. In the same way that these reliefs do not fit into the normal categories of painting or sculpture, his plan for a tower (*Monument to the Third International, 88;* never executed) is neither architecture nor sculpture, but an object enlarged on a gigantic scale (its overall height would be nearly 2,000 feet!), or, in other words, a construction. But the term construction is also used for that "unconscious element in architecture" (Siegfried Giedion) that people had long been ashamed of but that was now due for rehabilitation.* At any rate, the Constructivists did not interpret this rehabilitation as the sublimation of technique that Perret, for example, was thinking of when he wrote: "Technique, when spoken poetically, leads to architecture." They saw construction as anti-architecture, just as montage was anti-art. Tatlin's tower is the total (anti-) work of art. "War to the death to art in all its forms," ran the *Constructivist Manifesto* of 1921.

In addition to Picasso's constructions, Tatlin had been fascinated by a product of pure engineering, a "motherless daughter"—the Eiffel Tower in Paris (1887–89), which he saw as the ideal example of construction as an alternative solution to architecture. Eiffel had been able to make his tower transparent, to give it "nonsubstantial substance" (Lissitzky), only because he did not, as the classical rules of architecture required, offer a contrast between the open space surrounding it and the totally controlled internal space of a closed structure. Instead, the tower penetrated—and was itself penetrated by—"real" space. Here transparency does not create a mystical feeling of withdrawal from the world, as it does in the fantasy architecture of the Expressionists; rather, it signifies the removal of the last true barriers between inside and outside. The transparent grilles and bars of the iron structure, with their total lack of "ennobling" trimmings, would also become one of the standard props of Constructivism, particularly of Russian Constructivism.

* Giedion means that construction fulfills the same role in architecture as does the unconscious in psychology. For him, the new "constructivist" approach in architecture functioned like psychoanalysis: it freed the architect from the "shame" inspired by the view of the naked structure.

78 PABLO PICASSO, THE THREE MUSICIANS. 1929. Oil on canvas. 200.5 × 223 cm. Guggenheim Fund, Museum of Modern Art, New York.

79 JUAN GRIS, GUITAR AND BOWL OF FRUIT ON A TABLE. 1918. Oil on canvas. 60 × 73 cm. La Roche Donation, Kunstmuseum, Basel.

80 ALBERT GLEIZES, COMPOSITION. 1921. Oil on canvas. 64.5 × 53.5 cm. Marguerite Arp-Hagenbach Collection, Kunstmuseum, Basel.

81 LE CORBUSIER, VERTICAL GUITAR. 1920. 160 × 130 cm. Le Corbusier Foundation, Paris.

82 AMÉDÉE OZENFANT, CUP, GLASSES, AND BOTTLES IN FRONT OF A WINDOW. 1922. Oil on canvas. 130 × 96.5 cm. La Roche Donation, Kunstmuseum, Basel.

83 LE CORBUSIER, STILL LIFE WITH OBJECTS. 1924. Oil on canvas. 81 × 100 cm. Le Corbusier Foundation, Paris.

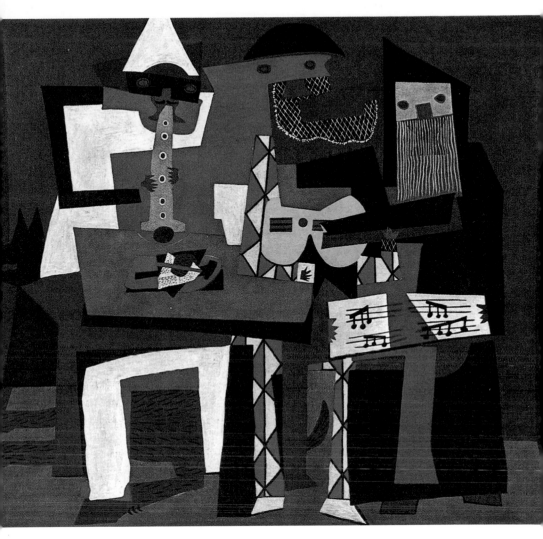

78

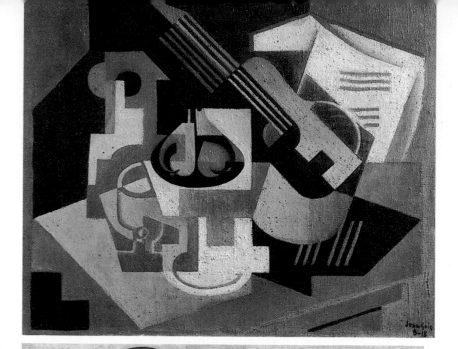

79

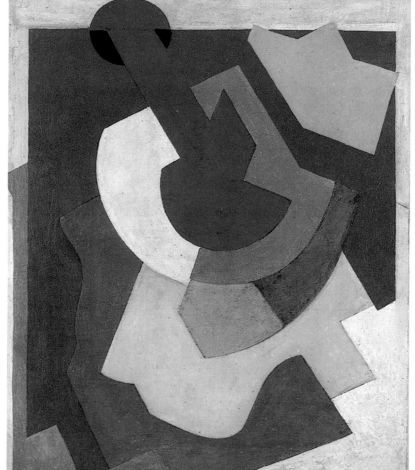

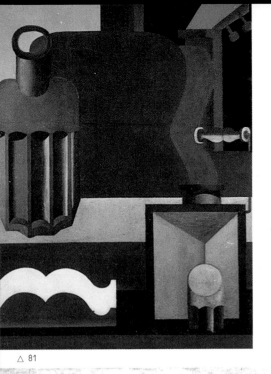

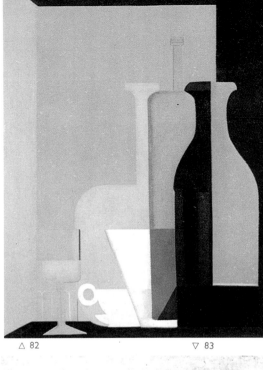

△ 81 △ 82 ▽ 83

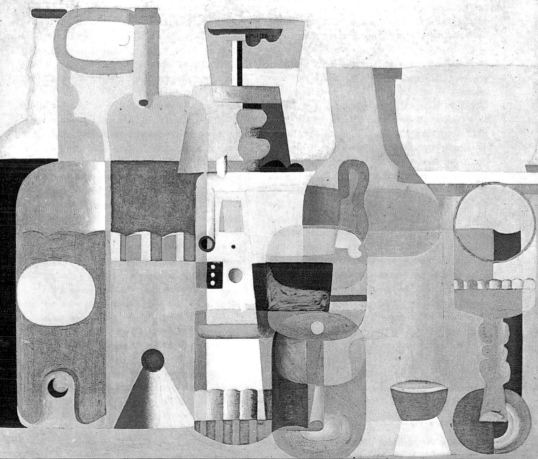

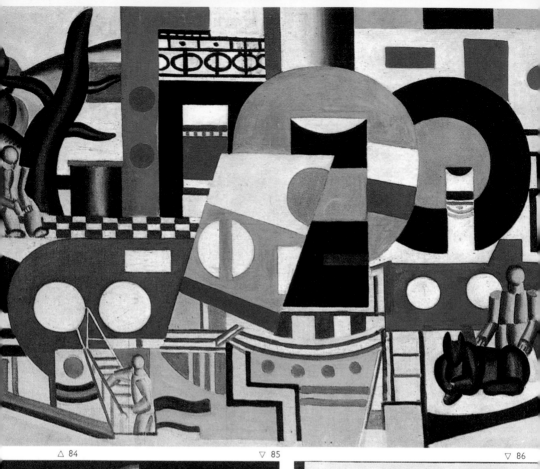

△ 84 ▽ 85 ▽ 86

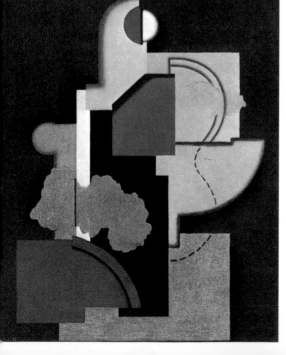

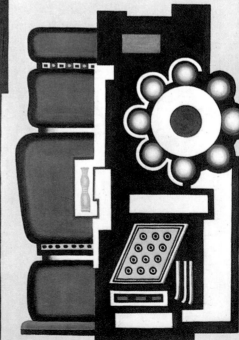

84 FERNAND LÉGER, THE TUGBOAT. 1920. Oil on canvas. 104 × 132 cm. Musée de Peinture et de Sculpture, Grenoble.

85 WILLI BAUMEISTER, RED AND OLIVE CONSTRUCTION. 1924. Oil on canvas. 100 × 81 cm. Private collection, Stuttgart.

86 FERNAND LÉGER, STILL LIFE WITH BALL BEARING. 1926. Oil on canvas. 146 × 114 cm. La Roche Donation, Kunstmuseum, Basel.

87 HENRYK BERLEWI, MECHANOFACTURE. 1923. Gouache on paper. 55 × 44 cm. Kaiser-Wilhelm-Museum, Krefeld.

87

But Eiffel had brought his construction even closer to life by incorporating into it the functional movement of the elevators, which are completely visible—and this long before the Futurist Boccioni proposed the expression or representation of movement theoretically. Tatlin's tower was designed to have not only masses of elevators and escalators but gigantic glass-walled revolving rooms—revolving around the oblique "dynamic axis" he had borrowed from his archenemy Malevich. Even in less utopian objects the Constructivists emphasize the mechanical movement of elevators, which had a futuristic appeal in Russia in the post-Revolution period (89).

Although the symbols that the Soviet Constructivists used in raising their monuments to modernity were different from those of the German Expressionists, they had the same romantic belief in the imminent metamorphosis of the still-passive masses into an active people's community. They interpreted modernity as the open-ended expansion of man's technical potentialities, for it is not only the vertical structure of Tatlin's tower design that makes it an analogue to Mendelsohn's Einstein Tower in Potsdam (see also 128). It is true that the movable structures (exhibition pavilions, rostrums, bookstalls) of early Constructivism, which act merely as signals, are conditioned by the limited resources of the Soviet Union at this date and by the demands of Agitprop. They also, as traditionally happened with festival decorations, enabled artists to experiment with form before later transferring their discoveries to other, more functional types of buildings. But the Constructivist movement was soon to undergo a radical transformation. Partly under the influence of Production Art, which aimed to elaborate everyday objects, and of "proletarian culture" (Proletkult), and partly owing to the spread of the concept of planning in both the East and the West, the cult of technological form in isolation was rejected as mere primitive

romanticism. It was replaced by painstaking research into processes and by a scientific analysis of the technical, economic, and social components of the building program under discussion; the formal aspect was thus systematically superseded.

It was not only in Russia at the time of the first Five-Year Plan that this second Constructivist movement, also known as Rationalism, caught on. It was also favorably received in the mid–1920s in Central Europe, in Holland (Mart Stam, b. 1899), and in Switzerland. Gropius appointed its best-known representative, the Swiss architect Hannes Meyer (1889–1954), to be his successor in running the Bauhaus (1928–30). Although Meyer's design for a school (*90*) shows certain formal relationships to Russian work, these similarities are no longer used for their own sake but only isofar as they are useful from the economic or functional point of view. In its formal restraint, Meyer's later masterpiece, the training center for officials of the German federation of trade unions in Bernau, near Berlin (1928–30), also anticipates the functionalism of the Ulm College of Design planned by the Zurich painter, sculptor, and architect Max Bill more than twenty years later (*207*).

Architecture and Abstraction

But as with painters, when architects began to come to grips with the machine they did not do so in a purely anti-art spirit. For instance, when Le Corbusier came up with his hotly debated characterization of dwelling places as "machines for living," he did not mean that houses and apartments should be transformed into science-fiction machines designed for robots. What he was trying to say was that the architect should tackle the problem of housing in the same spirit as an engineer embarking on plans for building a ship or an airplane. He must adopt a way of thinking that corresponded to the *esprit nouveau,* rather than merely imitating the shapes and lines of machines. Needless to say, the creations that result from this process are as far removed from those produced by conventional building practice, in which buildings are treated individually, as mass-produced products are from craft work. Since the engineer's goal is the same as the artist's—to create order—architecture must inevitably achieve a new harmony of form if it adopts the engineer's methods, according to Le Corbusier. The same optimism is the basis of the Bauhaus ideology. It is true that Gropius's phrase, "art and technology: a new unity," which dates from 1923, was generally interpreted as an anti-art statement and was approved or rejected as such. But Gropius saw it as merely a methodological challenge: If art is to survive, it cannot casually overlook the fact that mechanical methods of production have fundamentally changed man's—and the creative artist's—relationship to his environment. On the other hand, technology can become a force for social progress only if, like art, it recognizes that its most important task is to create a harmonious order.

Gropius offered a dazzling illustration of this thesis when he designed the new Bauhaus building in Dessau (*91*), which was the first large-scale commission taken on by the "new architecture" (later known as the International style). Even more remarkable than the transparency created by Gropius's lavish use of glass distributed

in a great variety of ways is the free, but seemingly purely functional, layout of the architectural members, which are very clearly separated one from the other. Yet this alleged functionalism submits meekly to esthetic principles of design. Mies's design for a country house (67) combines Frank Lloyd Wright's centrifugal groundplan with the four-dimensional look of the open rectangle favored by early Neo-Plasticism; Gropius also bases his ideas on Wright's groundplan, using it here to create stresses between the various wings, which are clearly inspired by Malevich's *Planit* design. Admittedly, these stresses are more obvious if you look at the model from above than if you walk around the richly articulated complex of buildings at ground level.

The layout of Le Corbusier's plan for the League of Nations building (92) looks even more intricate. Here the individual wings are not uniformly derived from basic prismatic shapes and their spatial organization does not depend on a geometric schema that is immediately apparent. Compared to the somewhat rigid articulation of the Bauhaus, the distribution of the architectural masses creates a looser, almost random effect, without a hint of Wright's system of elements radiating out from a central core. But then one is struck by the rhythmic alternation of fixed, strongly emphasized pivotal points and, stretched tautly between them, rectilinear connecting areas that are treated in a more neutral way. The spatial relationships are synchronized with great precision, resulting in an overall system that is full of dynamic coherence and is somewhat reminiscent of the transparent still lifes produced by the Purist painters (83).

Machines for Living

The half-dozen single-family houses and the housing estate that Le Corbusier built in the 1920s transfer into architectonic space the new discoveries made in painting. At the same time, they represent an attempt to test the five points (*pilotis,* terrace roof, free groundplan, free façade, row of windows) on which he based his revival of residential building—whether private houses or whole estates—and, indeed, of town planning in general. These buildings use two of the leitmotifs of post-Cubist theory—transparency and the theme of floating—in a particularly coherent way. Here, unlike Constructivism, the methods used in modern building technology are not adopted for their own sake. And Le Corbusier does not—as in the architectural designs produced by De Stijl artists—sacrifice the living variety of shapes that results from specific functional requirements to the alienating process of standardizing elements by means of a predefined abstract system of forms. The architectural members into which the mass is broken up are admittedly based on a small number of basic geometric shapes. But they retain their identity as *objets plastiques,* as bottles and glasses do in Purist still lifes. At the same time, although the range of colors that Le Corbusier uses on inside and outside walls, in order to "abolish mass and create space," is limited, it remains open-ended, unlike Van Doesburg's. The spatial complexity of Le Corbusier's buildings is even greater than in the very fluid designs of Mies van der Rohe (Barcelona Exhibition, German Pavilion, 1929). One reason is the use of *pilotis* (free-standing piers with structural function), which give the optical effect of

raising the buildings off the ground when the ground floor is recessed. Another is the transparent effect created by the fusion of inner and outer space and the clash of colors against one another. Yet another is the enlivening effect throughout of the tensions that arise between one *objet plastique* and another and of the gliding movement of the ramps running from floor to floor. Significantly, the violent attacks that these houses provoked are directed primarily against the *pilotis*. People felt that by detaching residential buildings from the ground, architects were uprooting hearth and home. And yet Le Corbusier did not see this as an anti-architecture gesture in any sense of the term, though it did represent a conscious break with the pre-industrial tradition of a building of heavy masonry. Just as paintings could now "leave the wall" because they had been freed from their traditional function as representational or decorative art, and could be viewed entirely through the eyes of *esprit nouveau*—as objects of meditation—so now architecture should take advantage of the opportunity offered by the modern technique of skeleton construction and "leave the ground." In this way, it could satisfy pressing social and economic needs, in particular, by providing additional effective areas for diverse purposes, and enabling residential and traffic areas to be distributed in a new way.

Treating architecture as a product that could be mass-produced from prefabricated components did admittedly force both architects and consumers to rethink their ideas. Yet Le Corbusier went beyond a mere acceptance of this process of industrialized architecture to the *objet architectural*. This concept was an exact parallel in all respects to that of the *objet plastique* in painting or sculpture. It opened up a wide range of new perspectives for the future, as the 1960s were to show.

Architecture and Functionalism

The worldwide depression of the early 1930s hit modern architecture particularly hard. In Germany, the National Socialists' first move was to drive out the Social-Democratic municipal authorities, who had entrusted progressive architects and town planners such as Ernst May (1886–1970) or Martin Wagner (1885–1957) with various large-scale projects, particularly housing estates. The Nazis then forced the actual architects, from the Taut brothers to Mies, Mendelsohn to Gropius, to emigrate.

Similarly, the beginning of the Stalinist era in the Soviet Union brought an end to a period of experimentation that included commissions given to Western architects under the first Five-Year Plan. Almost all European countries underwent a reaction that forced a return to an academic style for public buildings and a "folksy" style for private dwellings—all in the name of tradition, or "sound popular instinct." And yet wherever it was not actually stamped out by force, the new architecture stood its ground with tenacity although it underwent a metamorphosis as a result of confrontations among the architects of various countries within the Congrès Internationaux d'Architecture Moderne (CIAM), which had been founded in 1928.

In contrast to the first heroic period, the second phase of what is known as the International Style marks a new urge to come into closer contact with reality. In the

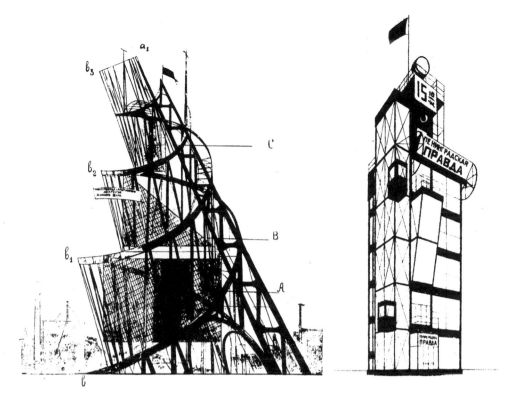

88 VLADIMIR TATLIN, DESIGN FOR A MONUMENT TO THE THIRD INTERNATIONAL. 1920. Never constructed.

89 ALEXANDER AND VLADIMIR VESNIN, DESIGN FOR A BUILDING FOR THE LENINGRAD PRAVDA. 1924.

90 HANNES MEYER and HANS WITTWER, DESIGN FOR THE PETERSSCHULE. 1925. Basel.

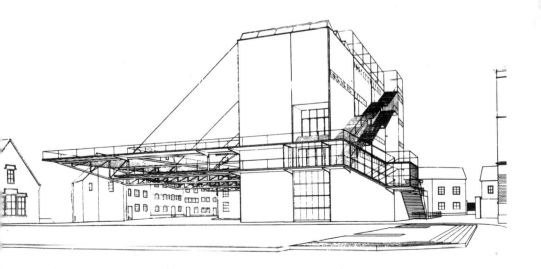

1920s, polemical intransigence had been essential if the new principles and the new formal language were ever to win through. Now people were switching to a more flexible process of adjustment to the realities of planning and technology.

Attempts were made to give the previously somewhat abstract call for functionalism a more concrete note, particularly in relation to making buildings more durable and more comfortable to live in. The main protagonists of this pragmatic attitude are such architects as Alvar Aalto (b. 1898) and Richard Neutra (1892–1970). Aalto's concern for observing the laws of biology as closely as possible later led him to abandon the post-Cubist geometric style to which he adhered in his early work (97) and encouraged him to create a type of architecture that was very close to nature, the European counterpart of Wright's organic architecture. On the other hand, Neutra emphasized the need to take psychological and physiological factors into account, both in his designs—which were mostly for luxury housing—and in his writings and lectures. Similar considerations underlie a number of excellent designs from the same period. For instance, the tobacco factory (96) built by L. C. van der Vlugt (b. 1894) and Johannes Brinkman (b. 1902), the school complex (98) of André Lurçat (1894–1970) and the two houses (99) built by Alfred Roth (b. 1903), his cousin Emil Roth, and Marcel Breuer (b. 1902) represent, along with Aalto's sanatorium, important stages in the history of architecture. Another famous example is Le Corbusier's Swiss House for the Cîté Universitaire in Paris (95).

Materials that had formerly been camouflaged by a white or colored coating, making them seem uniform and abstract, began here to display their natural textures. The concrete for the *pilotis,* which were now treated three-dimensionally instead of being linear, was left raw and gray; the side and back walls were faced with stone slabs; and a whole wall was even made of quarry stone. This provided very durable surfaces as well as a new presence in the individual architectural elements, whether they were supporting pillars or infills. The emphasis on creating an effect of solidity—of substance—paved the way for transforming the smooth outer envelope of the building into a honeycomblike, three-dimensional structure. By the end of the 1930s, this tendency was fully developed in such buildings as the Ministry of Education in Rio de Janeiro (100).

Responding to functional demands, the Swiss Pavilion is split into two contrasting parts. Sleeping areas are made up of repeated identical cell units raised off the ground on *pilotis.* Rooms for communal activities, or such special requirements as a director's apartment, are at ground level, arranged in an open layout. This schema made it possible to break up the usual massive block, both functionally and visually. In the past forty years, this type of architecture has become the norm all over the world, wherever there is a need for large rooms to be used by a many different large groups, together with a series of identical small units for individual use, such as offices, hotel rooms, or hospital wards.

If we compare the Education Ministry in Rio (100), in its high-density urban setting, with the freely three-dimensional treatment of Wright's Falling Water house

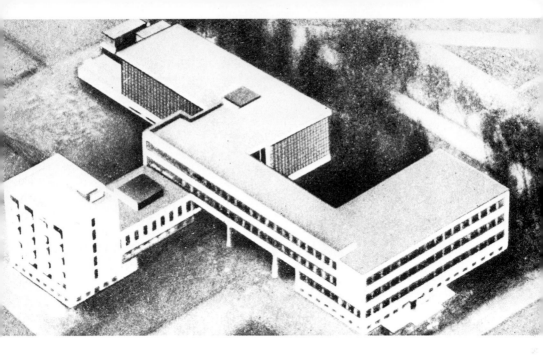

91 WALTER GROPIUS, BAUHAUS BUILDING IN DESSAU. 1925. Model. Bauhaus Archive, Darmstadt.

92 LE CORBUSIER, DESIGN FOR A COMPETITION FOR THE LEAGUE OF NATIONS BUILDING IN GENEVA. 1927–28. Rejected.

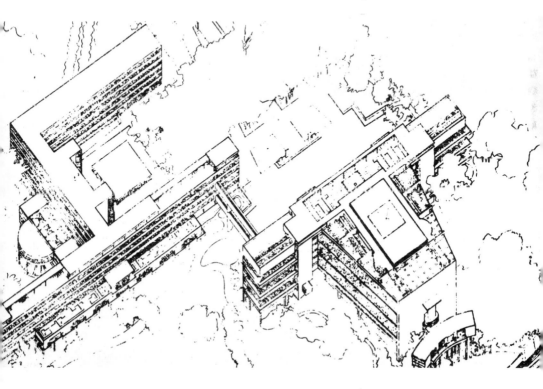

(*101*), which he dramatically built over a waterfall in open country, we may be tempted to think that this merely confirms the polarity (long a cliché) between social commitment on the one hand and individual expansiveness and romanticism on the other. Yet these two buildings, apparently so different, show that on the eve of the World War II the two major representatives of modern architecture, though poles apart in other ways, in fact see eye to eye regarding style. Wright is not afraid of detaching at least part of his house from the ground so as to bring it into closer contact with nature—despite the fact that he had often sneered at Le Corbusier's "boxes on stilts." His huge balconies reach up and out, while shadowy cavities thrust deep into the heart of the building. The house is no longer earthbound, but transparent—clearly under the influence of the European "new architecture." And by this time even Le Corbusier could see no contradiction between this effect and a more strongly emphasized three-dimensional substantiality in individual shapes.

Sculpture and the Human Figure

At the beginning of the 20th century, sculptors, like architects, could not draw on a fund of experience of the kind that the Impressionists and Post-Impressionists had handed down to painters, nor did they have the same revolutionary stimuli. Only one of them, Auguste Rodin (1840–1917), had managed to break through to a new era. But in his work, fundamental insights into the essence of three-dimensional form were so much a part of his strongly subjective, personal message that there was no chance of its becoming a basis for the evolution of a new stylistic approach. Although painters were trying to follow Van Gogh's "more music and less sculpture," and also exploiting color as their chief expressive means, the decisive stimulus for a revival of sculpture nevertheless came from them.

Gauguin's experiments with ceramics and woodcuts, which attracted a good deal of attention from the avant-garde at the turn of the century, were more important for the development of modern art than such factors as Cézanne's emphasis on solid geometric shapes or the three-dimensional synthesis of form in Degas's *Dancers* and *Horses*. Aristide Maillol's (1861–1944) decision to switch from painting to sculpture can also be traced back to Gauguin. And so can the archaizing tendency he soon revealed as he sought an almost rocklike effect of substantiality. But in contrast to Gauguin's aggressive primitivism, Maillol's cheerfully archaic approach did not involve an attempt to lose himself in a mythical and primeval background of exotic cultures. Instead he drew on the tradition of the Mediterranean peasantry. The slight swelling or sinking of a living form in Maillol's work creates the balance between tension and repose, between fluidity and controlled structuring, that is the hallmark of classical art (*102*). But his spontaneously classicizing attitude should not be confused with the attitude of so many of the latest classicists. They are often grouped with Maillol, although they were not bold enough to break away from a set of rules of which Maillol himself was totally unaware.

The Romanian sculptor Constantin Brancusi (1876–1957) was just as deeply rooted

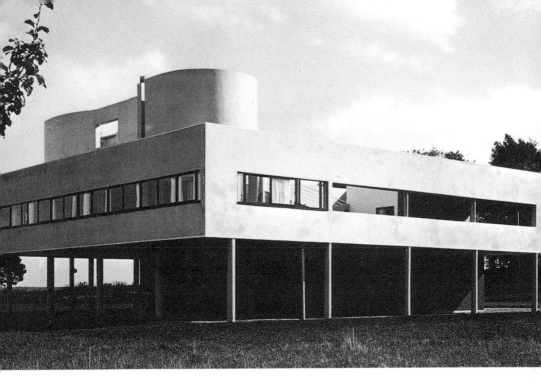

93, 94 Le Corbusier, Villa Savoie, Poissy. 1927–31. The hanging garden; (*below*) the façade from the garden.

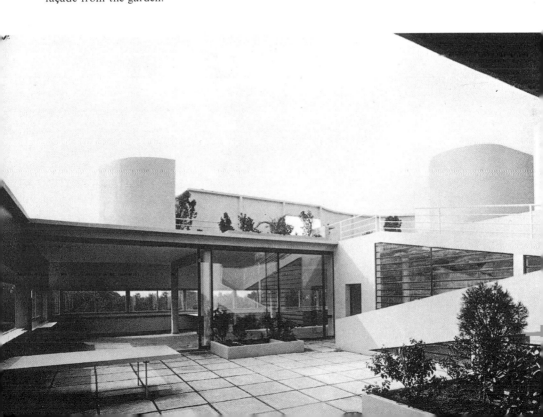

in rustic Romanic culture as Maillol, a French Catalan, and just as spontaneously involved in exploring pure form. He was also stirred by the linearism of the Art Nouveau, as Maillol had been in his early work. But the artistic traditions of his native land offered him quite different stimuli. Even though Maillol showed little interest in the psychology or the potential symbolic meaning of his figures, he did his best to convey their physical individuality as fully as possible, whereas Brancusi gradually turned away from individual characterization. Rather as in icon painting, he sought ways of picking out the timeless inner core from the wealth of transient individual appearances, realizing that this alone would enable him to understand and explain them. But unlike the Russians, who saw abstraction as a departure from any type of objectivity, Brancusi concentrated form to such an extent that the original object of his inspiration is no longer perceived, yet the form clearly still belongs to the realm of organically living beings. The fundamental shape, to which all forms tend to return, is not the cube or the sphere, but the egg. He returned to the same motifs again and again for decades, until he had distilled from them forms that were as reductive and as pure as they possibly could be. A good example is the *Sleeping Muse* (*104*), a theme that appears in his work from 1906 to 1925.

A countertrend to this process of concentrating three-dimensional masses in order to obtain a purified nuclear form was the tendency of some modern sculptors to dissolve the compact mass so as to create an open structure linked to the surrounding space. This type of open structure appears with particularly spectacular effect in Cubist sculpture (*23–26*). Although this tendency was strongly influenced by Analytic Cubism, it really goes back to the active exploration of the relationship of figure or object to space that is a characteristic feature of all modern painting. For instance, in his *Serpentina* (*105*) Matisse transfers into the three-dimensional sphere his experiments with colored masses distributed over the surface of a painting. The volumes are not joined according to the laws of solid bodies but are designed from the outset to carry the overall rhythm of the work, and an awareness of activating the surrounding space. So also are the works of the German Wilhelm Lehmbruck (1881–1919), who, like Matisse, tried to integrate the surrounding space into a piece of sculpture (*103*). Yet, paradoxically, the means he used, to turn Van Gogh's phrase around, were not as

95 LE CORBUSIER, SWISS HOUSE FOR STUDENTS AT THE CITÉ UNIVERSITAIRE, Paris. 1930–32.

96 J. A. BRINKMAN and L. C. VAN DER FLUGT, VAN NELLE TOBACCO FACTORY. Rotterdam. 1928–30.

97 ALVAR AALTO, SANATORIUM FOR TUBERCULAR PATIENTS, Paimio, Finland. 1929–33.

98 ANDRÉ LURÇAT, KARL MARX SCHOOL, Villejuif, France. 1931–35.

99 MARCEL BREUER, ALFRED AND EMIL ROTH, TWO BLOCKS OF APARTMENTS IN THE DOLDERTAL, Zurich, 1934–36.

100 LUCIO COSTA, OSCAR NIEMEYER, A. REIDY, AND OTHERS, MINISTRY OF EDUCATION, Rio de Janiero, North façade. 1937–43. (Le Corbusier acted as consultant.)

101 FRANK LLOYD WRIGHT, FALLING WATER, KAUFMANN HOUSE, Bear Run, Pennsylvania. 1936–37.

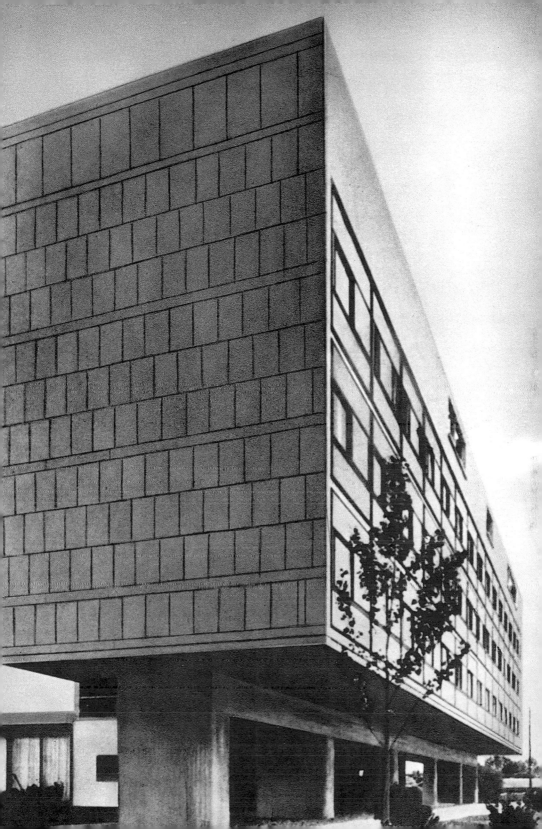

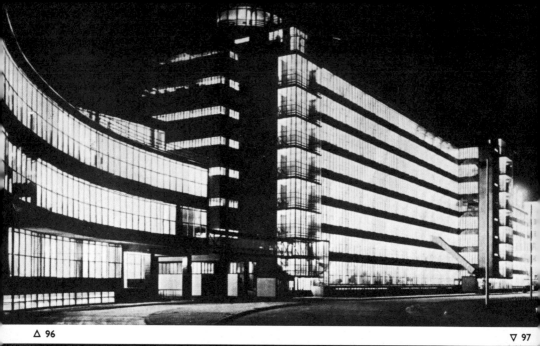

△ 96

▽ 97

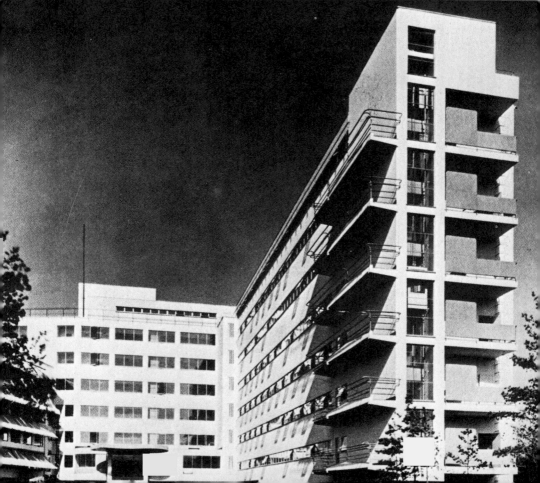

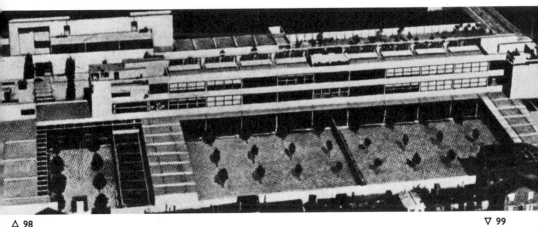

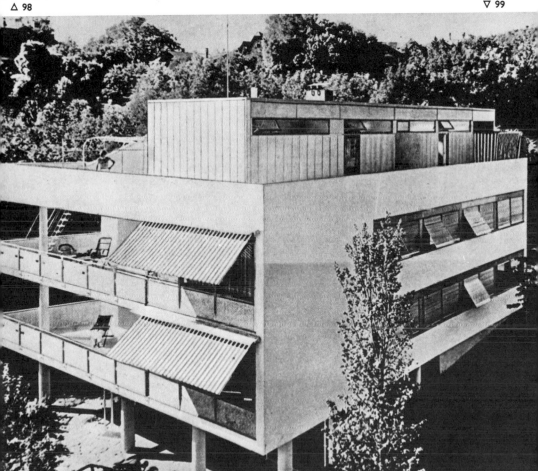

△ 98 ▽ 99

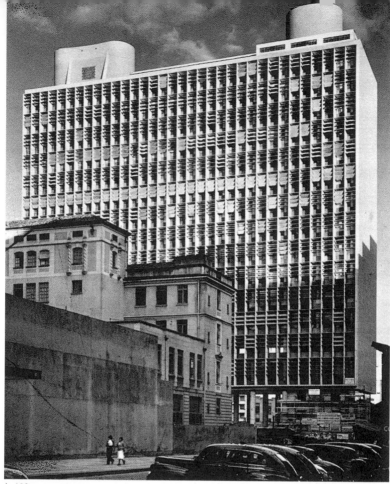

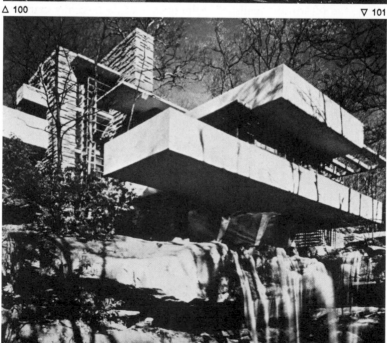

strongly sculptural as those used by Matisse, who actually was a painter. This process of stylization involves literary elements just as much as formal stimuli. But it is the literary aspect that won Lehmbruck his fame—and the same is true of the German sculptor Ernst Barlach (1870–1938) and the French Antoine Bourdelle (1861–1929).

Multifaceted Realism

The return to a more realistic portrayal of the human figure and of objects in all fields of art between the World Wars is usually interpreted as a reaction against two things: the fervent emotions of Expressionism, which was always bent on intensity of expression, and the intellectualism of post-Cubist art, which worked only with "pure" design elements. The point of departure may well have been a campaign started by the Italian periodical *Valori plastici* (1918–21) just after World War I. Speaking against the "excess" perpetrated by the Cubists and Futurists with their fragmentation of form, the instigators of this campaign urged artists to remember the "plastic values" of the classical tradition, which meant the integrity of form, modeling with chiaroscuro, and illusionistic and perspective construction of pictorial space. Their call was reechoed throughout Europe.

There is no doubt that the reactionary element in that "call to order" (Jean Cocteau) played an important, and at times decisive, part in the realistic movement of the 1920s and 1930s. As is well known, this reaction also took on political color, chiefly in Germany and in Russia. But whatever significance may be attributed to the political factor from the viewpoint of the sociology of art, it is barely relevant to the history of style. In fact, of all the artists who remained faithful to the outer appearance of objects and figures, only those who sought to continue progressive experiments played any part in the further development of the style.

Paradoxically, the return to "realistic" techniques is often basically caused by the same considerations that had led to a break with likenesses or even with objectivity in general. A good example is Otto Dix's (1891–1969) portrait of a literary habituée of the Romanische Café in Berlin (*109*). The distortion of the spatial structure and the anatomical proportions and the impact of vermillon on crimson are derived from the methods that the Brücke painters used to create shock effects. But unlike such painters as Kirchner or Schmidt-Rottluff, Dix reproduces detail with the precision of an old master, employing the technique of egg tempera, rarely used since the Renaissance. It is this pedantic attention to detail, this discordant combination of obsolete technique and modern subject matter, that makes Dix's ostensibly realistic portrait resemble the ersatz structures of the Dada movement.

Another painter who disapproved of interpreting the environment subjectively or symbolically was Max Beckmann (1884–1950). He adhered instead to an apparently objective inventory of established facts. His return to a sober style of painting does not mean a scrupulously exact rendition of objects, as in Dix's work, but it does involve unpoetic treatment of form and color. The close links between this and Expressionism can be clearly be seen in the aggressive use of line to de-beautify things,

and also in the dissonant note struck by the conspicuously supercooled color. In spite of his objective approach, Beckmann will turn a rugby match, which a painter such as Delaunay saw as a swirl of moving masses of color, into a metaphor for the brutality of the struggle for existence that underlies our modern world (*110*).

The "realism" practiced by Oskar Schlemmer (*111*) is just as multidimensional, though the symptoms of it are quite different. His Seurat-like stereotypes of chessmen or figures so rounded they look as if they have been turned on a lathe are just as far removed from reality, just as artificial as, say, his 1921 sculpture (*52*), which he himself called "abstract," or the geometrically stylized dancers in his ballets with their padded costumes. In neither case is Schlemmer concerned with individual characterization. He is interested instead in the problem of the figures' relationship to space. But while he tries in his sculpture to depict the interplay of all possible types of spatial relationship in a single synthetic structure, in his paintings he uses the individual figures to reveal only a single component of the more or less complex structure that underlies a given spatial configuration—a stage, a room, a balcony, or, in this case (a particularly dynamic example), a staircase.

The painting of Fernand Léger (1881–1955), too, tended to be monumental at the outset. His dynamic "modern landscapes"—towns, stations, ships (*84*), machines— which portray man in conjunction with his new environment, as the product of collective action, were already monumental in their choice of subject matter and the orchestration of form and color. But his still lifes, which are very close to architecture (*86*), are even more so. In them every single component of the environment, even the most insignificant, is allowed to make the maximum formal impact. This effect is achieved by means of a precise truthfulness to its elementary structure, which allows drastic changes in scale (*86*). In the process of getting so closely involved with the object, Léger then works out "pictorial analogies" for nonmechanical forms such as people, clothes, animals, stones, and leaves. They allow him to explore a great variety of shapes and materials and to become fully aware of their realistic content, without running the risk of an insipid realism. Léger uses shorthand symbols and stereotypes on a systematic basis—for depicting hands, for instance, or for faces. His reason for doing this was not merely an urge to achieve the greatest possible legibility by a sketchy simplification and repetition of shapes. He also believed, as did Piero della Francesca and the Tuscan fresco painters, that genuine folk art—which is how he understood monumental art—should be devoid of personalized expression (*112*). In this he was in fact following the example of Henri ("le Douanier") Rousseau (1844–1910), and he remained faithful to this conviction to the last, even in the period when he was

102 ARISTIDE MAILLOL, POMONA. 1910. Bronze. Height, 161 cm. Galerie Dina Vierny, Paris.
103 WILHELM LEHMBRUCK, KNEELING WOMAN. 1911. Cast stone. Height, 173.5 cm. Museum of Modern Art, New York.
104 CONSTANTIN BRANCUSI, SLEEPING MUSE. 1909. Bronze. Musée National d'Art Moderne, Paris.
105 HENRI MATISSE, SERPENTINA. 1909. Bronze. Height, 56.5 cm. Museum of Modern Art, New York.

△ 102 ▽ 104 △ 103 ▽ 105

strongly committed politically. He combined Rousseau's ultrarealism—which Kandinsky and Picasso, Delaunay and Apollinaire, de Chirico and Klee, Derain, and many other painters gazed on in amazement and humility (106)—with the poetic, even naive freshness with which Rousseau himself tackled even the most trivial scenes. For Rousseau's magic did not in fact need the exotic charm of distant primeval forests (which he actually dreamed up in suburban gardens outside Paris) to reach its full flowering. It comes over just as strongly when he is depicting the most prosaic incidents.

Compared to Rousseau's robust way of making everything into an object, the subtle stylization of the human figure advocated by Amedeo Modigliani (1884–1921) may seem subjective (108). But if we compare his line, which is sharply expressive but always remains serene, with the wild daubs of paint used by a painter such as Chaim Soutine (1884–1943)—with whom he is far too often lumped together under the heading "Expressionist"—we realize that the structural force of this line is in fact an essential feature of his art. It is immediately obvious in his graphic work and his sculpture, as well as in his painting. Soutine tears form apart so as to reduce it to a projection of his inner visions, while Modigliani's aim is to reconstruct such visions with as much solidity as possible, although he avoids any hiatus or increase in rhythm that might jeopardize the melodic ebbing of the line. His line never occurs independently, as the Art Nouveau arabesque does; it is never anything more than one element—although a major one—in the structure.

Few artists felt the effects of the "return to tradition and reason" as strongly as André Derain (1880–1954), whose work underwent a radical change of direction (107; compare 9). Whereas a continuing preoccupation with the artist's detachment links Picasso's "hellenistic" or "Ingresesque" drawings irrevocably with his late Cubist work, Derain was completely absorbed in his attempts to evolve an increasingly traditional realistic style. His urge for discipline and concentration caused him to give up all free experimentation, but he soon became so absorbed by the art of the past that his work eventually degenerated into a noncreative posing and gesturing, a mere anthology of reminiscences of all previous styles.

Even Matisse appears to have had some doubts in the 1920s about exploring new ground, though he never denied the achievements of the prewar years, as Derain did. But although Matisse's output in the middle years lacks the experimental *élan* of the prewar period, he continued to produce work that not only matched his earlier paintings in quality but also anticipated a good deal of the greatness of his late work. A good example is *The Dream* of 1935 (113), which, together with a half-dozen or so equally strong paintings, represents an important connecting link between his early compositions (8) and his later ones (141).

The Dream Element

As early as 1911 such painters as Duchamp and Picabia recognized that the Cubist fragmentation of form provided a point of departure not only for abstract con-

struction controlled by the intellect, but also for a type of art that was free from any logical constraint ("a-logical").

Simultaneity, resulting as it did from a process of breaking open the external form, removed altogether the psychological distance between the viewer and the object—the Fauves had already reduced it considerably by making color an element in its own right. The continuous process whereby the object merged with the surrounding space resulted in a mutual interpenetration of the ego and the world around it. Duchamp's *Chessplayers* (1911), for example, does not depict a pair of players sitting opposite each other, as, say, Cézanne's *The Cardplayers* (1892) does. It has also ceased to be a Cubist "still life with chessboard" in the style of Marcoussis's *Draughtsboard,* painted a year later. It transports us right into the middle of the confused whirl of combinations that each of the players imputes to the other, and therefore into the atmosphere in which they find and identify with each other, spiritually speaking. The simultaneity is no longer purely visual, but also psychological. By contrast, the geometric elements on which the Cubists based their outer shapes were so neutral that they were interchangeable. Any significance they had came solely from the structure into which they were integrated (*21*). In 1912 Picasso used this free interchangeability of forms to evolve the principle of collage semistructures (*42*). Picabia's American abstracts of 1913 can also be interpreted in this way (*39*).

Russian-born Marc Chagall (b. 1887), who came to Paris in 1910, felt, like Duchamp, that simultaneity represented a means of expressing the complexity and mobility of psychological states. At the same time, simultaneity is one of the tools of folk art, which was the great passion of the Russian avant-garde at that time. The Russian painters who belonged to the movement known as Primitivism, which had been launched by Larionov and Goncharova in 1911, were particularly keen on folk art. Unlike Duchamp, however, Chagall was not concerned with depicting several different layers of consciousness at once. What he wanted to convey was the versatility of the vision that allowed the man dreaming it to be omnipresent. In *The Village and I* (*114*) the lover finds himself back again with—or possibly still with—his distant bride, and in his confusion he offers his birthday gift of a bunch of flowers to the cow she is in the process of milking instead of to her. This painting can be read in several different ways. The virtuoso exploitation of Cubist transparency and simultaneity, combined with the "orphic" treatment of color, space, and time lifts us up into the intoxicating, floating feeling of a dream.

By contrast, in de Chirico's visions the place (a townscape with no people in sight) and the time (a hot afternoon in late summer drawing sluggishly to a close) are pinpointed with precision and always remain the same. They seem so oppressive that there appears to be no chance whatever of escaping from them. The views of streets, with their exaggerated perspectives and their blankly staring arcades recurring *ad infinitum*, do admittedly invite escape, but a shadow blocks our path as we try to leave, heralding a nameless tragedy, of which we shall never know the details (*115*).

The torment sparked by this uncertainty, a foreboding of a coming nightmare, is

caused by our realization as we dream that things that seem so well organized when we are awake are in fact a total mystery—and that we are not intellectually equipped to cope with it. De Chirico's spatial construction, in its unrelenting regularity, denotes the trap man set for himself when he took refuge in an artificial environment defined rigidly by the categories of daytime thought. In such an environment man can continue to exist—if at all—only as an artificial ("de-natured") structure (*49*).

This process of alienating the everyday world by casting doubts on time and space became another leitmotif for painters, who in the 1920s were influenced in varying degrees by contemporary psychology and psychopathology as they struggled to give visual expression to the "surreal." The word had been coined by Guillaume Apollinaire in 1916 and refers to the nocturnal side of reality, which we can reach only by switching off the learned reactions that operate by day and concentrating exclusively on the unconscious. One of the few painters who did genuinely convey the uncanny feeling produced by the way we experience time and space in dreams was Yves Tanguy (1900–55; *116*). It is not only man who has completely disappeared from his surreal landscapes, as he has from de Chirico's towns: Scarcely anything at all is left of the clutter of civilization he once surrounded himself with. All we see is an occasional shape looming out of the primeval earth, which stretches to infinity. And these shapes are difficult to identify: Some seem to be mere flotsam and jetsam ground down by a million tides; others look like fossils or minerals, emerging to a larvalike existence.

The Unconscious Takes Over

But in their attempt to concretize "super-reality" in all its manifestations, and thus to penetrate to the bottommost layers of the psyche, the Surrealists were not content with merely alienating time and space. All form of control by reason had to be eliminated. In the *Surrealist Manifesto* of 1924, the movement's founder and chief theoretician, the neurologist and poet André Breton (1896–1966), called on artists to undertake a systematic examination of the potentialities offered by chance and automatism. He was appealing particularly to writers, but he cited collages made by Ernst, who

106 HENRI ROUSSEAU, THE WEDDING. 1905. Oil on canvas. 163 × 114 cm. Guillaume Walter Donation, Louvre, Paris.

107 ANDRÉ DERAIN, TWO SISTERS. 1914. Oil on canvas. 195 × 130 cm. Rump Collection, Statens Museum for Kunst, Copenhagen.

108 AMEDEO MODIGLIANI, WOMAN WITH A WHITE COLLAR. 1917. Oil on canvas. 92 × 60 cm. Musée de Peinture et de Sculpture, Grenoble.

109 OTTO DIX, PORTRAIT OF SYLVIA VON HARDEN. 1926. Mixed technique on panel. 121 × 88 cm. Musée d'Art Moderne, Paris.

110 MAX BECKMANN, RUGBY PLAYERS. 1929. Oil on canvas. 213 × 100 cm. Wilhelm-Lehmbruck-Museum, Duisburg.

111 OSKAR SCHLEMMER, BAUHAUS STAIRCASE. 1932. Oil on canvas. 161.9 × 113.7 cm. Museum of Modern Art, New York.

112 FERNAND LÉGER, THREE MUSICIANS. 1930. Oil on canvas. 117 × 112 cm. Von der Heydt Museum, Wuppertal.

113 HENRI MATISSE, THE DREAM. 1935. Oil on canvas. 80 × 65 cm. Pierre Matisse Gallery, New York.

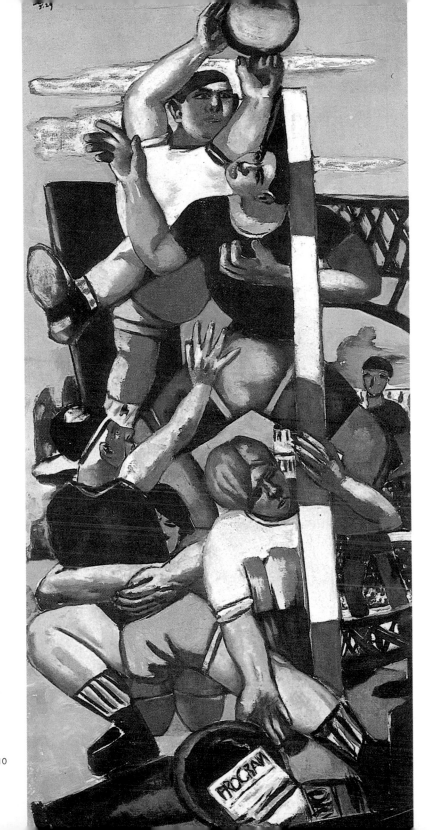

had accepted Breton's invitation to move from Cologne to Paris in 1922. Like Breton, Ernst had studied philosophy and psychopathology. He saw collage as "the exploration of little-known fringe realms of thought by means of irrational methods. Among these is the systematic coupling together of two realities that appear unsuited to each other, on a plane that is apparently foreign to them."

The Dadaists had claimed that the idea of resorting to chance—which Hans Arp and Sophie Taeuber had already tried in Zurich in 1915—was an anti-art gesture, capable of unmasking the lie of bourgeois traditions of art. With Ernst it became a means of revealing unconscious psychic stresses. Its function was therefore changed to fit in with an individual psychological interpretation. Collage, which Ernst began to develop in this direction in 1918, was complemented in 1925 by *frottage* ("rubbing") a graphic technique that enables the painter to "compel inspiration," in the sense of Breton's demand. Materials with rough surfaces, such as unplaned planks, bits of bark, leaves, or even nails and other objects, are placed beneath a sheet of drawing paper and the artist then rubs over the surface with the broad side of a pencil lead. If a canvas covered with dry paint and a steel wire brush are used instead of paper and pencil, it becomes a *grattage* ("scraping"). In the same way that Leonardo could pick out a battle scene in the patches of damp on an old wall, Ernst discovered shapes in the raised pattern left by the materials he had put under the paper. These shapes often suggest childhood experiences long forgotten, as for instance the forest of birds, beaks, and round eye produced by the graining around a knot in a lump of wood (*117*).

"Forcing inspiration" by these unconventional methods seemed to Ernst to be only one step in the process of creating an image, which the artist could then refine or adjust in a thoroughly conscious way. He thought the same of the technique known as dripping, which he invented in America during World War II. In this he differed from Jackson Pollock (*150*), who took up the technique but treated it as a self-sufficient means of expression. Meanwhile, the question of whether pictures could be painted "purely automatically"—with *l'écriture automatique* writers had already produced some interesting texts—provoked a blazing controversy, which eventually involved the question of whether such a thing as Surrealist painting was possible. André Masson's scribblings, which seemed to be nothing more than an outpouring of impulses that had not yet jelled into pictures, pointed the way to a nonrepresentational, Surrealist style of painting. For a long time Masson (b. 1896) was the only artist to follow this new direction, though his friend Joan Miró did come part of the way with him. The first painter to follow his example was Pollock (1912–56), whom he met in New York in 1942, as did Ernst. Masson himself did not stick rigidly to expressing himself in nonpictorial terms, but succumbed to the literary temptation of revealing and illustrating the impulses of the unconscious mind. This led him to mythological themes expressing archetypal states (*118*). Masson's very profilic output influenced and inspired a large number of artists, perhaps even more than that of Ernst, which was deeply rooted in the fantasy world of Romanticism.

But Masson's work shows that the pictorial concept given to Surrealist artists by the movement's theoreticians did not always fit what they produced.

Metamorphosis

Klee saw dreams as a way of experiencing mobility and changeability of form rather than as a path to self-knowledge. "Form is less important than formation," he said. An examination of metamorphosis—the process of transformation that form constantly undergoes—led him to analyze, the "pictorial means" of dots, lines, surfaces, and colors in the work he produced immediately after the war and in his teaching at the Bauhaus. He came to believe that only the combined use of these means could enable painters to find similes for the universal phenomenon of formation that allows the picture to become a pictorial symbol of the world. Klee did not express this genesis in the distant realms of dramatic cosmogonies; rather, he revealed it in the most trivial incidents, in both natural and manmade objects, between which it spins a web of fluid interrelationships (*119*). The pictorial expression of this cosmic simultaneity followed directly from the Cubists' and the Orphists' break with the conventional idea of a staple object encased in a self-contained form.

Klee's experiments with systematic modifications of a system of forms and colors (begun in 1921) were also based on the idea of transparency, of opening form to let in the surrounding space, and of mobility of the color. These experiments, which can be counted as the first instances of serial art, had a considerable influence on the teaching system at the Bauhaus. Klee's idea was to see how far a form or color could be modified before it lost its identity and became a new form or color.

The themes of genesis and metamorphosis also underlie the work of Joan Miró (b. 1893) and Jean (Hans) Arp (1887–1966). With them the organic metaphor that links very different areas of the formal world in a loose but compelling relationship replaces the assemblage, which held an equally important role in the work of de Chirico or Schlemmer, and in Dada and Cubist sculpture (*44–52*). In Miro's nude (*120*) the body is represented by a fish, the breasts by a yellow pear and a bright red round orange, the genitals by a green leaf. The head with its single eye is a white oval casting a green shadow, and a fluttering brown curtain indicates hair. The dotted lines that mark out the basic structure do not link together the individual floating elements that make up the figure; each maintains its independence as a poetic symbol that acts on the viewer's imagination and sensuality.

114 MARC CHAGALL, THE VILLAGE AND I. 1911. Oil and canvas. 191.2 × 150.5 cm. Museum of Modern Art, New York.

115 GIORGIO DE CHIRICO, SECRET AND MELANCHOLY OF A STREET. 1914. Oil on canvas. 87 × 71 cm. Private collection, Washington, D.C.

116 YVES TANGUY, LA TOILETTE DE L'AIR. 1937. Oil on canvas. 99 × 80 cm. Niedersächsische Landesgalerie, Hanover.

117 MAX ERNST, BIRD MONUMENT. 1927. Oil on canvas (grattage). 81 × 65 cm. Private collection, Neuss, West Germany.

118 ANDRÉ MASSON, MADAME L. C. 1943. Private collection.

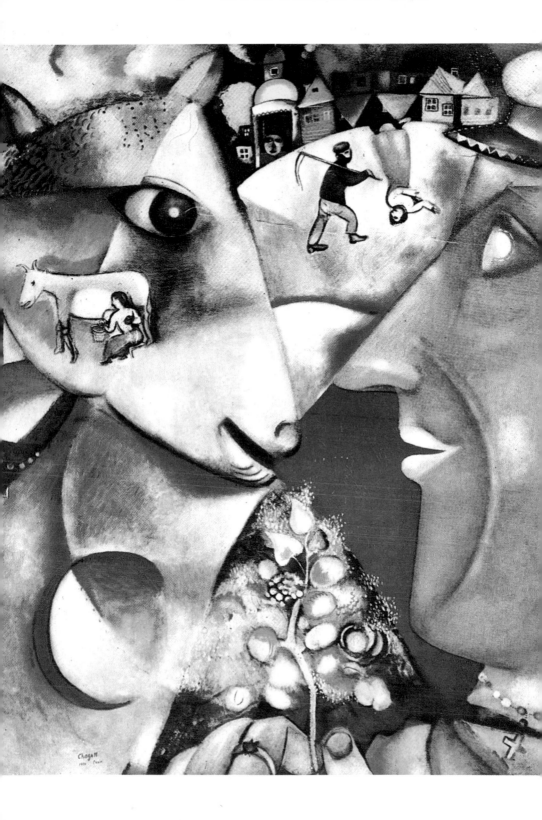

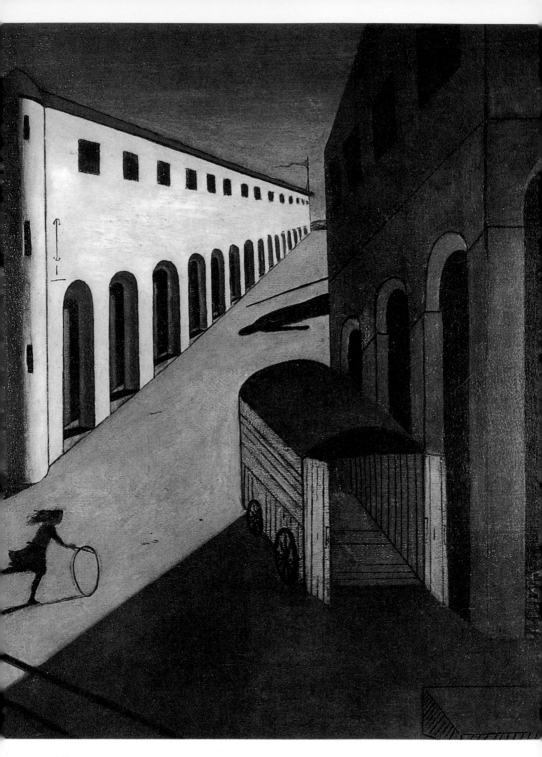

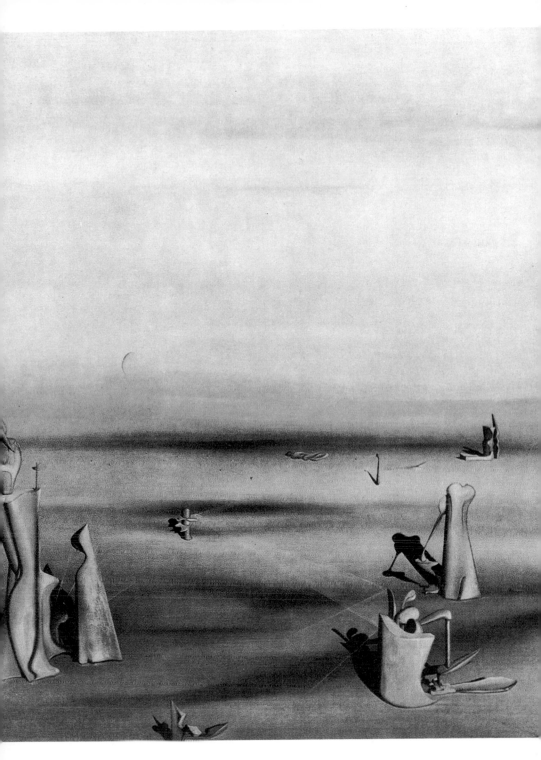

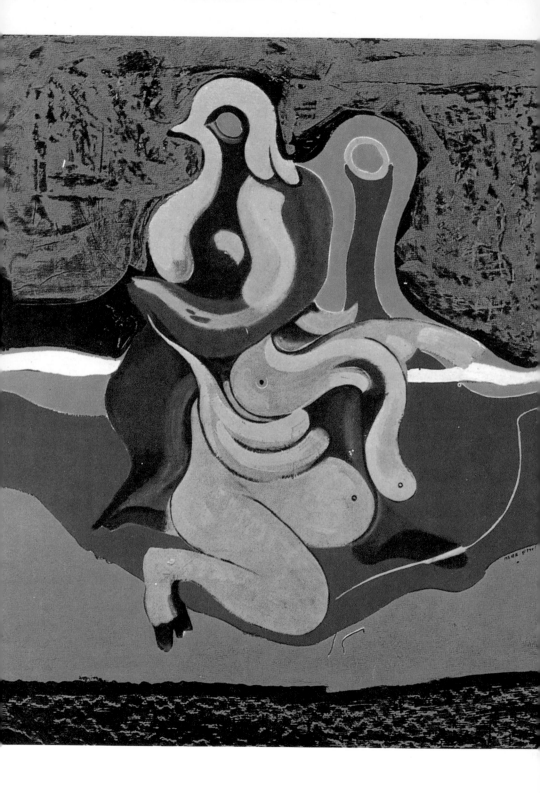

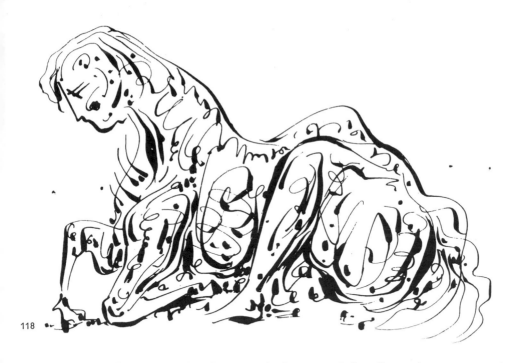

118

Arp, too, puts formation before form. But he interprets it literally, as the *concrétion* of material producing a formal structure whose momentary constellation stimulates the imagination. This allows the imagination to experience the ongoing, self-creating process of nature. Like Klee and Miró, Arp places considerable emphasis on humor, which helps the artist invent "plays on form," analogous to the poet's plays on words. Through this kind of double meaning, these plays on form, he can reveal relationships that would otherwise remain hidden—and which are sometimes positively uncanny (*121*).

So all three artists interpreted simultaneity as a mobility of form that throws doubt on the permanence of individual objects—trees, clouds, fish, stones, or people—and on the existence of separate kingdoms within nature as arbitrarily classified by the working mind. In paintings this mobility is expressed in the unstable relationships generated by the lack of a decisive difference in density between the form and the pictorial ground. The abolition of the force of gravity in Arp's and Miro's dream art brings it close to contemporary abstract painting, with which Klee's very complex work already had links (*75*).

Geometric Abstraction

After 1930, mobility and floating were again the leitmotifs of nonrepresentational painting, even more so than in the 1920s, in fact. Thanks to his regular contact with Klee at the Bauhaus over a period of several years (1922–30), Kandinsky's expressionism, which had already been toned down by Suprematist influences (*75*), mellowed completely. The last picture he painted in Berlin before moving to Paris, *Development in Brown* (*123*), does admittedly contain the clashing themes of hope and menace. But the subtle way in which the transparent colors are modulated and the varied rhythmic

distribution of geometric areas on the surface sublimate the somber drama of the age (the rise of the Brownshirts) to create a majestically rounded harmony.

The road along which Alberto Magnelli (1888–1971) traveled on his way to abstract art was rather more complex. Starting out from the "lyrical explosions" of the war years, he then took a long detour via "poetic realism" (which led all Italian painting astray at this point). Returning to nonfigurative work in the 1930s, he began to pick out abstract structures from quarry stones discovered in Carrara (*Stones, 1932–34*), and over the years he developed this idea into monumental compositions full of strength and gaiety (*124*). Although Magnelli was quite economical in his use of form and color, when compared to the work Mondrian produced in the same years he seems almost baroque in his extravagance. Mondrian was in fact trying at that time to reduce the number of pictorial components to the absolute minimum. All that is left in the picture he proposed for the town hall in Hilversum (*125*) is a single asymmetrical black cross, with no sign of color. Since this cross is set within a square poised on one of its corner, it does not stiffen into a static schema but enters into an active relationship with the surrounding space beyond the edge of the painting. The painting hangs diagonally and does not sit firmly in its frame like a self-contained world. Instead it is merely a little piece of the flexible grid that symbolizes the world for Mondrian.

Other painters allowed certain elements of their paintings to jut out three-dimensionally from the surface—perhaps flat or up-ended areas or rods floating in space. The painting thus becomes a sort of painted relief, which can change drastically according to where the spectator stands and the angle of incidence of the light that these elements actually seem to move. The Englishman Ben Nicholson (b. 1894), for instance, who was influenced by Neo-Plasticism, uses narrow strips of shadow to create a fluid interrelationship between various different pictorial planes (*126*). Nicholson did not interpret the relief as the germ of an overall design, as the Neo-Plasticists did. He therefore makes no attempt to let this mobility radiate out beyond its borders. By contrast, it is just this type of radiation that Delaunay uses for developing his *Infinite Rhythms* (*122*). Some of his treatments of the theme are reliefs in which light plays "realistically" around forms and colors. But neither the origin of this expanding motif nor the effect it creates have anything to do with the gliding geometry of Neo-Plasticism. Rather, they go back to the moment in 1912 when Delaunay became convinced that "seeing is movement" and that space is a field of force against which

119 PAUL KLEE, FLOWER FACE. 1922. Watercolor. 35 × 22 cm. Edgar Kaufmann Collection, New York.
120 JOAN MIRÓ, NUDE. 1926. Oil on canvas. 92 × 73 cm. Arensberg Collection, Philadelphia Museum of Art.
121 JEAN (HANS) ARP, HEAD. 1929. Formerly in the collection of André Breton, Paris.
122 ROBERT DELAUNAY, RHYTHMUS. 1934. Oil on canvas. 146 × 145 cm. Musée National d'Art Moderne, Paris.
123 VASSILY KANDINSKY, DEVELOPMENT IN BROWN. 1933. Oil in canvas. Musée National d'Art Moderne, Paris.
124 ALBERTO MAGNELLI, ACCORDS ALTERNÉS. 1937. Oil on canvas. 97 × 146 cm. Private collection, Paris.

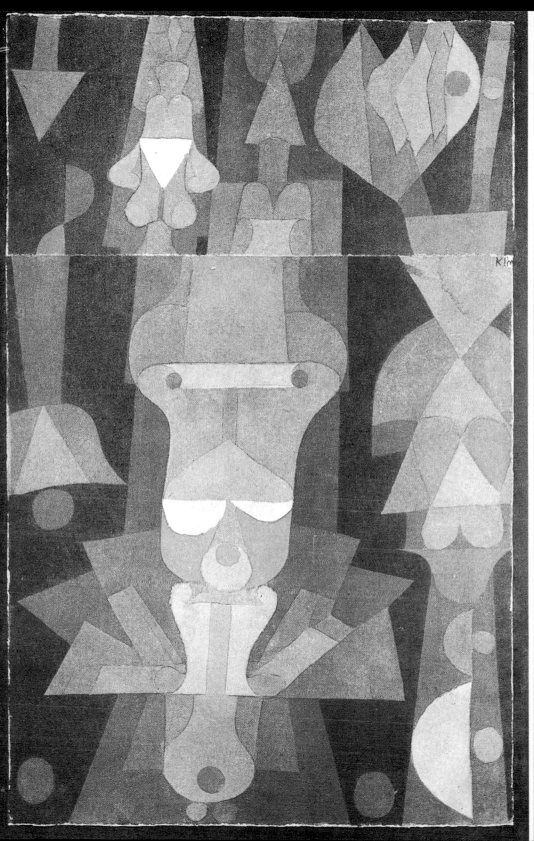

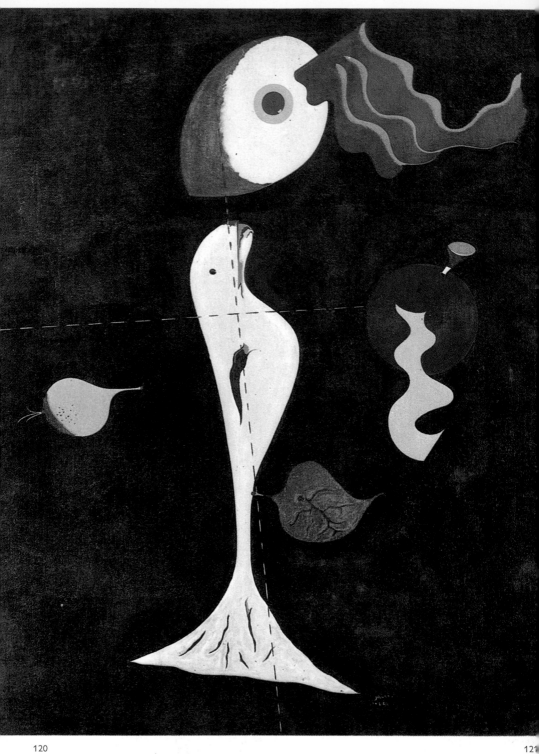

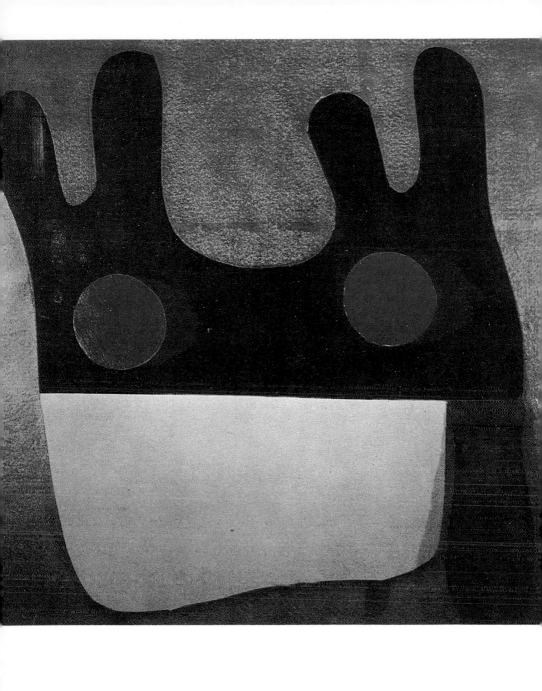

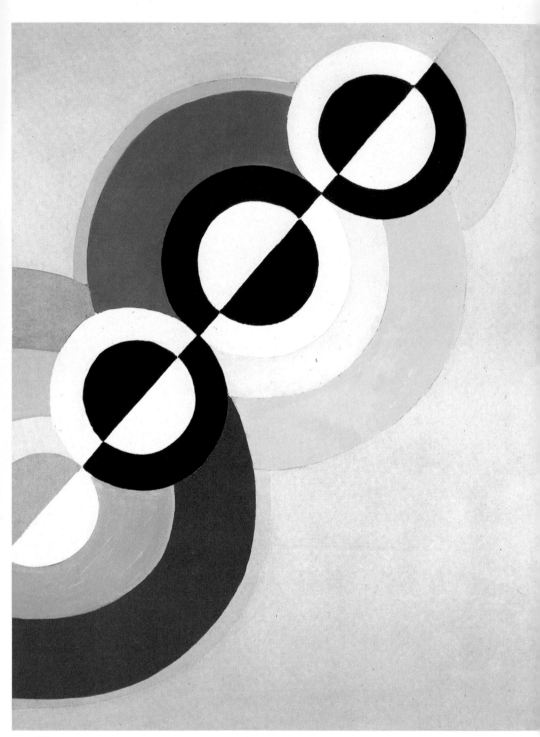

△ 123

▽ 124

125 PIET MONDRIAN, COMPOSITION WITH TWO
LINES. 1931. Oil on canvas. Stedelijk Museum,
Amsterdam.
126 BEN NICHOLSON, WHITE RELIEF. 1938. Oil and
pencil on wood relief. Tate Gallery, London.
127 FRANTIŠEK KUPKA, ABSTRACTION. Gouache.
Musée National d'Art Moderne, Paris.
128 NAUM GABO, MONUMENT FOR AN INSTITUTE
OF MATHEMATICS AND PHYSICS. 1925. Bronze.
Height, 61 cm. Presents whereabouts un-
known.
129 JULIO GONZALEZ, STANDING MAN, CALLED
GOTHIC. 1937. Bronze. Height, 57 cm. Col-
lection of Hans Hartung, Paris.
130 CONSTANTIN BRANCUSI, BIRD IN SPACE. 1925.
Height, 134 cm. Kunsthaus, Zurich.

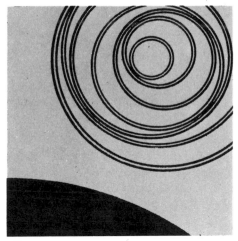

127

light breaks to reveal the wealth of colors within it (*32*). The vibrating effect created
by the propeller motif that is built up step by step in the *Infinite Rhythms* series is
produced solely by the use of color. The propeller theme itself is a derivation of
Delaunay's rotating circles of 1912 and could be seen vibrating in his large Orphic
compositions as early as 1914.

Spatial Sculpture

"Modern painting has come down off the wall," announced Le Corbusier in 1921.
In view of the Cubist idea of reducing the form of objects to their inner structure,
together with the Suprematists' and Neo-Plasticists' emphasis on basic (geometric)
shapes and the Dadaists' concept of the object as the opposite of the work of art, and
the way they cast doubts on traditional methods of creating art in general, sculptors
had no choice but to reexamine the traditional thought patterns of sculpture. They
felt compelled to accept the painter's appeal to open up their work, thus letting in the
surrounding space, and to remove the force of gravity.

The first of these concepts was soon realized. As early as 1913 Picasso had allowed
reliefs to escape from the frame (*12*). Then in 1917 Tatlin had removed them from the
wall by hanging them in a corner of the room. But when Rodchenko hung a kind
of armillary sphere from the ceiling, instead of mounting it in the usual way on a disc
or a stand—this was in 1920—three-dimensional sculpture abandoned its traditional
place on a pedestal, just as paintings and reliefs had earlier left the wall. So gravity
had also been "overcome."

This step was to have momentous consequences. The point is that it was not enough
to eliminate mass visually; the sculptor also had actually to reduce the specific gravity
of the construction to a minimum. And, in particular, he had to calculate the con-
struction itself with the greatest precision: He could no longer follow the stance,
based on the human body, that had guided sculptors for centuries. Instead he had to
develop a feeling for the way static forces work together, rather as the engineer does.

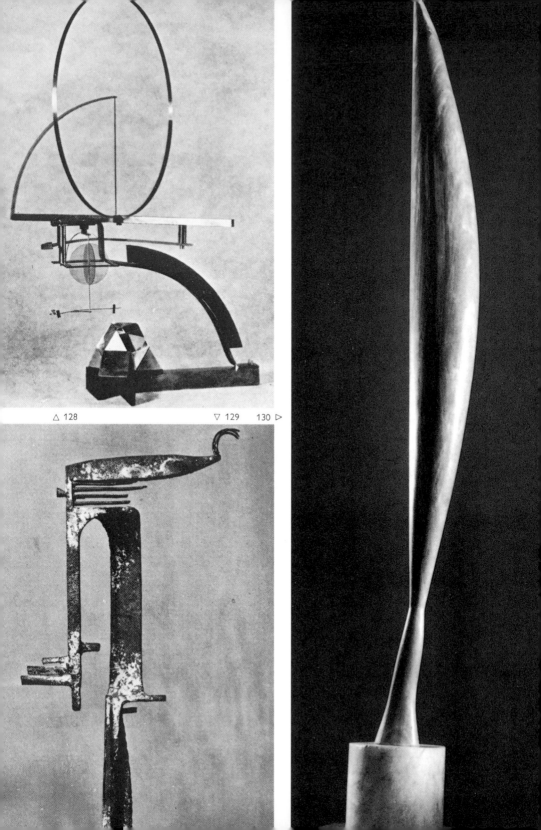

△ 128 ▽ 129 130 ▷

That is why Moholy-Nagy, when he began teaching at the Bauhaus in 1923, gave priority to exercises in statics involving airy wood and metal constructions. A year earlier he had tackled the problem of "floating sculpture" in his manifesto *A Dynamic-Constructive System of Forces.*

Naum Gabo (b. 1890), who was himself a qualified engineer, and his brother Antoine Pevsner (1886–1962) had already defined the methods used by modern sculpture in a theoretical statement made in 1920 (*Realist Manifesto*):

> Every engineer knows that the static forces of bodies and their material stability have nothing to do with mass. Examples are: an iron hoop, a crossbeam, a plinth. But you sculptors, of whatever school and whatever hue, cling to the centuries-old prejudice that volume cannot be made independent of mass. But look here: we produce the same volume out of four surfaces as you can produce with a mass weighing a hundred kilos. We thus give sculpture back the line as a "direction." We thus stand by depth as the only three-dimensional form of space.

Line as "direction," space as "depth" that cannot be subdivided into "masses" but is made up of a single field of forces or "directions"—these themes are closely related to the ones that Klee was adopting at about this time as a result of his analysis of "pictorial means." But although Gabo and Pevsner rejected the anti-art attitude of the Constructivists, with whom they had been on very bad terms until they left Russia, they placed the emphasis fairly and squarely on the objective and constructive aspect: "Plumb line in hand, our gaze as straight as a ruler, our mind as inflexible as a pair of compasses, we (realistic artists) construct our work. In the same way that the cosmos constructs its work, the engineer constructs his bridge, or a mathematician constructs his formulas." There was no room left for the impressions and intuitions of traditional art as individualistic. Rather, technological, scientific, and collective thought, in the hands of the modern artist, were to annihilate it. The Realists rejected any form of illusionistic or symbolic reinterpretation of materials. They claimed that the choice of these materials—steel and glass—and the method used to work them—polishing, chroming, and mounting, with the precision of scientific instruments— made the connection between technological and scientific progress on the one hand and sculpture's annihilation of mass and conquest of space on the other abundantly clear.

There is no trace of this optimism in the ghostly figures welded together out of scrap iron by the Spanish sculptor Julio González (1876–1942). The earliest date from 1930, and he continued making them for the last twelve years of his life. Lipchitz's *Seated Figure (51)* and even Picasso's loosely assembled *Seated Figure on the Seashore (53)* were still hewn out of the mass, whereas González's *Standing Man, Called Gothic (129)* is like a symbol flung freely into space, virtually a recorded gesture. "To draw in space" was also the ambition of the painter, who had until then been groping about uncertainly. Here the element of chance in the material the artist is using also plays a role, as though in his haste to make his gesture he had grabbed everything he could lay his hands on, so as to grasp this symbol before it faded before his inner eye. Once again space is pure "depth," line is a straight "direction," and the material

is unadulterated "reality." But intuition, gesture, and signature replace the rational and constructive element on which the "Realists" Gabo and Pevsner placed so much emphasis.

For Brancusi, however, there was no question of breaking up volume (*104*). According to him, sculptors should concentrate volume to such an extent that it is no longer experienced as a solid body thrusting space aside, but as a compressed movement communicating itself to space. For instance, *Bird in Space* (*130*) does not depict a bird or its trajectory as a structural alteration of space that has already occurred. The headlong yet gentle upward movement of the spindly, almost linear form breaks up the vibration of the whole structure of the space in exactly the same way as the bird did when it took off. The anatomical reality called "bird" has completely disappeared. But this does not mean that Brancusi believes that form can undergo a metamorphosis. He interprets it as "being," not as "becoming," and his aim in completely eliminating any inessential factors is to make this state of "being" unchangeable, even eternal.

Movement II

With his almost classical view of the unity of being and form, Brancusi is pretty much alone among the pioneers of modern sculpture. But the abolition of the force of gravity was closely followed by the abolition of the stability of bodies. It was not just that the Constructivists kept on returning to the theme of "real" movement that Boccioni had introduced in his theoretical statements of 1914. Tatlin's semimobile tower (*88*) was followed by a whole series of mechanically propelled constructions, leading up to Moholy-Nagy's *Light-Space Modulator,* which was exhibited in 1930. But the main aim of current theories relating to the genesis of form (succinctly summarized by Klee's "form is less important than formation") was to express the substantial link between form and movement in three-dimensional terms. For instance, in Gabo's *Virtual Kinetic Volume* (1920), the volume is created purely visually, by the rotating movement of a flexible piece of steel wire. But the idea of changeable and mobile form could also be suggested without dematerializing the volume. The fluctuating nature of the interrelationships between shapes that appear to be complete within themselves reveals their ambiguity. That is why Arp does not precisely define the relationships between the individual moving components of some of his "configurations" (*133*). He leaves the

131 ALBERTO GIACOMETTI, SUSPENDED SPHERE. 1930–31. Plaster and metal. 61 × 36 × 33.5 cm. Giacometti Foundation, Kunstmuseum, Basel.

132 ALEXANDER CALDER, THE MOTORIZED MOBILE (which interested Marcel Duchamp). 1932. Wood, iron wire, string, metal. Height, 105 cm. Collection of the artist, Saché.

133 JEAN ARP, TO BE EXPOSED IN THE WOODS. 1932. Bronze sculpture in three forms. Collection of Madame M. Arp-Hagenbach, Meudon.

134 NAUM GABO, CONSTRUCTION ON ONE PLANE. 1937. 48 × 48 cm. Solomon R. Guggenheim Museum, New York.

135 ANTOINE PEVSNER, SURFACE DÉVELOPPABLE. 1938. Oxidized copper. Peggy Guggenheim Foundation, Venice.

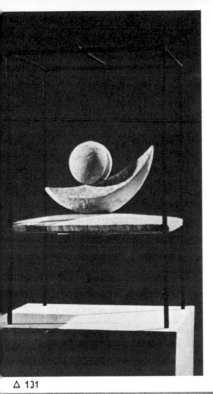

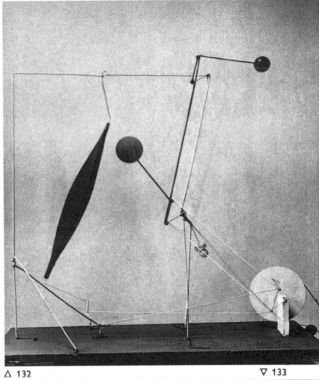

△ 131 △ 132 ▽ 133

viewer to do it for himself, thus forcing him out of his usually passive attitude. By interpolating a partner in the creative process who is completely independent of him —which thus adds the element of chance—he intends not merely to separate the work from its putative creator, the artist, and make it more like an anonymous product of nature; he also banishes the individual form to its place in the infinite chain in which "mother forms" are constantly replaced by "daughter forms." He therefore believes that a form's outer flexibility is indissolubly bound up with its inner mobility.

Suspended Sphere (*131*) by Alberto Giacometti (1901–66) cannot move freely, unlike the shapes in Arp's "configuration": it is trapped in a cagelike structure, which creates a gulf between it and the viewer—who is, as a matter of fact, very tempted to touch the whole structure and set the sphere in motion, though to reach into the forbidden area of the case would constitute a breach of taboo ("Don't touch!"). In addition, the deep cut in the sphere, echoing the sharp edge of the melon-shaped object underneath, creates the impression that the sphere can oscillate only following along· this edge. However, the distance between sphere and edge is too great for the two surfaces to touch, and this contradiction gives rise to the same frustrating tension between a feeling of belonging and a feeling of impossibility that underlies the collages of such an artist as Max Ernst, except that the sexual aspect of this tension is even clearer here.

Not all the experiments with suspended or movable bodies in the 1920s went beyond sculpture altogether, though they did lead in a direction that was diametrically opposed to the traditional concept of sculpture. Movement continued to be treated as a factor that could create volumes or make substances mobile, never as an entity in itself. Alexander Calder (b. 1898) was the first artist to free movement from this link with volume and create a purely kinetic art that is not dependent on sculpture.

The decisive stimulus for Calder's fundamentally anti-plastic view, which encouraged him to evolve a specific language of movement, came from his visit to a painter who totally rejected the idea of defining a substance, or, indeed, any type of form. That painter was Mondrian. The example of Mondrian's abstract mobile grid (*65*), which when slackened or tautened produces patches of color in space that are not linked to any supporting form, showed Calder that it would be possible to use the rhythms he had observed in individuals in a nonrepresentational way to give rhythm to space. He could therefore express the fourth dimension. Yet Calder's abstract *Motorized Mobiles* (*132*) are just as far removed from Kandinsky's or Lissitzky's experiments with abstract scenic plays as they are from Gabo's "virtual kinetic volumes." The moving components do not produce a series of abstract compositions made up of forms and colors any more than they create "virtual" volumes. They are purely and simply "compositions made up of movements," their significance coming solely from their rhythm.

Beyond Euclid

The far-reaching alienation of the sculptor from volume had been caused by the same drastic upheaval in the concept of pictorial space that was reflected in the great change in painting before World War I. For the various hypotheses put forward by Matisse,

the Cubists, Delaunay, Kandinsky, and Mondrian to replace the illusionistic, unifocal, Euclidean perspective space of the Renaissance did have one thing in common: They made it quite impossible to uphold the classical concept of volume. To what extent this upheaval corresponds to the simultaneous change in the ideas about space occurring among natural scientists and mathematicians is less sweepingly answered. Artistic motives were undoubtedly a decisive factor for the artist-pioneers; and certainly Klee's "paths to the study of nature" starts from artistic considerations. His views on "formation" do, it is true, fit in with the findings of modern doctrines of space, but it cannot be said that he applied these findings to the specific problems posed by paintings. Many painters and sculptors, however, such as Juan Gris, van Doesburg, Gabo, and most of those whose work was Constructivist and abstract, thought it imperative that artists who believed in modernity should incorporate into their work the findings of modern physics and mathematics on the dynamic structure of space. In their writings, and even in their choice of titles, they relied specifically on non-Euclidean geometry, on Einstein's theory of relativity, or on topology as a basis for their decision to replace the traditional concept of volume with "space-time" structures. But in fact even these artists did not really look for inspiration in mathematics and physics; what they looked for, and found, was confirmation of their own intuitions, which they attempted to express in an objective and anonymous style that corresponds to the *esprit nouveau* (*128*). Far from merely accepting recorded scientific results, many of these intuitions anticipate later developments, particularly in the field of architecture, in which the relationship between form and space is, of course, a pivotal issue. For instance, the compositions of Gabo and Pevsner, with their distorted planes and knotted-up spatial zones (*134, 135*), can be seen as the first manifestations of a feeling for space that was not realized in architecture until the 1950s and 1960s (*209*). (Twisted planes were already being used in isolation in the 1920s, however, particularly by the French concrete-engineer Eugène Freyssinet [1879–1962].)

136 Pierre Bonnard, At Table. *c*. 1935. Oil on canvas. 67 × 63.5 cm. Musée National d'Art Moderne, Paris.

137 Piet Mondrian, Broadway Boogie-Woogie. 1942–43. Oil on canvas. 127 × 127 cm. Museum of Modern Art, New York.

138 Pablo Picasso, Still Life with Ox Skull. 1942. Oil on canvas. 130 × 97 cm. Kunstsammlung Nordrhein-Westfalen, Düsseldorf.

139 Raoul Dufy, The Red Violin. 1948. Oil on canvas. 38 × 51 cm. Musée d'Art et d'Histoire, Geneva.

140 Nicolas de Staël, Landscape. 1953–54. Oil on canvas. 97 × 146 cm. Moltzau Collection, Oslo.

141 Henri Matisse, Zulma. 1950. Cut-out (gouache on paper). 235 × 145 cm. Statens Museum for Kunst, Copenhagen.

142 Alfred Manessier, Nocturne. 1957. Oil on canvas. 115 × 115 cm. Moltzau Collection, Oslo.

143 Karel Appel, Woman with Ostrich (Donna con Struzzo). 1957. Oil on canvas. Stedelijk Museum, Amsterdam.

144 Friedrich Hundertwasser, Blood-rain Drips into Japanese Water in an Austrian Garden. 1961. Mixed media. 131 × 163 cm. Collection of T. Yamamura, Nishinomiya City.

145 Wols (Wolfgang Schultze), The Birds. 1949. Oil on canvas. 92.2 × 65 cm. De Ménil Collection, Houston, Texas.

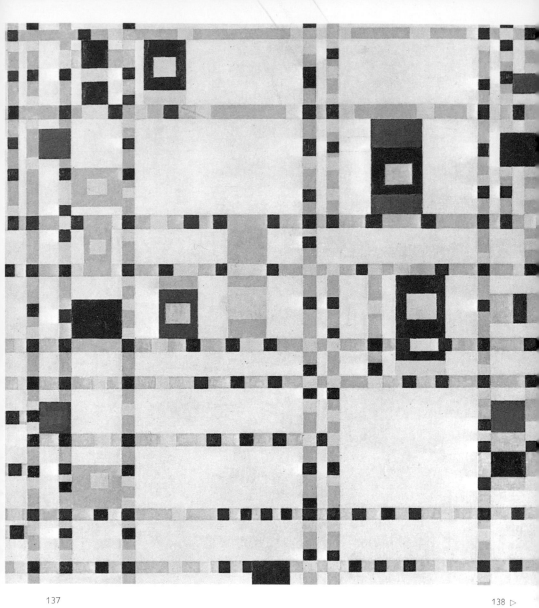

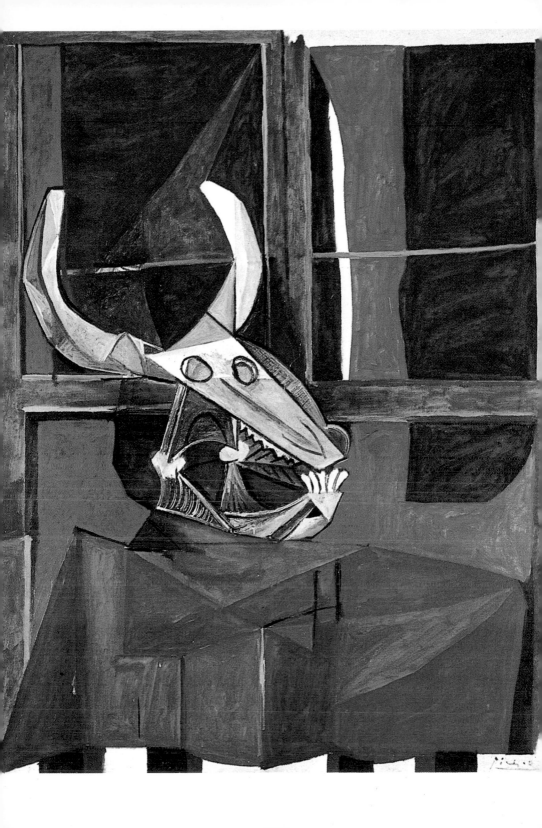

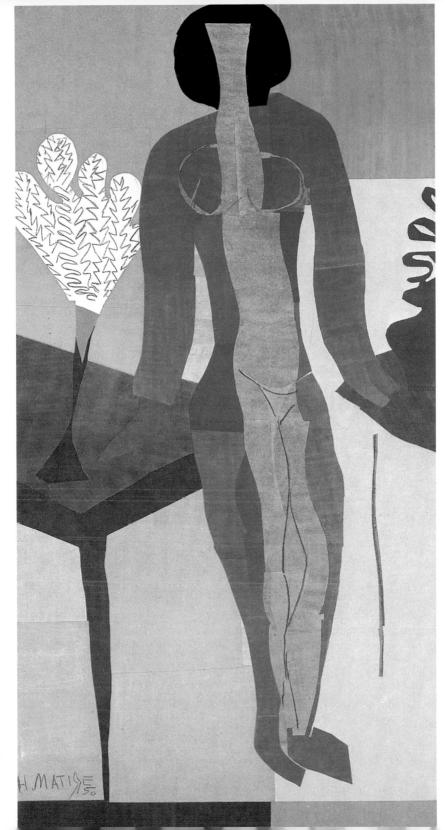

141

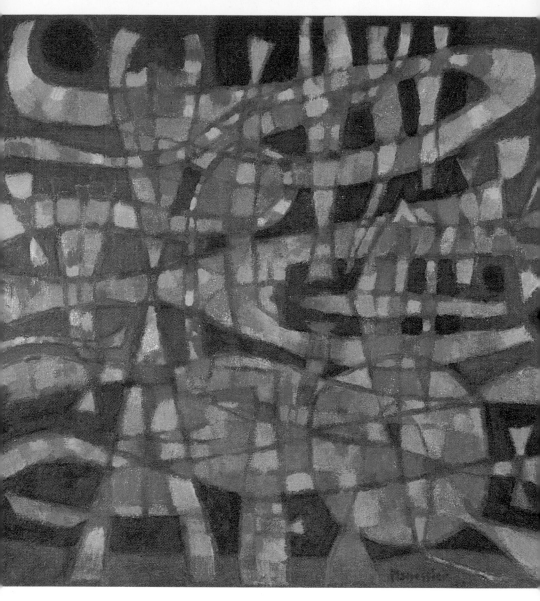

142

143
▷

144
▽

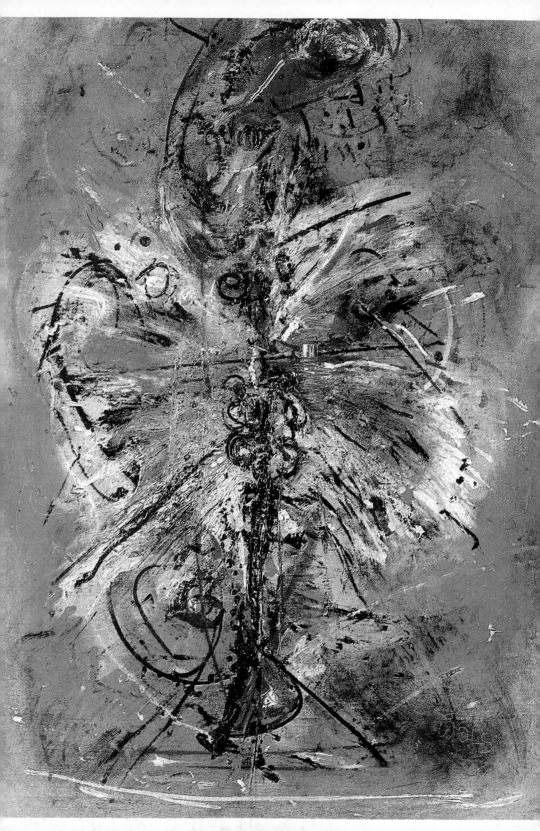

In works of this kind dating from their maturity the two brothers dealt with related themes, though they started out from very different attitudes and went completely separate ways in the creative methods they used. Only Gabo, who actually wrote the *Realist Manifesto*, faithfully reflects their professed belief in the example set by mathematics and physics and in an engineer's attitude toward the problems of form. Pevsner relied more, if anything, on biological examples—organisms germinating and unfolding in the process of growth, birds launching into flight. His questioning of volume in general had nothing to do with involvement in modern science; it arose from the traditional Russian icons. He was particularly interested in the sequence of negative and positive volumes in the facial areas in icons.

As the years went by, Pevsner and Gabo grew further and further apart in their choice and treatment of subtle materials that are difficult to use. Gabo found that Plexiglas, which is both easy to work with and transparent, best fulfilled his need for dematerializing three-dimensional means of expression. Pevsner stuck to bronze, though the treatment he gave it transformed it into a completely new material. By welding one tiny rod to another with infinite patience, he took Klee's and Kandinsky's concept of "formation" quite literally, for twisted planes emerged from the gliding sideways movement of the line. He thus prevented the material from being in any way massive. At the same time, the heat involved in the welding process gave it a rich color reminiscent of the ethereal, precious look of antique gold and silverwork. For both Pevsner and Gabo, technical invention and perfection in execution are at the service of spatial imagination, which intuitively seizes on the essential factors in the scientifically oriented contemporary view of the world and gives them shape.

Late Works and New Beginnings

In the period between 1935 und 1950, some of the artists who launched the great change in the first decade or two of the 20th century again assumed a leading role, some after a longer gap than others. Picasso's new interpretation of Cubist fragmentation of form as a vehicle for tragic Expressionism is quite definitely one of the most important artistic events of this period (*138*). Other instances are Matisse's return to a "hard" treatment of pure color and simplified form, Mondrian's discovery of optical components in his grid designs, and Bonnard's intensified use of analytical color lyricism (*136*). This reawakening of the creative force within artists who were already getting on in years is remarkable enough in itself. When Matisse cut out his larger-than-life-size *Zulma* (*141*), he was already eighty-one and had been seriously ill for years. Mondrian was seventy-one when he painted *Broadway Boogie-Woogie* (*137*); he died the following year. Raoul Dufy (1877–1953) was the same age, and almost paralyzed, when he produced *The Red Violin* (*139*), while it is common knowledge that Picasso's seventh decade was one of his most productive.

But what is even more striking is that these artists did not apparently need to take into account the work of the generations that had succeeded them before stepping back into an active role, though the situation had changed very drastically over a

quarter of a century. For instance Dufy moved on to "tonal" painting, so-called because the picture is dominated by a single color that has been purified until it is highly luminous. He leaves certain areas of the painting white to give the greatest possible intensity to this luminous tone. And so the Fauve generation's longing for immediacy of expression coupled with "pure" painting is fulfilled in the most detached way possible. It is only a short step to the work of Nicolas de Staël (1914–55), who was almost forty years younger. His compositions are based solely on the harmony of color intensities and are among the most characteristic manifestations of the art of the 1950s (140).

In the work he produced at the end of his life Matisse controlled his style even more strictly than Dufy. He readily accepted the limitations imposed on him by the technique known as *gouache découpée* (cut-outs) and in fact this constraint helped him to rediscover the concentration he had achieved in the decade between 1907 and 1917. The decorative and synthetic aim underlying his *Zulma* brings it very close to *Le Luxe* of forty-three years earlier (8). But in its transposition of form, its harsh lines and color contrasts (which Matisse heightens even further, as Dufy does in *The Red Violin,* by including large areas of white ground), it speaks the language of another era—not that of the 1950s, which had barely begun, but of the even more distant 1960s. Pop art and Hard Edge made use of an almost discordant color scale and a posterlike simplification of form, derived to a fairly considerable extent from Matisse's daring color harmonies and his concise, constructive line. Even the use of the thin, matte acrylic colors that were beginning to be produced chemically in the 1950s appears to have resulted from painters wanting to imitate the "cool glow" of paint as applied by Matisse.

At the age of seventy, Pierre Bonnard (1867–1947), too, found that remaining faithful to himself was the best way to make his style topical. He had always transposed subtly modulated paint, applied rather flakily, in a very imaginative way, and distorted the structure of space by his choice of surprising angles and his unobtrusive but distinctly alienating way of modifying aerial perspective. This slows down the process of reading the painting—the antithesis of Matisse's interest in creating pictures that are immediately legible—and had been the most important feature of the subtle and intimate poetry of the formerly "Japan-mad" Bonnard. But in the 1930s color became so intense that it threatened to burst open the pictorial structure completely—though it had in fact been loosened up many years before (136). Purely topological links are now established between one object and another. The painter doesn't arrange (or "compose") a "still life on a table"; rather, he records pictorially the emotions aroused in him by each individual object and thus contents himself with the poet Arthur Rimbaud's idea of offering a lyrical inventory of objects. Rimbaud had contrasted this

146 JEAN DUBUFFET, THE WISE MAN WITH THE ELEGANT NOSE. 1951. Galleria del Naviglio, Milan.

144

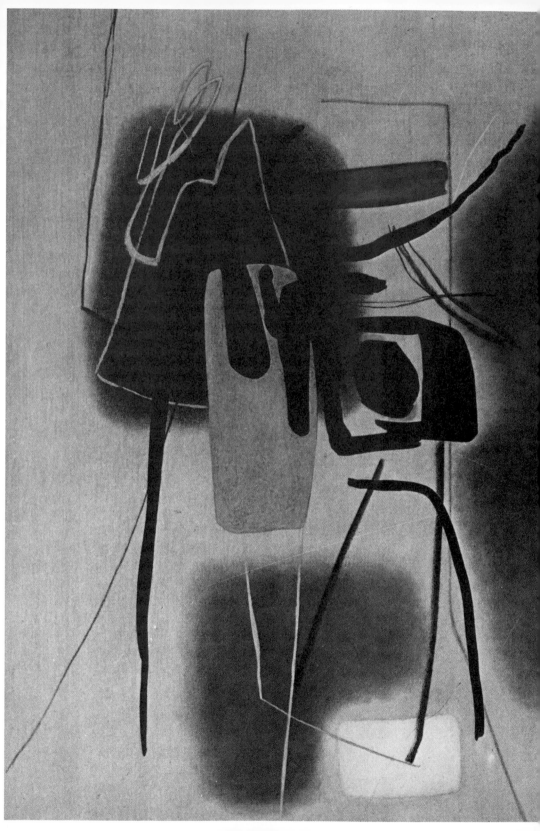

147 Hans Hartung, T 1936–2. 1936. Oil on canvas. 171 × 115 cm. Collection of the artist, Paris.
148 Paul Klee, Over and Up. 1931. Pen and ink on paper. Klee Bequest, Kunstmuseum, Berne.

148

with rebuilding the world in a discursive way, and it had also inspired the collages of words and images created by artists ranging from Apollinaire to Schwitters.

This process of listing the components of the real world led, by way of the poet Jacques Prévert's grotesquely absurd "inventories," to the idea of accumulating objects that have no logical connection between them. But Bonnard knew nothing of the meaninglessness of the world that the New Realists of the 1960s wanted to reveal (see page 187). He could only marvel at the splendor that lies hidden in even the humblest objects and express his sense of wonder by his ingenuous use of "painting's most innate tool"—color.

Mondrian and Bonnard are of course basically poles apart; in Mondrian's last paintings, however, the color is also so dynamic that it becomes the sole decisive factor. The spatial structure thus undergoes a profound change, since the rhythmic brilliance of the little patches of color into which the bars are broken up introduces a staccato feeling (137). This contrasts vividly with the restrained gliding movement of the grid-pattern on the picture plane that is the hallmark of his earlier work.

In 1942, exactly two years before his death, Mondrian subdivided his grid, which had long been uniformly black, into three interwoven networks restricted to the three primary colors, blue, red, and yellow. However, the impact of two colored lines meeting threatens to create the impression of a third (complementary) color at the point of intersection. To counteract this reading Mondrian introduces another primary

47

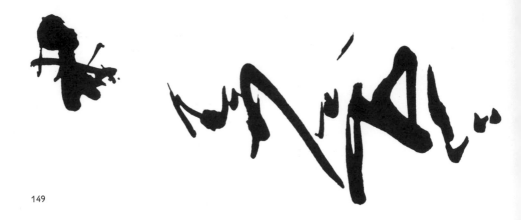

149

color at the intersections in the form of a small square. He therefore also over-comes the bar/spot ambiguity. The lines are seen as immaterial tracks with bright spots moving along them.

Paintings in which this change begins to occur (*Trafalgar Square; Place de la Concorde; New York*), or is completed (*Broadway Boogie-Woogie, 137*), make it clear that his increased use of optical components marks a turning point in Mondrian's art. But whether this can be interpreted as a move away from a quarter-century of uncompromising abstraction and a return to an empirical art with a message must remain an open question. We cannot definitely say, however, that Mondrian eventually abandoned his Neo-Plastic view of paintings as symbols of the structure of the world in favor of a purely "concrete" approach. There is no doubt, however, that these last paintings paved the way for the tendency in the following decades to "secularize" abstract art (that is, divorce it from theory or ideology) by increasingly concentrating on the visual element.

The cheerful work that Mondrian, Matisse, Dufy, and Bonnard painted at the end of their lives contains no hint of the anguish of old age or of the times. With Picasso, however, even before the outbreak of the Spanish Civil War, which was what first turned him into a politically committed artist, a piercing awareness of the tragedy of human existence breaks through. This awareness had, in fact, been a feature of his

149 K. R. H. SONDERBORG, UNTITLED. (Hamburg, 3. 10. 51.) India ink. 10.5 × 14.7 cm. In the artist's possession.

150 JACKSON POLLOCK, PAINTING. 1948. Oil on paper. 57.3 × 78.1 cm. Galerie P. Facchetti, Paris.

151 MORRIS LOUIS, GAMMA GAMMA. 1959–60. Acrylic on canvas. 255 × 380 cm. Kunst-sammlung Nordrhein-Westfalen, Düsseldorf.

152 MARK ROTHKO, EARTH AND GREEN. 1955. Oil on canvas. 230 × 187 cm. Ben Heller Collection, New York.

153 LUCIO FONTANA, SPATIAL CONCEPT. 1960. Oil on canvas. 80 × 100 cm. Ludwig Collection, Wallraf-Richartz-Museum, Cologne.

154 YVES KLEIN, MONOCHROME M 14, RED. 1957. Paper on cardboard. 27.5 × 44 cm. Collection of Mme Rotraut Klein-Moquay, Paris.

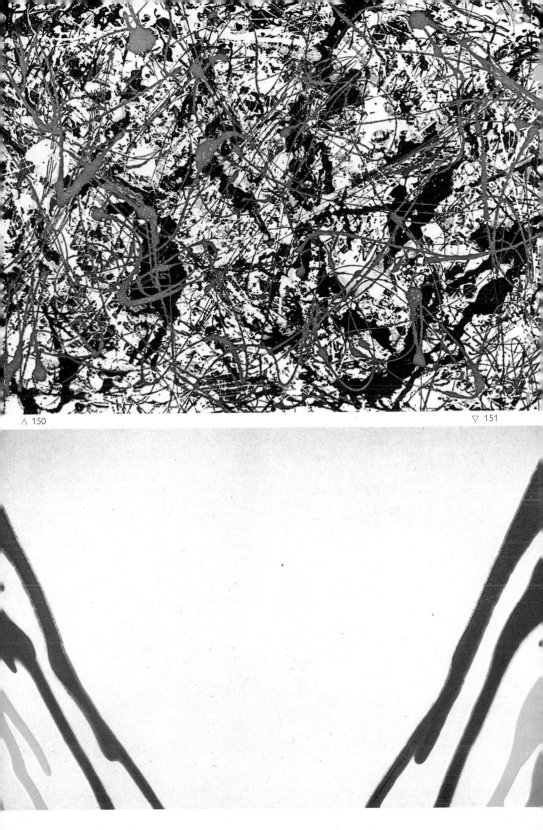

△ 150

▽ 151

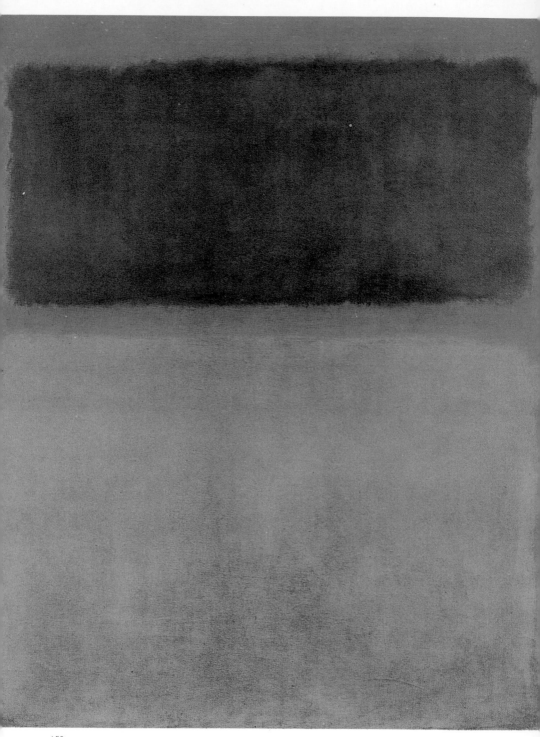

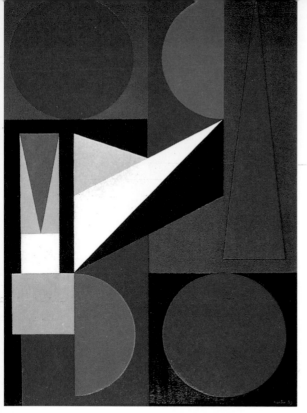

△ 155 156 ▷

155 Auguste Herbin, Laughter. 1959. Oil on canvas. 92 × 73 cm. Galerie Denise René, Paris.

156 Max Bill, 2 Color Groups with Dark-Square Excentrum. 1956. 100 × 100 cm. Artist's collection, Zurich.

157 Josef Albers, To Monte Alban. 1942. Zincograph. 60 × 49 cm. From the *Graphic Tectonic* series, printed in 1967.

157

early work, although the mischievous dialectics of Cubism, Neoclassicism, and Surrealism, which he had revered in the 1920s, did not express it clearly. All the same, two of the ideas he pursued at that time turned out to be particularly fruitful.

One of these was his "metamorphoses" of the human figure, as this tendency is called. His idea was not to explore new possibilities within the living form, as Klee, Miró, or Arp did, but to pinpoint the place where this form fragments (53). The other was a series of experiments in which he reintroduced movement into the rather unflexible system of stratified spatial planes. These experiments can be traced back by way of his "mirror" pictures of 1932 to *The Milliner's Studio* (1926). In this painting a network of strongly projecting curves intercepts the planes, which project and recede alternately, producing strong color contrasts. In his *Guernica* period (1937) he did admittedly chop up the harmonious lines of the arabesque, linking the opened-up areas on the surface even more closely by a series of aggressively slanting or jerkily crooked lines. The violent distortions are reminiscent of the metamorphoses he created in his so-called Surrealist period.

In the work of Picasso's old age his gloomy Expressionist note gives way to a Dionysian hymn to life, work, sex, and peace that is endlessly repeated. This late work has had a very slight influence on younger artists.

Lyricism and *Art Informel*

In the first decade after World War II the abstract wave rolled onward with such might that only a few artists such as René Magritte (1898–1967) or Léger, whose relatively figurative style was firmly rooted in a rich fund of personal experience,

153

158

158 VICTOR VASARÉLY, ERIDAN C. 1963. Oil on canvas. Galerie Denise René, Paris.

159 ALEXANDER CALDER, SUMAC IV, RED. 1953. Mobile; sheet steel and steel wire. Sprengel Collection, Hanover.

160 MARCEL DUCHAMP, ROTORELIEF NR. 1. CO-ROLLAS. 1935. Cardboard. Diameter, 20 cm. Private collection.

161 VICTOR VASARÉLY, ENCELADE. 1956–59. Artist's collection.

162 HEINZ MACK, ROTORELIEF. 1967. Aluminum. Galerie Denise René, Paris.

163 FRANÇOIS MORELLET, WOVEN SPHERE. 1962. Stainless steel. Galerie Denise René, Paris.

164 ALEXANDER CALDER, HEADS AND TAIL. 1965. Stabile, 550 cm. Nationalgalerie, Berlin.

165 DAVID SMITH, CUBI XVII. 1963. Stainless steel. 273.7 × 163.5 cm. McDermott Fund, Museum of Fine Arts, Dallas, Texas.

166 DON JUDD, UNTITLED. 1965. Sheet iron. 437 × 102 × 79 cm. Locksley Shea Gallery, Minneapolis, Minnesota.

167 MATHIAS GOERITZ, FIVE TOWERS FOR A SATELLITE TOWN IN MEXICO. Highest point, 59 meters.

168 CÉSAR, COMPRESSION. 1960. 153 × 73 × 65 cm. Musée National d'Art Moderne, Paris.

169 ZOLTÁN KÉMENY, METALLO-MAGIC. 1963. Brass. 137 × 95 cm. Kémeny Bequest, Musée d'Art Moderne, Paris.

170 JEAN TINGUELY, THE ELECTRO-IRONIC BRAIN. 1960. Iron. 80 × 144 × 55 cm. Staatsgalerie, Stuttgart.

171 GERMAINE RICHIER, THE ANT. 1953. Bronze. 100 × 108 × 60 cm. Galerie Creuzevault, Paris.

172 OSSIP ZADKINE, THE RUINED CITY (Memorial for Rotterdam). 1951–53. Bronze. Height, 6.5 meters. View taken from Leuveshuis in southwestern Rotterdam.

173 ALBERT GIACOMETTI, CITY SQUARE. 1948. Bronze. 21 × 63.5 × 44 cm. E. Hoffmann Bequest, Kunstmuseum, Basel.

174 KENNETH ARMITAGE, STANDING GROUP 2. 1952. Bronze. Height, 104.5 cm. Bertha Schaefer Gallery, New York.

175 FRITZ WOTRUBA, STANDING FIGURE. 1958–59. Limestone. Height, 192 cm. Artist's studio, Vienna.

176 HENRY MOORE, RECLINING MOTHER AND CHILD. 1960–61. Bronze. 84.5 × 219.7 × 97.8 cm. Walker Art Center, Minneapolis, Minnesota.

managed to escape it. Geometric abstraction and purely visual, or "concrete," art (*155*) staged a comeback, particularly in France, Scandinavia, and Switzerland. This triggered off a large number of further developments (*161–67*). But in contrast to the abstract art of the interwar years, which was predominantly geometric and impersonal, the postwar abstract art of the 1950s mainly shows a tendency to be subjective, both in Europe and in the United States. Although labels like Tachism, *art informel,* and Abstract Expressionism can be applied only to certain aspects of this art, we can see almost everywhere a tendency to treat the picture structure as a fluid system of colored notes and free graphic symbols in which the individual form is no longer perceived as independent, or even permanent. Leading representatives of this move-

△ 160

161 ▷

▽ 162

▽ 163

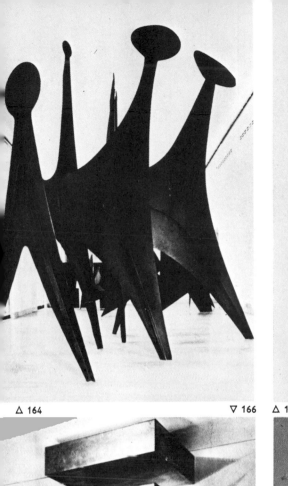

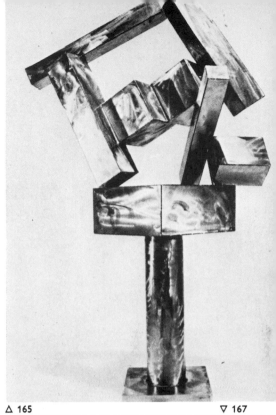

△ 164 ▽ 166

△ 165 ▽ 167

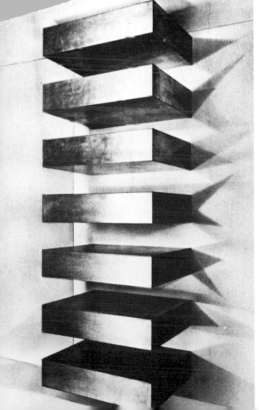

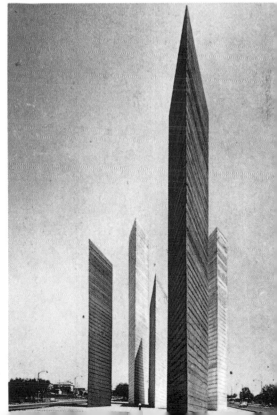

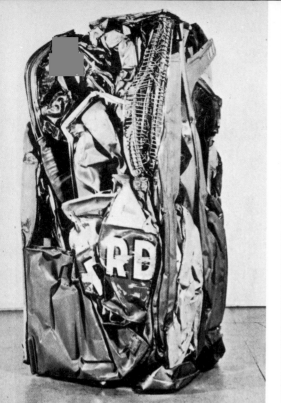

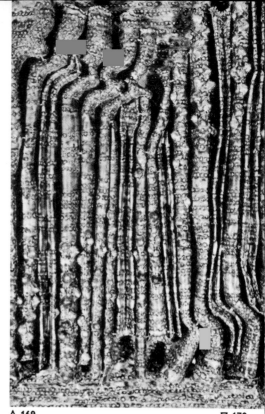

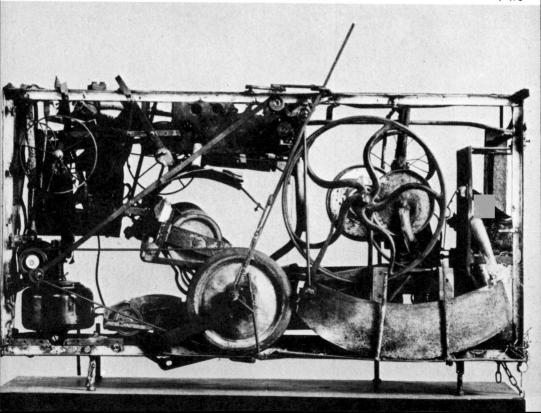

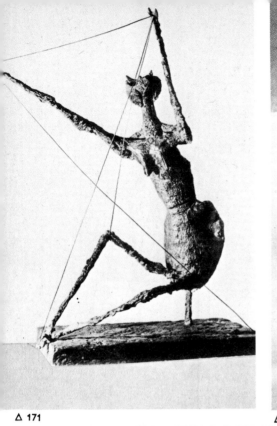

△ 171 △ 172 ▽ 173

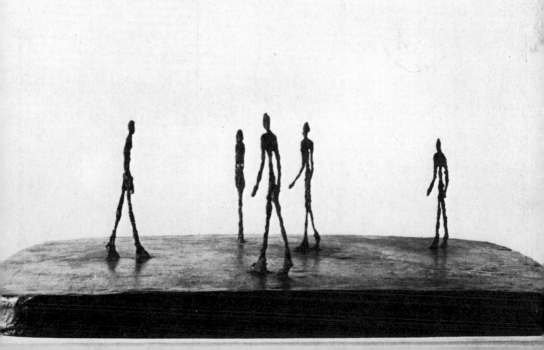

△ 174

▽ 176

ment were always emphasizing that any attempt to draw a distinction between representational and nonrepresentational was irrelevant to their work. For instance, the lyrical artists of the School of Paris—Roger Bissière (1886–1964), Alfred Manessier (b. 1911; *142*), Jean Bazaine (b. 1904), Maria Elena Vieira da Silva (b. 1908), Gustave Singier (b. 1909), Pierre Tal Coat (b. 1905), and many others—objected to their carefully calculated transpositions of landscapes, moods, or even historical or religious themes being classified as abstractions. The Expressionist and neo-Surrealist painters who formed the CoBrA group—Asger Jorn (1914–73), Constant (b. 1920), Karel Appel (b. 1921; *143*), Corneille (b. 1922), Pierre Alechinsky (b. 1927), and so on—were just as categorical in their belief in "reality," though in fact they distorted the human figure in a very aggressive fashion and interspersed it with all sorts of trimmings from *art informel.* "I don't think I can give anything that is completely free from any associations," said the American artist Franz Kline (1910–62), whose black-and-white abstractions can in fact be interpreted as industrial landscapes or incidents in the life of a big city. By contrast, the German artists Ernst Wilhelm Nay (1902–68) and Fritz Winter (b. 1905) and the Italians Afro (Basaldella, b. 1912), Emilio Vedova (b. 1919), Giuseppe Santomaso (b. 1907), and Antonio Corpora (b. 1909) were on the whole very convinced supporters of abstract art.

The art of the postwar years, when the last tremors of the great upheaval of the war were combined with new tensions (the Cold War, the end of the colonial empires, racial conflicts), shows an infinite variety of "realistic" and abstract influences, quite apart from literary and philosophical ones. It ranges from Bonnard to James Ensor, Rouault, and Kokoschka, from Klee to Kandinsky and Miró, from medieval stained glass to Eastern calligraphy, from the interlaced patterns of early Scandinavian ornamentation to the Art Nouveau arabesque, which reappeared in the early psychedelic icons of Klimt's fellow-countryman Friedrich Hundertwasser (b. 1928; *144*). One particularly striking point here is the variety of different ways in which Klee's work and teaching were interpreted. He inspired the Swiss concrete artists to evolve a type of serial art (*156*), whereas the French, who had thought of Klee as a Surrealist in the interwar years because he occasionally exhibited with the other Surrealists, now saw him as a sort of introverted Bonnard with a tinge of mysticism—an impression given by a small retrospective held in Paris in 1948. But the same cannot be said of his former pupil at the Bauhaus, Wols (Wolfgang Schultze, 1913–51; *145*), who was then living in Paris. Wols transformed Klee's constructive treatment of the elementary pictorial tools—the line and the patch of color—into a method for dissolving form.

The passively detached attitude to the world around him that made Wols object to the active "shaping" of the 1920s is a decisive factor in all Tachist and *art informel* painting. This type of art was sponsored by Wols, along with two other lone wolves, Jean Fautrier (1894–1964) and Camille Bryen (b. 1907). Paintings are not a projection of the painter's impressions, feelings, or visions, rendered more or less freely, but a sort of crude imprint of the world around him. The indistinct traces on the

surface of the picture that take the place of clearly defined forms are not evidence of any activity on the part of the artist, as in "gestural" painting (*147*); they merely point to the presence of other beings—people, animals, objects—with which the painter has come into contact, more involuntarily then voluntarily. For instance, birds do not have a symbolic and personal significance for Wols, whereas this is what makes them interesting for Ernst (*117*). They are neither interesting nor uninteresting; they are simply there. And the painter's job is to record the marks of their rather tiresome presence, without imprinting any ready-made visual or philosophical mold on them. They are simply spots in the forefront of his consciousness; he has no desire to gain mastery over them and would prefer to dispense with them altogether (*145*).

Materials

Wols did not mean his painting to have any kind of anti-art significance. Like life and death, art was a matter of indifference to him, in that he saw it as just one aspect of the social scene. His sole reason for eliminating the image of things—actually, it would be more accurate to say that he tried to prevent elements from coming together into rational, comprehensible structures—was to reproduce with the greatest possible immediacy the way alienating external elements can oppress one's consciousness. The same cannot be said of Jean Dubuffet (b. 1901). It could admittedly be thought that the idea behind his "material" paintings, as with Wols's *art informel* realism, was to show the radical dissolution of the psychological distance between the spectator and the objects he was viewing—whether these objects were beards, women, tables, cows, or road surfaces. But his prolific writings leave us in no doubt of his intentions: When he collected his *art brut* ("crude art"—work produced by mental patients, social deviants, prisoners, and others outside the social order) or used nothing but "rubbish, refuse, filth, and scrap iron" in his own work, he wanted this to be seen as an act of anti-cultural subversion. He wanted to "rehabilitate discredited values" and, in so doing, to degrade the values that culture thinks highly of.

This use of material society holds in low esteem does not represent a new departure

177 ROBERT RAUSCHENBERG, CHARLENE. 1954. Combine painting. 192 × 361 cm. Stedelijk Museum, Amsterdam.

178 RICHARD HAMILTON, INTERIOR II. 1964. Oil, collage, cellulose, metal relief on fiberboard. 122 × 162.5 cm. Tate Gallery, London.

179 RAYMOND HAINS, DUBUFFET IN VENICE. 1964. Décollage. Cavellini Collection, Brescia.

180 DANIEL SPOERRI, ROBERT'S TABLE. 1961. Wooden tray with various objects mounted on it. 200 × 50 cm. Ludwig Collection, Wallraf-Richartz-Museum, Cologne.

181 MARTIAL RAYSSE, LIFE IS SO COMPLEX. 1966. Low relief in Plexiglas, 12 segments, each 50 × 65 cm. Musée de Peinture et de Sculpture, Grenoble.

182 ANDY WARHOL, 210 COCA-COLA BOTTLES. 1962. Synthetic polymer silk-screened on canvas. 209.5 × 266.7 cm. Harry N. Abrams Collection, New York.

183 JASPER JOHNS, THREE FLAGS. 1958. Oil on canvas. 78.4 × 115.5 cm. Burton Tremaine Collection, Meriden, Connecticut.

184 ROY LICHTENSTEIN, YELLOW-GREEN BRUSHSTROKE. 1966. Oil on canvas. 215 × 460 cm. Ströher Collection, Hessisches Landesmuseum, Darmstadt.

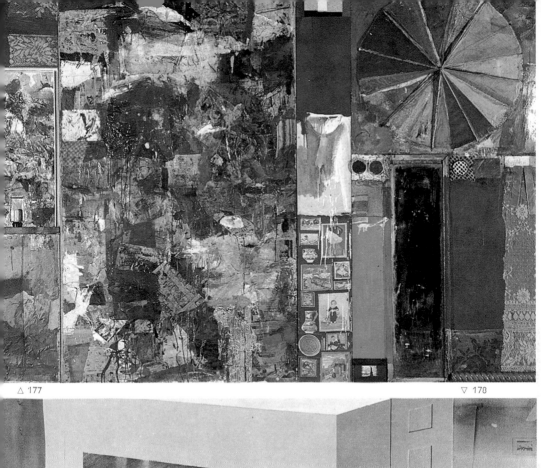

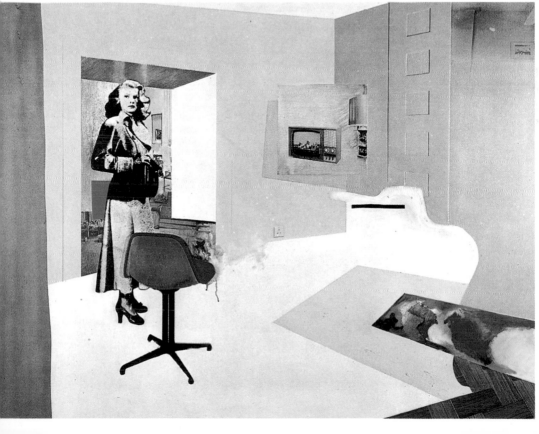

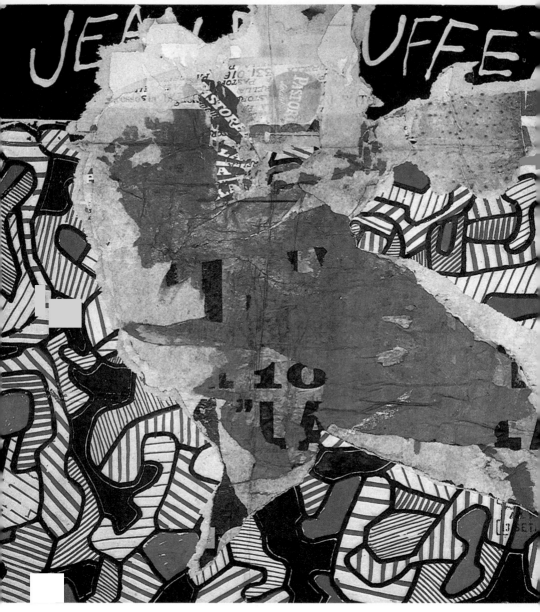

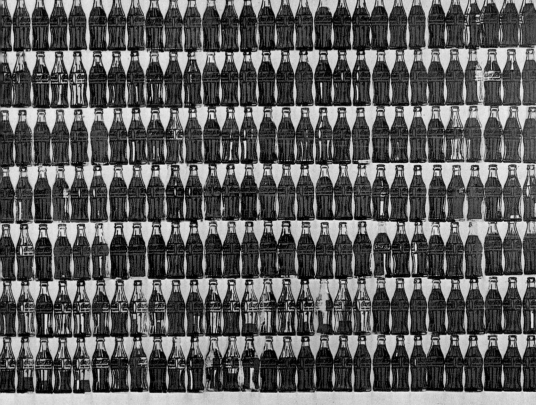

▽ 182

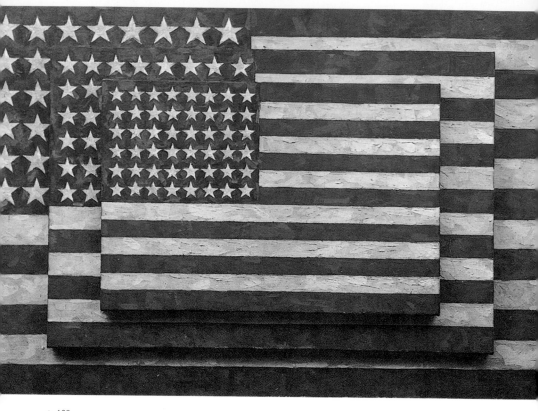

△ 183

▽ 184

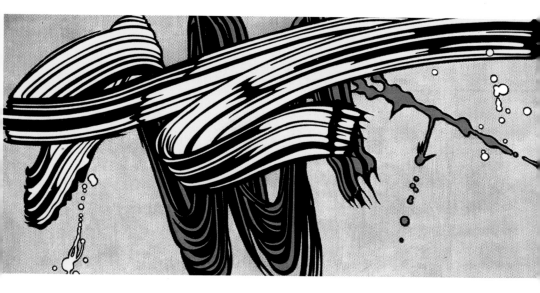

in modern art. As early as 1914 Klee was getting inspiration from children's scribblings, and later on he read and became enthusiastic over Hans Prinzhorn's book about work produced by mental patients. About the same time, Grosz was discovering unrecognized masterpieces in graffiti in public lavatories, while Schwitters was being gripped by a manic passion for junk (43). Ever since the Cubists had introduced the principle of collage, the use of trivial, noncultural materials and objects had been one of the main weapons in the armory of progressive art, particularly Surrealist art. But with the exception of Duchamp's ready-mades (47), these materials were almost always used in conjunction with other more traditional methods, and so, in the end, they were "culturally" integrated. Dubuffet thought that he could break out of this circle by totally withdrawing his work from the system of values promoted by humanist styles. He rejected even the most straightforward rules of the system—"work must be neat and tidy," "color must be brilliant," "form must be easily understandable," and so on. "I am thinking of paintings," he wrote in 1945, "that consist purely and simply of a single, monochrome bit of rubbish, with no variations in tone or in importance, or even in the way it glows or in the texture. It would create its effect purely by means of the many different kinds of signs, marks, and impressions left by one's hand as one handled the stuff." It was not until fifteen years later that Dubuffet actually created "anti-pictures" of this kind, which he called "texturologies" and "materiologies." (In defiance of his anti-cultural aims, however, these paintings were promptly integrated into the cultural and commercial—scene.)

In these experiments in which Dubuffet tried to reduce painting to this apparent zero-point, we can trace the systematic demolition of traditional painted culture. But unlike Picasso's metamorphoses (53), Dubuffet's precisely controlled retrogressive step does not lead to the figure's dehumanization. His misshapen *Wise Man* (146), with his "elegant" nose, tiny squinting eyes, and loose teeth, scratched into the thick mish-mash of paint as if by a child, loses nothing of his humanity, or even of his personality, in this anticultural treatment. Whereas Picasso's nightmare visions convey the idea that man's inner being is in danger, Dubuffet sticks to criticizing the forms of culture, without seriously questioning the social order itself.

His influence was already being felt, via Asger Jorn, by the CoBrA group. In the next phase of development, neither "object" art nor "dustbin" art—ranging from Junk art in America to *décollage* (179), the Romanian Daniel Spoerri (b. 1930; 180), and the German Joseph Beuys (b. 1921)—would have been thinkable if he hadn't done the preliminary work. On the other hand, even in the 1950s other artists had already come upon "material" art, though by a different route. Examples here are the sculptors Eduardo Paolozzi of Scotland (b. 1924; 188), Zoltán Kemeny of Transylvania (1907–65; 169), and César of France (b. 1921; 168), and painters like the Spaniard Antoni Tàpies (b. 1923) and the Italian Alberto Burri (b. 1915). In the work of all these artists, materials and objects are no longer treated as subject matter for a picture. Their handling of the materials as materials heralds a new form of realism—the "realism of the materials" or a new "materialism."

Action and Space

When "material" artists like Dubuffet or Tàpies "handled the stuff," their idea was not simply to jeer at the habits of traditional painting but also to leave behind on the canvas "living impressions," or, in other words, marks that would be more real than those created by a brushstroke that traces out a fictitious form. "It's great fun," agreed Hans Hartung (b. 1904) in 1954, "to act on the canvas," meaning as he added later, "to scratch, tear and squirt... to put it briefly, to do anything but paint." Whether we characterize their work as gestural art or Abstract Expressionism or Action Painting, action painters were not interested in freedom, but in the "reality" of their work. They wanted to replace the fictitious art of painting by real action.

Form, however, continued to lose reality. Kandinsky had taught his pupils to reduce a complex of forms to their inner lines of force, and Klee showed how lines, which represent the path of a movement, can take possession of space without necessarily producing forms (148). At about the same time, the young Hartung noticed that in a Rembrandt drawing of a lion each stroke expresses "pent-up force" in such a concentrated way that the actual form of the lion is virtually superfluous: "The picture is secondary to the idea it conveys." Other artists, such as the German Julius Bissier (1893–1965) and the American Mark Tobey (b. 1890), noticed that in Zen calligraphy the dynamics of the gesture were reflected without any form being interposed. In the United States the Abstract Expressionists—Willem de Kooning (b. 1904), Arshile Gorky (1904–48), Jackson Pollock (150), among others—took over techniques such as "dripping" from the European Surrealists (Ernst, Masson), with the idea of recording the stimuli experienced by the unconscious in as automatic (or form-free) a manner as possible.

Now that form had been eliminated it was replaced by time and space, for if painting is action, the time spent in performing this action is "real" time. Thus for many of his paintings K. R. H. Sonderborg (b. 1923) does not merely give the place and date (149) but also the time it took him to paint it ("14.32 to 15.14"). Yves Klein (1928–62) and Georges Mathieu (b. 1921) would sometimes even perform the act of

185 LEE BONTECOU, UNTITLED NO. 38. 1961. Wall relief. 142.2 × 100.3 × 55.9 cm. Walker Art Museum, Minneapolis, Minnesota.

186 CLAES OLDENBURG, SOFT SCISSORS. 1968. Linen stuffed with kapok, liquitex. 183 × 89 × 15 cm. Terbell Jr. Collection, Pasadena Art Museum, Pasadena, California.

187 LOUISE NEVELSON, ODE TO ANTIQUITY. 1957–58. Wood. A. Goldberg Collection, Boston, Massachusetts.

188 EDUARDO PAOLOZZI, FOUR TOWERS. 1962. Aluminum. 203 × 79 × 71 cm. Scottish National Gallery of Modern Art, Edinburgh.

189 KURT SCHWITTERS, MERZ BUILDING, Hanover. 1924. Destroyed.

190 EL LISSITZKY, PROUN ROOM. 1923. Stedelijk van Abbe Museum, Eindhoven. Reconstruction.

191 MARCEL DUCHAMP, SIXTEEN-MILE-LONG PIECE OF STRING, 1942. New York. Destroyed.

192 GEORGE SEGAL, THE RESTAURANT WINDOW. 1967. Sidney Janis Gallery, New York.

193 FREDERICK J. KIESLER, THE ENDLESS HOUSE. Ground plan of the upper story, final version. New York. 1960.

△ 185 ▽ 187 △ 186 ▽ 188

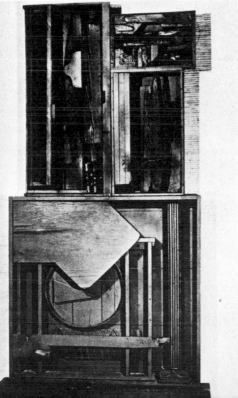

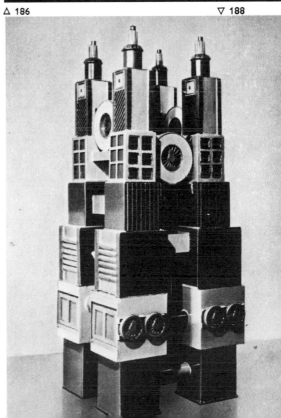

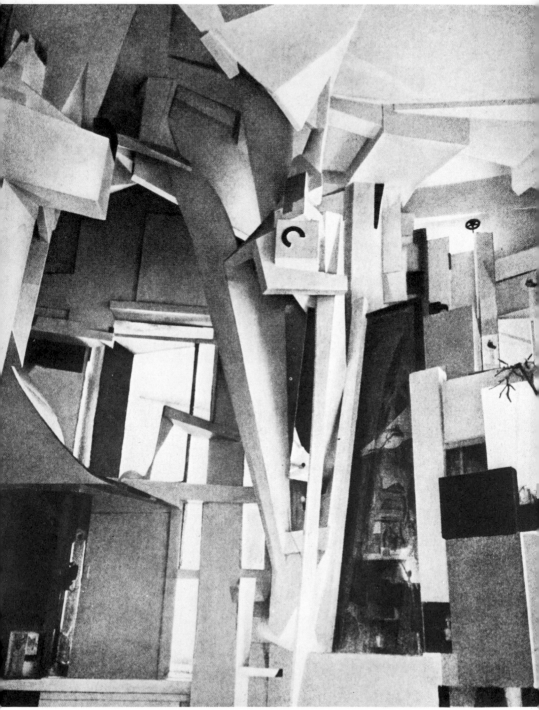

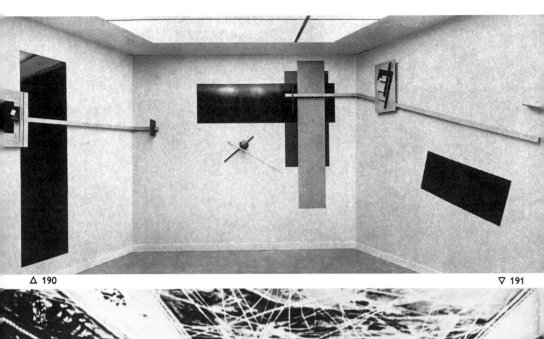

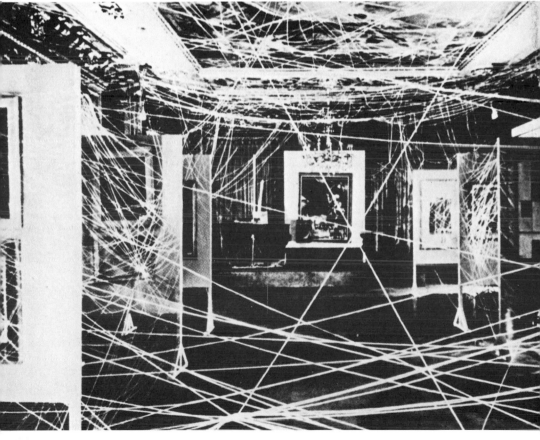

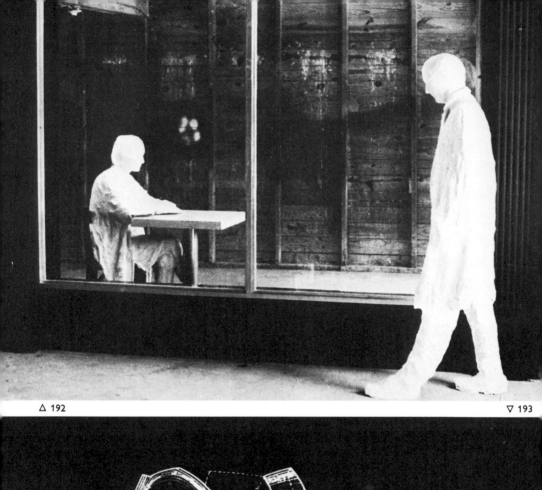

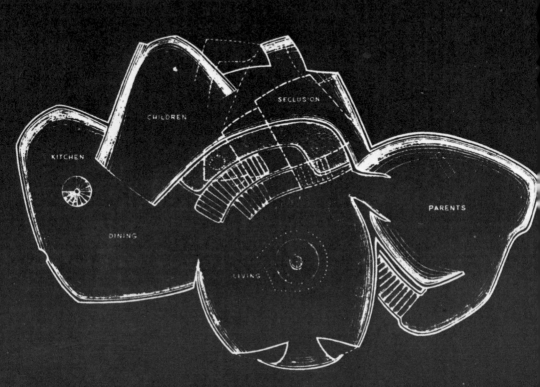

KITCHEN

CHILDREN

SECLUSION

PARENTS

DINING

LIVING

painting in front of guests. In this way the individual action becomes a collective Happening, recorded visually in the painting in terms of real time—just as a tape could record it acoustically.

Space, too, becomes real in a new way. When Pollock "acted" on a canvas he did not hang it on the wall but laid it out on the floor. The point was that he didn't want to have it *in front of* him ; he wanted to be able to get at it from all sides, or even walk on it. And the canvas on to which Mathieu flings his colors is no more than an upright screen on which the dancing movement of the act of painting is projected life-size.

The increased size of the canvas, particularly among American Abstract Expressionists, is another clear indication of the change in the significance of pictorial space. Neither the painter nor the viewer was supposed to commit himself to any point laid down in advance. If the viewer stands looking at paintings by Kline, Morris Louis (1912–61; *151*), or Mark Rothko (1903–70; *152*), which are very close to the dimensions of the world around him, he experiences the afocal structure (an instant clue that the illusory space of humanism does not apply) in an immediate, "real" way. The impression he gets if he looks at the equally afocal but smaller paintings of, say, Mondrian or Miró is very different. It is not just that the psychological distance between the viewer and the painting has been eliminated. The *physical* distance has also gone. The picture has literally become both for the spectator and for the painter the space in which they live and breathe, an environment that can be experienced in concrete terms. This new spatial element links Pollock and Kline with Barnett Newman (1905–70) and Rothko, despite the otherwise striking contrasts in their work—action versus stasis, aggression versus inwardness, and pure gesturing versus "all-over" technique and color field painting. It was even adopted by those who belonged to the anti-Expressionist tendencies of the 1960s—Ad Reinhardt (1913–67), Ellsworth Kelly (b. 1923), and Frank Stella (b. 1935); by Pop artists; and by many sculptors with their monumental "primary structures" (*165–67*).

Following the example of two Russian-born Frenchmen, Nicolas de Staël (1914–65) and Serge Poliakoff (1906–69), European artists concentrated on intensity of color rather than large canvases as a way of creating "real" space, though they also occasionally used huge formats. For instance, Yves Klein, who claimed that he was "a painter of space, not an abstract painter but a spatial realist," believed that the spatial reality of his monochrome paintings depended solely on the brilliance of their single color—yellow, pink, gold leaf, red (*154*) or, generally, a deep blue. The purpose of this "spatial reality" was *l'imprégnation,* the idea that the viewer should become mystically and optically immersed in the painting. In his use of texture effects he creates so much depth that the painting becomes a spatial reality completely dominating its surroundings, regardless of how large of small it is.

Another painter who gave his canvases (again painted in one color only) "real" space was Lucio Fontana (1899–1968): his method was to slash them open with a knife. The zone of actual space behind the picture surface (which has no depth in itself) was thus revealed and could be brought into the picture (*153*).

Modular Art and Serial Art

However spectacular the gestures that led to structured form being completely replaced by indications of movement or by space that had been made absolute and totally empty, this was not the first time that artists had tried to reject pictorial space made up of individual forms as old fashioned. As early as 1915 Mondrian had exiled form in favor of "relations." This was in his *Pier and Sea* paintings, which consisted of loose networks of plus and minus signs. He went on from there to devote himself entirely to the goal of "changing dimensions so as to set in motion the only constant relationship, the right angle, and to bring it to life" (*65*). "The idea of cultivating individual form is drawing to a close," he wrote shortly before his death. "The cultivation of conscious relationships is beginning." Thus even at this early date (1942) he anticipated the introduction of structuralist theories.

Mondrian's work is in fact one of the two main sources of "relational" art, which developed remarkably rapidly in the third quarter of the century. The other source was the Bauhaus, where Josef Albers (b. 1888) was inspired by Klee's example to embark on serial art once again. Series of paintings such as *Transformations of a Schema* or *Structural Constellations* show the importance for Albers of the serial principle with regard to method. Like Mondrian, he used exclusively linear elements (or ones with colored surfaces) based on the relationship between the horizontal and the vertical. But unlike Mondrian, he "sets this construct in motion" by using the serial modification of a single element to create optical illusions such as *trompe-l'œil* rooms (*157*). These force the spectator to be involved in nonstop activity, and the visual lack of stability makes the pictorial space as cogent and as real as the large afocal surfaces of the Abstract Expressionists.

Although one of Albers' former pupils at the Bauhaus, Max Bill (b. 1908), did adopt the serial idea of his teacher's work (which Sophie Taeuber had already tried out), he did not follow up the visual side. Bill was the leading member of the concrete art group in Zurich, which also included Camille Graeser (b. 1892), Verena Loewensberg (b. 1912), Richard P. Lohse (b. 1902), Gottfried Honegger (b. 1917), and many others. Taking up the ideas put forward by Van Doesburg at the end of his life, and particularly those of Georges Vantongerloo (1886–1965), he interpreted "relation" as the mathematical relationship that enables one to deduce a dynamic and concrete organization of space from an elementary modulus. To do this he generally used arithmetical or algebraic progressions or, more rarely, the Fibonacci series. He saw the square as the basic modulus and the basic pictorial form and systematically explored its structure with regard to its "relational" powers (*156, 207*). For instance, the dynamic articulation of his *Two Color Groups* (*156*) derives from the way the planes of the colored areas are duplicated, these areas being deduced from a black modulus placed off-center. In the outer group the duplication occurs in reverse of the movement within the inner group.

Auguste Herbin's (1882–1960) interpretation of the modulus and of programming, although quite different, is equally developed and precise. According to his color/form

cipher code (*alphabet plastique*), which was influenced by Baudelaire's and Rimbaud's theories of *"correspondances,"* not only does every elementary geometric figure correspond to a primary color; a letter can also be allotted to every combination of plus-form-color. As result, the composition of a painting can be read off letter by letter from its title. Thus a painting entitled *Rire* ("Laughter," *155*) should be a synthesis of the objective form/color units labeled R (twice), I, and E, in the same way that the work offers a synthesis of the individual letters.

These somewhat eccentric ideas had less of an influence on the art of the 1950s than the brutal determination with which Herbin related the most simple geometric figures to pure, contrasting colors. Together with Léger's monumental objectivity, Arp's call for absolute purity of form and material, and Magnelli's subtle but rigid geometry, this played a considerable part in the emergence of geometrical abstractionists in France—Victor Vasarély (b. 1908), Jean Dewasne (b. 1921)—and in Scandinavia—Richard Mortensen (b. 1910), Olle Baertling (b. 1911)—and even influenced the American Hard Edge painters.

Movement III

Artists who thought that a work of art had to be a "real" object could only approve the idea of programming every detail of a picture's design and execution in advance. But many of them rejected as idealistic the use of mathematical models for defining nonvisual modular structures. As they saw it, a painting could be "objective" only if it was treated as a purely visual object—in other words, when its sole function was to arouse the spectator to visual activity. This can be achieved by creating situations whereby the eye is caught up in a series of insoluble contradictions, as it is in Albers's constructions (Op art). Alternatively, it can be created solely by mobility, with movement actually incorporated into the painting's structure (kinetic art).

Taking Herbin's "plastic alphabet" as his starting point, Victor Vasarély developed the principle of modular programming into an optical system. He did this by relating the units of moduli in terms of color or position in such a way that the eye cannot accommodate them. Realizing that his retina has been thrown off balance, the spectator thinks that the object is moving (*158, 161*). Every possible aspect of this visual aggression was exploited by the GRAV (Groupe de Recherches d'Art Visuel, founded in 1960) and by the other international groups that joined the New Tendency (founded in 1961 in Zagreb), as well as by Op art, which was launched in 1965 by an exhibition called "The Responsive Eye" at the Museum of Modern Art in New York.

In kinetic art, the optical illusion does not occur until the spectator changes his position or sets the object in motion. An early example is the "rotorelief" stuck onto a phonograph record by that universal pioneer Marcel Duchamp (*160*). As far back as 1920 he had produced another motorized construction, his *Rotating Pane of Glass,* which may have been inspired by his very first ready-made, the *Bicycle Wheel* of 1913. Kinetic also, among other works, are the *Physichromies* (*35*) of Carlos Cruz-Diez (b. 1923), with their insubstantial colored texturing that does not open up until the viewer starts walking past, as in the relief pictures of Yaacov Agan (b. 1928); the spatial

paintings of Jesus Raphael Soto (b. 1923), in which suspended rods tremble and thus appear to break up a neutral background; or the hanging, spherical structures (*163*) of François Morellet (b. 1925), which revolve on their own axis and are thus transformed into a smoothly flowing interplay of light reflexes. Similarly, Heinz Mack (b. 1931) combined several different rotating movements with the idea of dematerializing the object (*162*).

Both Morellet's sphere and Mack's discs, being made of reflecting materials, actually incorporate the effect created by light. The members of the Bauhaus (in their abstract projections around 1920), had already recognized that the "amaterial materiality" of light praised so highly by Lissitzky made it effective in dematerializing objects. Op and kinetic artists—Nicolas Schöffer (b. 1912), Julio Le Parc (b. 1928), and many others—exploited the unsettling effect produced by the incessant action of light on the retina, offering countless variations on this theme.

But creating optical illusions and unsettling the eye is only one of the possibilities open to "object" artist for using actual movement, whether or not it is accompanied by light (and sound) effects. Calder's motorized constructions (*132*) had already turned the space-time element into a "real" event. In his mobiles (*159*) he uses natural, chance movement instead of mechanically programmed movement, or, in other words, periodic instability. He thus scales down to a minimum the particular significance of the individual form by using serially modified elements. On the other hand, his stabiles

194 GORDON BUNSHAFT (of Skidmore, Owings & Merrill), LEVER HOUSE, New York. 1951 52.

195 LOUIS I. KAHN, RICHARDS MEDICAL RESEARCH BUILDING, UNIVERSITY OF PENNSYLVANIA, Philadelphia. 1957–61.

196 FRANK LLOYD WRIGHT, ADMINISTRATIVE OFFICES AND LABORATORY TOWERS FOR THE JOHNSON'S WAX COMPANY, Racine, Wisconsin. 1936 39 and 1947 50.

197 M. E. HAEFELI, W. M. MOSER, R. STEIGER. A. M. STUDER, ZUR PALME, multistory building in Zurich. 1960 64.

198 LE CORBUSIER, LA CITÉ RADIEUSE, Marseille. Living units of standard size for 337 homes. 1947 52.

199 EMILE AILLAUD, LA GRANDE BORNE, housing estate at Grigny, near Paris. 1966 70.

200 ATELIER 5, Halen estate, near Berne, with single-family houses for 78 families. Planned 1954–59, built 1959 61.

201 LE CORBUSIER, DESIGN FOR A HOSPITAL IN VENICE. Second version. 1965.

202 LE CORBUSIER, LA TOURETTE MONASTERY, Eveux-sur-l'Arbresle, showing the "undulating glass wall." 1957 60.

203 PHILIP JOHNSON, JOHNSON HOUSE, New Canaan, Conn. 1947 49.

204 EERO SAARINEN & ASSOCIATES, GENERAL MOTORS TECHNICAL CENTER. Testing station for engines at Warren, Michigan. 1948 56.

205 PAUL BOSSARD, LES BLUETS, housing estate at Créteil, near Paris, with 560 apartments. Planned 1959 60, built 1961–62.

206 FRANK LLOYD WRIGHT, SOLOMON R. GUGGENHEIM MUSEUM, NEW YORK, showing the central hall. Planned 1943 46, built 1957-59.

207 MAX BILL, HOCHSCHULE FÜR GESTALTUNG (College of Design), Ulm, showing the covered passage from the residential wing to the community center. 1953-55.

208 EUGÈNE FREYSSINET, SKETCH FOR THE PONT ST. MICHEL, Toulouse. 1958.

209 KENZO TANGE, MODELS OF THE OLYMPIC SPORTS CENTERS IN TOKYO. Planned 1963 64, built 1965 67.

210 PIER LUIGI NERVI, EXHIBITION HALL, Turin. 1948 49.

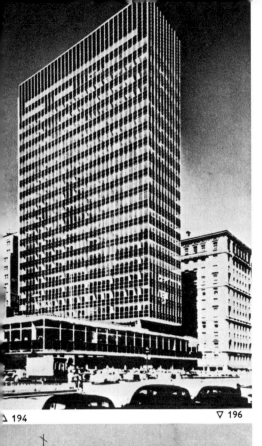

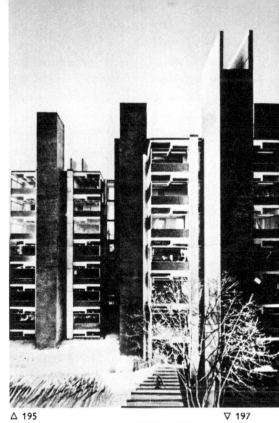

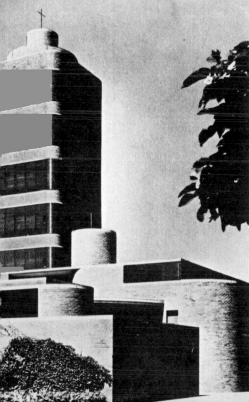

△ 194

▽ 196

△ 195

▽ 197

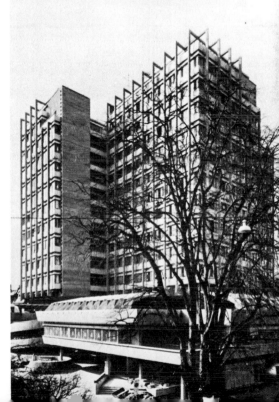

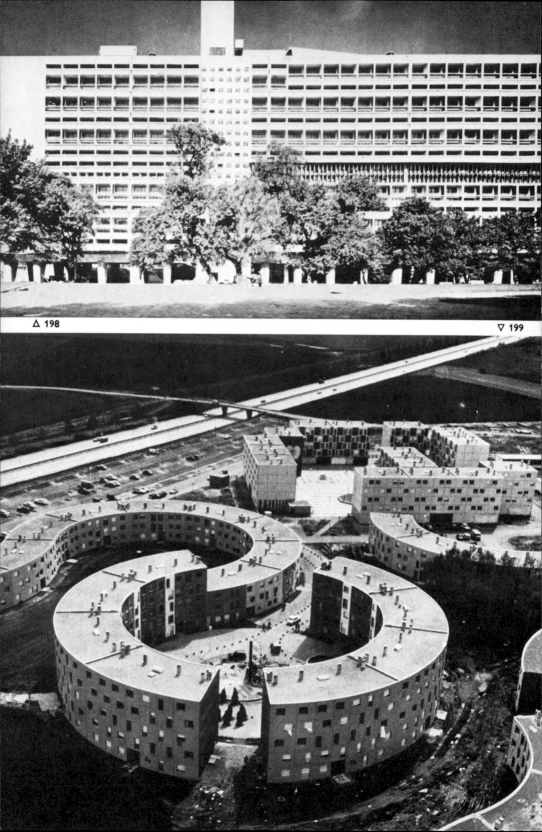

△ 198

▽ 199

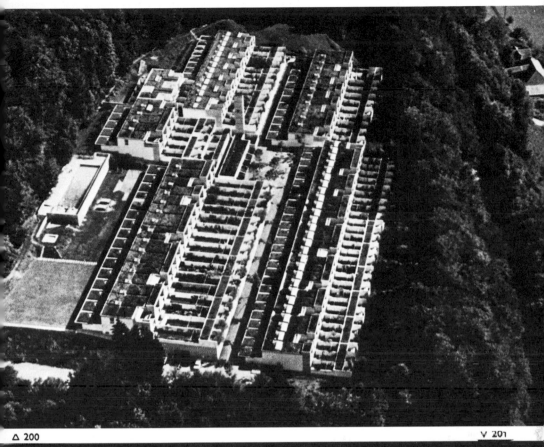

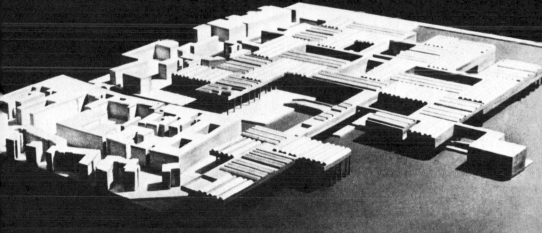

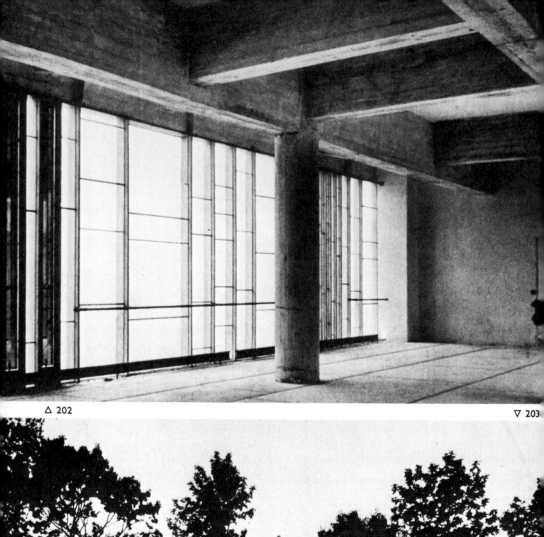

△ 202

▽ 203

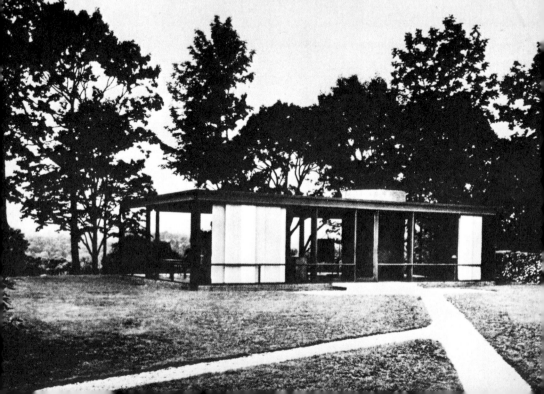

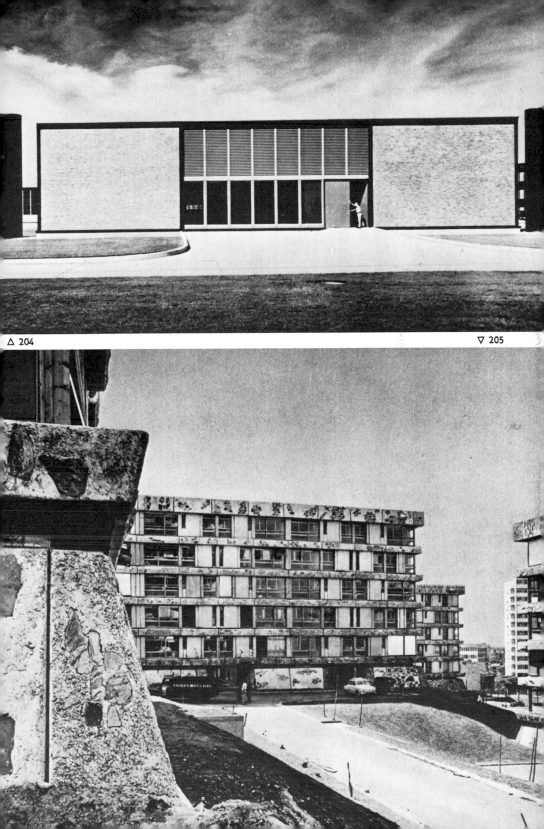

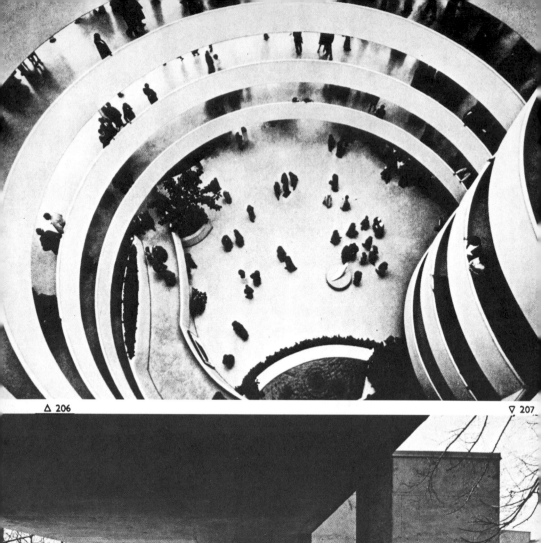

△ 208

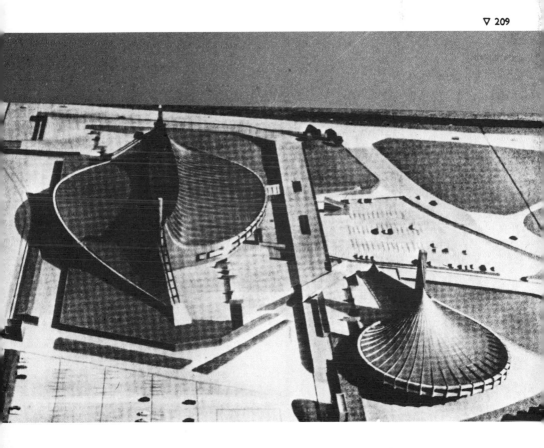

▽ 209

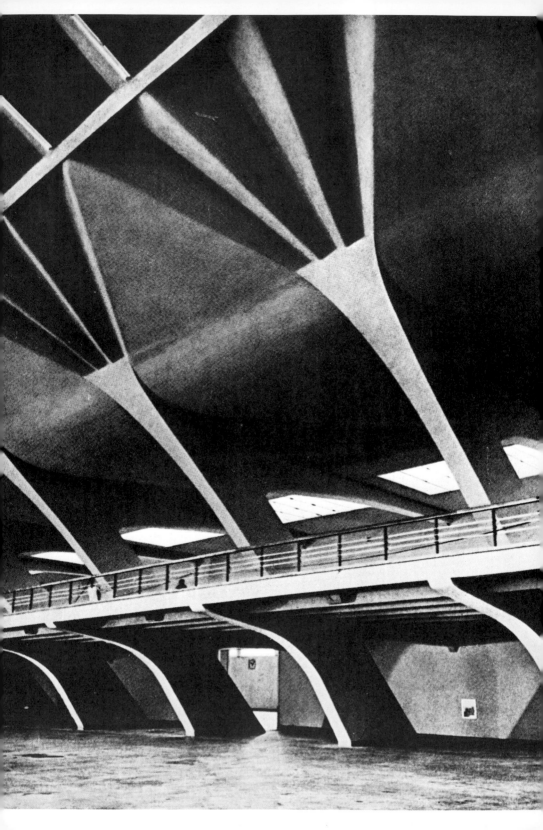

(*164*) resemble modern architecture in that they create movement by not pinning us down to one position but by encouraging us to walk—or even drive!—around and through them. That is why these modern monuments fit in so well with life on the streets.

Other nonoptical interpretations of movement are given by artists such as Pol Bury (b. 1922), whose work involves various elements that change their position in a series of jerky movements, thus creating an uncanny feeling of secret life. Yet another example is Takis's (b. 1925) electromagnetic constructions, which aim to make the invisible visible. Meanwhile Jean Tinguely (b. 1925) uses movement to criticize, in a vehicle that is, literally, destructive, the social order that is perfectly symbolized by the flawless, totally monotonous way machines function. Many of his ludicrously useless machines (*170*) actually destroy themselves, thus offering a sort of Last Judgment on the absurdity of mechanized civilization.

Situations

In the 1950s sculptors showed just as strong a tendency to abstraction as painters. A large number of sculptors—Reg Butler (b. 1913), Robert Jacobsen (b. 1912), Norbert Kricke (b. 1922), Berto Lardera (b. 1917), Ibram Lassaw (b. 1913), Richard Lippold (b. 1915), Kenneth Martin (b. 1905), Hans Uhlmann (b. 1900), and many others—tried to prevent volumetric effects by projecting signlike combinations of linear or planar elements into space. Even the influence of *art informel* and *art gestuel* is reflected in sculpture—as in the works of Eugène Dodeigne (b. 1923) and Francesco Somaini (b. 1925). Others—Hans Aeschbacher (b. 1906), Eduardo Chillida (b. 1924), Etienne-Martin (b. 1913), Fritz Wotruba (b. 1907; *175*)—preferred to create compact, constructive, or organically conceived structures that are very close to architecture.

Yet some of the most important sculptors of the 1950s stuck to the human figure. Only rarely was this theme treated in terms of humanist rhetoric, for instance in the work of Ossip Zadkine (1890–1967; *172*) or Giacomo Manzù (b. 1908). More often it is modified to sound a mythical note, as in the work of sculptors such as Henry Moore (b. 1898; *176*), Marino Marini (b. 1901), Barbara Hepworth (1903–75), Germaine Richier (1904–59; *171*), and many others. Alberto Giacometti (*173*) transformed it into an existential vision that went way beyond the traditional concept of sculpture, at least in its early stages.

Moore believes that the figure is bound to the chthonic (that is, terrestrial) forces of nature by its mass and its material; he sees nature itself as a primeval landscape made up of lumbering hills and maternally protective hollows, to which the figure adapts. Germaine Richier prefers to identify nature with the most aggressive personifications of these forces—the praying mantis, the red ant, hurricanes—and sees it as an incrustation of the flesh (compare Kafka's *Metamorphosis*), always capable of suffering and of making others suffer. An even more violent Expressionism can be seen in much of the work produced by the younger generation of sculptors, which might be described more as "defigurative" than figurative (Roel d'Haese, b. 1921; Jean Ipousteguy, b. 1920).

Giacometti's figures, equally emaciated, have nothing to do with this type of Expressionism. He tried desperately to record man in three-dimensional terms, not in a vacuum, but in the real, open situation in which he encountered him. As result the figure sacrifices a good deal of its significance to the surrounding space, although its relationship to this space is an extremely active one. We might perhaps modify Boccioni's formula of a *scultura d'ambiente* and call this "situation sculpture." The underlying aim of all modern sculpture is to draw the spectator into a real, open situation created either by means of a crude naturalism (*192*) or, conversely, by reducing the formal content and the power to convey anything to the absolute minimum of "primary" structures (minimal art, *166*)—a process not unlike Giacometti's method, though it might not seem so.

To begin with, this development led to a renaissance of monumental sculpture, which can be compared with the new use of giant formats in painting—Calder's stabiles (*164*), Gabo in Rotterdam, David Smith (1906–65; *165*), Mathias Goeritz (b. 1915; *167*), Philip King (b. 1934), Antony Caro (b. 1924), Bernard Luginbühl (b. 1929), Don Judd (b. 1928; *166*), Robert Morris (b. 1931), Kenneth Snellson (b. 1927), and others. These new monuments have very little in common with traditional monuments, since their sculptors do not want them to point beyond everyday reality or to remain aloof from the surrounding space but to be bound up with it in the most intimate way. A straight line leads from here to the Environment.

As in painting, the new concept of reality brought about a very profound change in the sculptor's relationship to his material and in his understanding of what he was doing. Many sculptors made the material the real subject matter of their work, evolving various techniques, particularly in metal-working, to help them create new effects. The charm of Zoltán Kemeny's assemblages (*169*) and of the work of Francesco Somaini and the Pomodoro brothers, Arnaldo (b. 1926) and Gio (b. 1930), lies in the mixture of precision and primitiveness, of apparent casualness and perfection resulting from these methods.

All these artists retained complete control over the creative process. Only if this control is eliminated can the process become "real" in the sense of a natural phenomenon. Thus although César (Baldaccini, b. 1921) is a sculptor to his fingertips, his sole contribution to the creative process underlying his *Compressions* (*168*) or his later *Expansions* is to operate the press or squeeze out the polyurethane foam. The rest of the process is left to the material itself. In trying in this way to overcome the subjectiveness of "action" art, César sounds one of the keynotes of the New Realism.

Consumer Icons

But the painters who rebelled against the personality cult in Action Painting were not satisfied with seeing the artist robbed of his control over the way his work was executed. They wanted to eliminate the element of chance as well. They therefore reduced the formal content of the painting to a few stereotyped elements, as with Frank Stella's parallel stripes or Jasper Johns's (b. 1930) panels of numbers and flags (*183*). But of

course a relentless stream of stereotypes and clichés, in the sense of figurations totally devoid of any personal content, was being turned out all the time by the mass media. Newspaper photos, television stills, posters, illustrated advertisements, color transparencies, and comics have created a new visual reality. This anonymous picture language, together with the mechanical reproduction techniques that are bound up with its presentation, was taken over by Pop artists and the New Realists so that they could provide an "objective" record of the revolution in our contemporary visual culture. Robert Rauschenberg (b. 1925), for instance, makes collages from press pictures of current events and newspaper headlines, while Roy Lichtenstein (b. 1923) blows up bits cut out of comic strips. Richard Hamilton (b. 1922) created *Homage to the Chrysler Corp.* from advertising leaflets and took a scene from an old thriller as the starting point for his uncanny and mysterious *Interior II* (*178*), which looks almost like one of Max Ernst's collages. Ben Day dots (produced by low-quality typographic screen techniques, as in newspapers) are used a good deal, blown up to huge proportions, as for instance in Rauschenberg's gigantic silkscreen prints (*Currents, Booster,* etc.). Lichtenstein uses the dots so systematically that they have virtually become his personal trademark. His *Brushstrokes* (*184*)—ironical "homages to Action Painting"—and his variations on Monet's *Cathedral* series are intended as art criticism.

Huge formats are common and so are gaudy photographs inspired by posters (particularly film posters and those in subways and train stations) and by cinemascope. Martial Raysse (b. 1936; *181*) sees the photograph as having "the function of middleman," while Joe Tilson (b. 1928) mounts his paintings like slides. Juan Genovés (b. 1930) sets his blackish-gray *reportage* paintings of brawls and scenes of panic within the round frame created by the camera lens, and Eduardo Paolozzi (b. 1924) takes everything from the visual subculture of both hemispheres and even from Japan and puts it all into his collage-encyclopedia.

But the demand for "objectivity" still hadn't been fully satisfied: "I feel that a painting is more real if it is made out of bits of the real world," says Rauschenberg of his Combine Paintings (*177*). The painting stepped out of the canvas while the actual object was incorporated into it. The assemblage and the ready-made were back in business. Andy Warhol (b. 1930) cast soup cans in bronze, Jim Dine (b. 1935) modeled ties and hats in aluminum or painted tennis shoes, and Tom Wesselmann (b. 1931), Claes Oldenburg (b. 1929), and George Segal (b. 1924; *192*) constructed kitsch interiors, called Environments, in which there is room to walk about. Daniel Spoerri (b. 1930) goes even further: He doesn't clear the table after eating, but leaves it just as it is, with scraps of food, dirty dishes, empty bottles, and sticky glasses, as if for an on-the-spot legal investigation (*180*). Similarly, the *décolleurs* tear off the wall a crust of paper and plaster made up of several layers of tattered posters stuck on top of each other and transfer it as is to a sheet of fiberboard (*179*)—we are very nearly back with César's *Compressions* (*168*) by this stage.

Since the soul-destroying repetition of stereotyped forms, in words and images, in industrial products and architecture is the most striking visual monument of the

consumer society, it naturally gives the new "art of the real" one of its main themes. Warhol had to ladle up the same canned soup day after day when he was a child, so he always paints that same soup can; or else he piles up boxes of soap powder as if in a supermarket or lines up hundreds of Coca-Cola bottles in nice tidy rows (*182*). He papers whole walls with colored proofs of newspaper pictures of Marilyn Monroe, Jackie Kennedy, and Elizabeth Taylor, who gaze at us with set smiles; he treats them no differently from the endlessly repeated head of the solemn cow on a can of condensed milk. He is not accusing or approving, just soberly stating the facts— principally, the fact of consumption—recording them with indifference. Even newspaper clippings and pictures on topical political subjects (the Kennedy assassination or the Vietnam War) are treated by Pop artists solely as components of the visual environment.

The European New Realists' reason for using stereotypes taken from the mass media was based more on what Raysse has called the "hygiene of seeing." Their attitude toward these stereotypes was more detached and more active than that of the Americans. This is just as true of the English artists Hamilton, Tilson, Paolozzi, and the London-based American R. B. Kitaj (b. 1932) as it is of the Continental *décolleurs* Raymond Hains (b. 1936), Jacques de la Villegle (b. 1926), François Dufrêne (b. 1930), Mimmo Rotella (b. 1918), Wolf Vostell (b. 1932), the object artists Spoerri and the Japanese Testsumi Kudo (b. 1935), and the Nice School—Raysse, Yves Klein, and Arman (Armand Fernandez Arman, b. 1928). *The World Divides in Facts* is the title of one of Paolozzi's sculptures. The facts—the eye, mouth, and forehead into which the sterile face of the pin-up girl processed by Raysse in many of his works disintegrates—are established by the mass-medium advertising photograph. Like the hard and shiny colored Plexiglas from which they are cut out, they are "invariable" (*181*). They are also "not freely moveable," although they can be positioned in various ways; moving them "would be a variation of Action Painting and would result in a Tachist method of structuring them." Subjectivity and improvisation are therefore rejected. Raysse said that his "activity is a reflection of the language of pictures." Mass media have trivialized this language in a thoroughly revolutionary way. Pop artists unblinkingly recorded the state of affairs brought about by this phenomenon, making the omnipresence of the new pictorial subject matter as a new form of reality the subject of what was, according to their theories, a realistic portrayal. The New Realists, on the other hand, raised the question of how these new pictorial subjects should be dealt with if their activity was to remain, as Raysse suggested, *cosa mentale,* or even *cosa sentimentale.*

Environment

The Cubists had already raised the problem of reintroducing pictures into real space as *objects*. But just as the Dadaists were the first artists to follow the lead of collage (*41, 42*) and make the transition from the *tableau-objet* to pure object art (or anti-art) (*45–48*), so the Neo-Plasticists and the Suprematists were the first to put an end to questions about the much-discussed fourth dimension. The point is that both the Stijl

artists and Malevich felt that paintings enabled one to formulate the space-time problem only in theoretical terms. It was not enough for them to have a "real" relationship with the surrounding space. The space itself must be treated as a sort of picture.

Whereas the Stijl group understood the idea of a stereotyped spatial organization chiefly from the point of view of collaboration between creative artist and architect (68), Malevich with his *Planit* designs and Lissitzky with his *Proun* pictures explored an intermediary zone somewhere between painting, sculpture, and architecture that should also include movement—that of the person who steps into it—and thus time as well. Lissitzky's ephemeral Proun room (*190*), executed three years before Van Doesburg redesigned the Aubette in Strasbourg, represents the first occasion when a total space was calculated entirely in terms of the movement made by the person looking at it. Thus while an "abstract" trend toward shaping space according to stereotyped formular sought to include the person visiting it or living in it. other experiments, taking the object as their starting point, presupposed that the visitor or inhabitant had been excluded. Thus in his Merz buildings (*189*) Schwitters took away the functional definition of homes designed for people and turned them into boxes for objects (his beloved "junk"). Unlike the cupboards or boxes (*187, 188*) of Louise Nevelson (b. 1900) or Eduardo Paolozzi, the spectator could walk into Schwitters' structures, though only on certain conditions. Then, with his *Sixteen-Mile-Long Piece of String* (*191*), Marcel Duchamp made it difficult for visitors to walk around an art exhibition, the idea being to make them experience the relationship between the objects and the space more intensely. The tension or frustration created by the partial or total blocking off of certain spatial areas makes the visitor aware of the existence of space—an effect that Giacometti achieved in his Surrealist caged structures (*131*) by creating taboos.

"Anti-architecture" of this kind stands in exactly the same relationship to normal space as an anti-art object to traditional works of art. But the Venezuelan Jesus Raphael Soto (b. 1923) goes even further than this with his *pénétrables*, in which space itself becomes an object. As the visitor plunges headlong into these curtains, which are made of bits of string hung up on metal rods and are several feet deep, he no longer sizes up the space by eye but touches it with his whole body and clutches at it with his hand.

Although these *pénétrables* may seem to be an isolated phenomenon, they are, in fact, merely an extreme example among countless experiments designed, as are the *pénétrables*, to define the adventure of space in other than visual terms, yet without eliminating the visual element entirely. A combination of the experiments concerning space and time made by the abstract avant-garde in 1920, and the Surrealists' findings on the object, of Dada collage and the technique of film cutting, of the elementary language of forms and colors used by the early abstract painters and the effects of modern lighting techniques, offered various possibilities for bringing space, object (whether artifact, idea, or work of art), and subject together in an active relationship.

This new active relationship was exploited particularly often by exhibition designers. Lissitzky and Herbert Bayer (b. 1900) did some important pioneering work in this field.

From here various roads led either on to the Happening or back to open or closed spaces in the sense of an expanded monumental art. In this category we can include landscape designs such as the "gardens of meditation" by Bayer in Aspen, Colorado, and Isamu Noguchi (b. 1904) in Paris (UNESCO building, 1958); the diggings, heaps of earth, and vast graphic works produced by the bulldozer and tractor artists under the heading "land art"; and also all types of three-dimensional structures for living in or playing with where the artist has reacted against the sober utilitarianism of modern high-density housing estates by treating space purely and simply as something to move about in, as a psychological stimulus. A good example of this treatment is the "endless house" designed by the Viennese environmental pioneer Frederick J. Kiesler (1896–1965; *193*). Although the original version, which dates from 1924, evolved from a geometric structure inspired by Neo-Plasticism, Kiesler subsequently adopted an ageometric, organic articulation based on the womb. But over and above the change in the formal language the emphasis was still on the primacy of the psychological function of structured space.

The (almost) living pictures created by artists such as George Segal (b. 1924; *192*) or Edward Kienholz (b. 1927) were also concerned with psychological reality, though they are connected with a very different type of display art—waxworks. The idea here is not to create ideal spatial areas, but to alienate the spectator to a certain extent by means of theatrical props, scenery, and figures, thus making him consciously experience situations that he participates in unconsciously every day of his life. In Segal's street scenes, or in other scenes in cinemas or snackbars, space is presented mainly as an empty space, as the distance between us and the scene—as in Giacometti's "situation sculptures" (*173*).

New Media—Art Without Works of Art

Since about the mid-1960s the stylistic development of art has been dominated by a rapid erosion of the traditional concept of the artist's activity as a process whereby forms are fashioned with the aim of creating works of art. Action Painting, "material" art, and "relational" art had all cast doubts on the existence of form; the artist's participation is reduced to the decision to get the process started, or the business of organizing a program, or even to simply being there, as with Yves Klein or Piero Manzoni (1933–63). The element of chance is also used in "situation" art; in the pictures of Michelangelo Pistoletto (b. 1933), for instance, life-size figures are painted on a mirror, and spectators, passers-by, and the whole of the surrounding space are reflected in it. Chance is used on an equally systematic basis in programmed art, where it appears in, say, François Morellet's work as the "aleatory factor." The Dadaists also emphasized the "uselessness" of art, thus robbing the artist's work of any degree of permanence, which it must have if it is to be interesting to collectors and thus a work of art. For instance, Picabia would execute large pencil drawings ("express pictures") with other people looking on and then promptly rub them out. Klein, Mathieu, and

others followed his example later on. Similarly, the "Over-Dada," the Berlin artist Johannes Baader, would destroy his huge collages of torn posters as soon as he had finished them.

The most ephemeral and changeable materials—paper, ash, smoke, steam, water, ice, light, grass, earth, food (ranging from cabbage to margarine)—were now enlisted to help create objects, "traces," or events, the sole purpose of which was to demonstrate the concept of transience. The idea was to present objects that had escaped any form of value judgment or exploitation, particularly the commercialization to which even so-called revolutionary art had long ago submitted, and contrast them with a society that degraded everything to the level of a consumer product. This pious intent was quickly sabotaged, since art dealers were soon managing to persuade collectors to look on the most extraordinary products and manifestations of the new avant-garde as promising investments.

Society was quite openly criticized by the type of *arte povera* that uses the methods of "junk" art as weapons for fighting culture (Joseph Beuys for example). But a large number of other factors also cast doubts on the survival of the work of art, almost all of them resulting from an urge to think through to the end problems that had been raised earlier.

The tendency to do away with the purely visual element can already be seen in the Cubists' debates on the fourth dimension. It now led to attempts to "shape the invisible," an example here being Takis's experiments with electromagnetic fields. But it also led to new ways of "integrating the arts" that appealed to all the senses, particularly those of hearing, smell, and movement; the idea was to allow the recipient to become an active participant. It is not far from this "art of participation" to the Happening. Here the artist merely contributes a few props and some suggestion for directing it—though in fact the Happening quite often consists in using the props for some completely different purpose (or even destroying them altogether) and ignoring the artist's suggestions—for example, Allan Kaprow (b. 1927), Jean-Jacques Lebel (b. 1936), and Wolf Vostell.

Even more radical, though less striking, was the way in which the "art of suggestion" (*l'art de proposition*) appealed to the participant's spontaneity by simply suggesting a subject for him to construct or a situation for him to think through. This proved impossible so long as he obeyed the traditional laws of seeing and thinking; the object of the exercise is to bring him into conflict with these laws and thus provoke him into treating his own experience independently and critically.

The spectator had already been confronted with the contradictions inherent in the process of seeing by the work of Albers (*157*), and, after him, by most of the Op artists. They would use complicated designs that needed to be executed with the greatest precision. The enigma lay in the actual object. But now the focal point of the process switched back from the execution to the initial conception. The object need not even be physically there any more. It was enough if it existed in the *imagination* of the artist's partner and could therefore be felt as a challenge.

Conceptual art and process art differ widely in the extent to which they dematerialize the creative act. Process artists count the material realization as part of the act. Thus after describing a gigantic hole that he would like to have somebody dig, Walter de Maria (b. 1935) adds: "The process of digging the hole would itself be part of the art." But those who advocated the more radical conceptual art claimed that it was enough just to describe the act. The work of art is replaced by a report of the way it *may* occur, the "visual" element therefore leading to "oral" communication—an unmistakable sign that artists were growing tired of images in an age saturated with them.

Architecture in the Consumer Age

There is no space here to do more than mention the most important of the many factors that influenced architecture after World War II. The first of these is that the size of architectural commissions had changed, thanks to the population explosion and the increasingly rapid pace of urbanization. Then there was the industrialization of architecture, which involved not only the much-discussed process of standardization by the use of prefabricated components, but also the unsettling effect created by the almost infinite number of materials and techniques available. Another factor was a new flexibility in the function of buildings, which can be seen in the way even recent ones are continually being used for different purposes. This means that a building is in danger of seeming unfunctional if it is slotted straight away into a preplanned category. Yet another factor is the lack of legislative restrictions on property rights, which means that any attempt to put the equation architecture = town planning into practice is bound to be frustrated. As a result, it was impossible to coordinate either the scale or the function of the various new urbanistic concepts.

Then again, much as in sculpture and painting, doubts are growing about methods and aims, and these are shaking the confidence of architects. The idea that they should be involved solely with the purely formal process in realizing a plan already decided upon is viewed with disfavor on all sides, and architects are increasingly looking beyond their own specialist field, which they find too narrow. Ever since Perret's day, and particularly under the influence of the theories of construction that grew up in the period after World War I, the field of construction, where there was no question of subjective artistry, had exercised a great fascination. In the age of the computer, the symbolic figure of the civil engineer has been replaced to a certain extent by the data-processor and the professional planner. Combinatory analysis and the ability to devise systems are considered more important than creative imagination, which bears the taint of the bourgeois and romantic cult of personality—though in fact the most admired building engineers, such as Eugène Freyssinet (1879–1962), Pier Luigi Nervi (b. 1891), Robert Le Ricolais (b. 1894), Eduardo Torroja (1899–1961), Konrad Wachsmann (b. 1901), and Frei Otto (b. 1925), hold the opposite view. Even when it comes to inventing systems, these men give intuition about form priority over the ability to calculate (*208, 210*).

On the other hand, the idea that every architectural commission is a sociological

exercise—and this is implicit in the equation architecture = town planning—has had the effect of stimulating a growing interest in the social sciences. Greater importance is attached to the interdisciplinary analysis of the functional objective than to the individual act of designing a building. Attempts on these lines are being made to break out of the intellectual isolation in which the architect has found himself, thanks to the teaching system used in colleges of art and architecture, and to adopt the latest methods of collective research and planning. This is producing, among other things, a worldwide crisis in architectural teaching, which now needs to be completely rethought.

Uncertainty in relation to form has been increased by the apparently conflicting systems in which the architectural Old Masters (Frank Lloyd Wright, Mies, Aalto, Le Corbusier) clothed their spatial intuitions, and also by the doubts cast on the concept of form in general by the most recent trends in painting and sculpture. Concepts such as pure spatiality, mobility, adaptability, or action, which had already been used in the new architecture of the 1920s, are now thought to be incompatible with the survival of form as a rigid structural system, without which architecture would never have managed to get by.

In view of all this, it is not surprising that even the few achievements that stand out as products of genuine creative inspiration from a vast number of mediocre buildings cannot be reduced to a common stylistic denominator. It would indeed be truer to say that the most characteristic feature of post-World War II architecture is the large number of widely conflicting trends within it. For instance, the tried and tested system of skeleton construction (2), which involves an orthogonal classical structure made up of tiny cells, is found alongside the stressed-skin system, in which baroque curving, twisted planes predominate (209). Whereas the technique of the curtain wall (194) thrusts the surface element literally into the foreground, reinforced concrete construction (198, 205) suggests an emphasis on single volumes and a sculptural treatment of the building as a whole. The advances made in air-conditioning techniques allow architects to let the inner and outer space merge into each other. In extreme cases, a completely transparent structure may even be arrived at (203). But an equally strong urge to seal off the outer shell of the building and so create a self-contained box can also be felt, the idea being to protect it from the aggressive forces at large in the outside world (205). The urge to master the maximum number of modern production methods, so that the precision and perfection that are the hallmark of mass-produced articles can be achieved in building as well, is at variance with the willingness to admit openly, even brutally, that there are shortages throughout the profession and a lack of materials dictated by the inadequacy of the finances available (200, 205, 207). High-grade steel polished to a matte finish is contrasted with shapeless undecorated concrete, while elsewhere architects may resort to preindustrial architectural designs, such as the flat barrel-vaulting seen in folk architecture in the Mediterranean region. At the end of the 1950s these influences gave rise to what is known as Brutalism, an almost expressionistic tendency to treat buildings as three-dimensional objects—for example, Alison Smithson

(b. 1928), Peter Smithson (b. 1923), and Otto Förderer (b. 1929). This tendency overlaps with various other types of reaction against technology, both in architecture and in sculpture and painting. The work of Louis Kahn (1901–74; *195*) and Paul Rudolph (b. 1918) is a strong influence here, together with Le Corbusier's later work.

In this context Brutalism might have changed direction and favored what appears to be the contradictory view—the complete negation of architecture. After all, living accommodation and functional areas are no more than consumer articles, commodities intended to meet rapidly changing requirements. For instance, the widely adopted theme of "adaptable" or "mobile" architecture was elaborated, partly under the influence of R. Buckminster Fuller (b. 1895) into the paradoxical notion of disposable architecture, which would feature built-in obsolescence and a deliberate disregard for problems of form design.

Similar ideas underlie the later work of Le Corbusier, in which he gives priority not to the functional element but to the relational element over the formal aspect. This is clear from his design for a hospital in Venice (*201*). Here the theme of a flat building that has no façade and can therefore grow unrestrictedly is expanded into the principle of total continuity in urban construction. But even in his "living unit" (*unité d'habitation*) in Marseille (*198*), a slab high-rise building that has aroused controversy because of its monumental appearance, the continuity of the relational fabric is guaranteed by the inclusion of a large number of communal facilities described as "extensions of the living cell." According to its creators, the Halen housing estate near Berne (*200*) is a typical example of social integration arrived at by "splitting open" the "living unit" and "laying it flat." In fact, it corresponds once again to the model of the continuous low-rise building without a façade.

This example shows how impossible it has become to assess architecture from the viewpoint of style. It seems rather as though the questionable nature of the concept of form itself, as in painting and sculpture, is the only point on which the representatives of the various different trends agree. This does not mean, however, that they all persist in merely negating form. So long as materials are worked, form is present. But whether or not a formal system can turn into its opposite, and whether or not equivalent relational structures can be created by means of totally contradictory formal systems—this widespread skepticism about the correct treatment for architecture in relation to its form must in the last analysis leave such questions to ideology.

GENERAL AND VISUAL ARTS

Amaya, Mario. *Art Nouveau*. London: Studio Vista; New York: Dutton, 1966.

Arnason, H. H. *History of Modern Art: Painting, Sculpture and Architecture*. New York: Abrams, 1968; London: Thames and Hudson, 1969.

Bann, Stephen. *Experimental Painting*. London: Studio Vista; New York: Universe, 1970.

Bann, Stephen. *The Tradition of Constructivism*. New York: Viking, 1973; London: Thames and Hudson, 1974.

Battcock, Gregory. *Idea Art: A Critical Anthology*. New York: Dutton, 1973.

—*The New Art: A Critical Anthology*. New York: Dutton, 1973.

Barrett, Cyril. *An Introduction to Optical Art*. New York: Viking, 1970; London: Studio Vista, 1972.

Bowness, Alan. *Modern Sculpture*. London: Studio Vista; New York: Dutton, 1965.

Buchheim, Lothar-Günther. *Die Kunstlergemeinschaft "Brucke"*. Feldafing: Buchheim 1956.

Burnham, Jack. *Beyond Modern Sculpture: The Effects of Science and Technology on the Sculpture of This Century*. New York: Braziller; London: Allen Lane, 1968.

Calas, Nicolas and Elena. *Icons and Images of the 60's*. New York: Dutton, 1971.

Celant, Germano (ed.). *Art Povera: Conceptual, Actual or Impossible Art?* London: Studio Vista; New York: Praeger, 1969.

Chipp, H. B. *Theories of Modern Art*. Berkeley: University of California Press, 1970.

Davis, Douglas M. *Art and the Future: A History Prophecy of the Collaboration Between Science, Technology and Art*. New York: Praeger, 1973.

Finch, Cristopher. *Image as Language: Aspects of British Art, 1950–68*. Harmondsworth: Penguin, 1969.

—Pop Art: *The Object and the Image*. London: Studio Vista; New York: Dutton, 1968.

Fry, Edward F. *Cubism*. London: Thames and Hudson; New York: McGraw-Hill, 1966.

Giedion-Welcker, Carola. *Modern Plastic Art: Elements of Reality, Volume and Disintegration*. Zurich: Girsberger, 1937.

Golding, John. *Cubism: A History and an Analysis, 1907–14*. Rev. ed. London: Faber and Faber, 1968; New York: Harper and Row, 1972.

Gray, Camilla. *The Great Experiment: Russian Art 1863–1922*. London: Thames and Hudson, 1963.

Haftmann, Werner. *Painting in the 20th Century*. 2 vols. Rev. ed. London: Lund Humphries; New York: Praeger, 1965.

Hamilton, George Heard. *Painting and Sculpture in Europe, 1880 to 1940*. Rev. ed. Harmondsworth and Baltimore, Md.: Penguin, 1972.

Hill, Anthony (ed.). *Data: Directions in Art, Theory and Aesthetics, an Anthology*. London: Faber and Faber. 1968.

Hulten, K. Pontus. *The Machine as Seen at the End of the Mechanical Age*. New York: Museum of Modern Art exhibition catalogue 1968.

Jaffe, Hans Ludwig. *De Stijl, 1917–31*. London: Thames and Hudson, 1970; New York: Transatlantic, 1973.

Kepes, Gyorgy (ed.). *Arts of the Environment*. New York: Braziller; London: Aidan Ellis, 1972.

—*Education of Vision*. New York: Braziller; London: Studio Vista, 1965.

—*The Man-made Object*. New York: Braziller; London: Studio Vista, 1966.

Module, Proportion, Symmetry, Rhythm. New York: Braziller; London: Studio Vista, 1966.

—*The Nature and Art of Motion*. New York: Braziller; London: Studio Vista, 1965.

Kultermann, Udo. *The New Painting*. London: Pall Mall Press; New York: Praeger, 1969.

—*The New Sculpture: Environments and Assemblages*. London: Thames and Hudson; New York: Praeger, 1968.

Lippard, Lucy. *Pop Art*. New York: Praeger, 1966; London: Thames and Hudson, 1967.

Madsen, Stephen Tschudi. *Art Nouveau*. London: Weidenfeldt & Nicolson; New York: McGraw-Hill, 1967.

Martin, Marianne W. *Futurist Art and Theory. 1909–15*. Oxford: Clarendon Press, 1968.

Müller-Brockmann, Joseph. *A History of Visual Communication*. Teufen: Niggli, 1971.

Myers, Bernard S. *The German Expressionists: A Generation in Revolt*. London:

Thames and Hudson; New York: Praeger, 1966.

Naylor, Gillian. *The Bauhaus*. London: Studio Vista; New York: Dutton, 1968.

Overy, Paul. *De Stijl*. London: Studio Vista; New York: Dutton, 1969.

Pevsner, Nikolaus. *Pioneers of Modern Design: From William Morris to Walter Gropius*. Rev. ed. Harmondsworth and Baltimore, Md.: Penguin, 1964.

Phaidon Dictionary of 20th-Century Art. London and New York: Phaidon, 1973.

Popper, Frank. *Origins and Development of Kinetic Art*. London: Studio Vista, 1968; Greenwich, Conn.: New York Graphic Society, 1969.

Read, Sir Herbert. *Contemporary British Art*. Rev. ed. Santa Fe, N. M.: Gannon, 1964; Harmondsworth: Penguin, 1965.

Richter, Hans. *Dada Art and Anti-Art*. London: Thames and Hudson, 1966; New York: Abrams, 1970.

Rickey, George. *Constructivism: Origin and Evolution*. New York: Braziller, 1967; London: Studio Vista, 1968.

Rose, Barbara. *American Art Since 1900: A Critical History*. Rev. ed. New York: Praeger; London: Thames and Hudson, 1975.

Rosenblum, Robert. *Cubism and 20th-Century Art*. London: Thames and Hudson; New York: Abrams, 1968.

Rubin, William S. *Dada and Surrealist Art*. New York: Abrams, 1969.

Russell, John, and Gablik, Suzi. *Pop Art Redefined*. London: Thames and Hudson; New York: Praeger, 1969.

Rye, Jane. *Futurism*. London: Studio Vista; New York: Dutton, 1972.

Schmutzler, Robert. *Art Nouveau*. New York: Abrams, 1970.

Seitz, William C. *The Art of Assemblage*. New York: Museum of Modern Art exhibition catalogue 1961.

—*The Responsive Eye*. New York: Museum of Modern Art exhibition catalogue 1965.

—*Sign, Image, Symbol*. New York: Braziller; London: Studio Vista, 1966.

—*Structure in Art and Science*. New York: Braziller; London: Studio Vista, 1965.

Selz, Peter. *German Expressionist Painting*. Berkeley: University of California Press, 1973.

Smith, Edward Lucie. *Movements in Art Since 1945*. London: Thames and Hudson; New York: Praeger, 1969.

Szeemann. H. *Wenn Attituden Form werden.* Berne: Kunsthalle exhibition catalogue, 1969.

Trier, Edward. *Form and Space: Sculpture of the 20th Century*. London: Thames and Hudson; New York: Praeger, 1968.

Waldberg, Patrick. *Surrealism*. London: Thames and Hudson; New York: McGraw-Hill, 1966.

Wingler, Hans Maria. *The Bauhaus: Weimar, Dessau, Berlin, Chicago*. Cambridge, Mass.: MIT Press, 1969.

Wodds, Gerald; Thompson, Phillip; and Williams, John (eds.). *Art Without Boundaries*. London: Thames and Hudson, 1972; New York: Praeger, 1974.

ARCHITECTURE

Ambasz, Emilio. *Italy: The New Domestic Landscape*. New York: Museum of Modern Art exhibition catalogue 1972.

Bachmann, Jul., and Moos, Stanislaus von. *New Directions in Swiss Architecture*. London: Studio Vista; New York: Braziller, 1969.

Banham, Reyner. *Age of the Masters: A Personal View of Modern Architecture*. London: Architectural Press, 1975.

—*The New Brutalism: Ethic or Aesthetic?* London: Architectural Press, 1962; New York: Van Nostrand Reinhold, 1966.

—*Theory and Design in the First Machine Age*. Rev. ed. London: Architectural Press; New York: Praeger, 1970.

Benton, Tim and Charlotte. *Form and Function: A Source Book for the History of Architecture and Design, 1890–1939*. London: Crosby Lockwood-Staples, 1975.

Besset, Maurice. *New French Architecture*. New York: Praeger, 1967.

Boyd, Robin. *New Directions in Japanese Architecture*. London: Studio Vista; New York: Braziller, 1968.

Bullrich, Francisco. *New Directions in Latin American Architecture*. London: Studio Vista; New York: Braziller, 1969.

Chermayeff, Serge, and Alexander, Christopher. *Community and Privacy*. New York: Doubleday, 1963; London: Penguin, 1966.

Collins, Peter. *Changing Ideals in Modern Architecture, 1750–1950*. London: Faber and Faber, 1967.

—*Concrete: The Vision of a New Architecture*. London: Faber and Faber; New York: Horizon Press, 1959.

Conrads, Ulrich (ed.). *Programs and Manifestoes on 20th-Century Architecture.* Cambridge, Mass.: MIT Press, 1971.
—and Marschalk, Werner. *New German Architecture.* New York: Praeger, 1962.
—and Sperlich, Hans. *Fantastic Architecture.* New York: Praeger, 1962.
Cook, Peter. *Experimental Architecture.* London: Studio Vista; New York: Universe, 1970.
Crosby, Theo. *Architecture: City Sense.* London: Studio Vista, 1965.
Feuerstein, Günther. *New Directions in German Architecture.* London: Studio Vista; New York: Braziller, 1968.
Giedion, Siegfried. *Space, Time and Architecture: The Growth of a New Tradition.* 5th rev. ed. Cambridge, Mass.: Harvard University Press, 1967.
Gregotti, Vittorio. *New Directions in Italian Architecture.* London: Studio Vista; New York: Braziller, 1968.
Hatje, Gerd; Hoffman, Hubert; and Kaspar, Karl. *New German Architecture.* New York: Praeger, 1956.
Heyer, Paul (ed.). *Architects on Architecture.* New York: Walker; London: Allan Lane, 1966.
Hitchcock, Henry-Russell, Jr. *Architecture: 19th and 20th Centuries.* Rev. ed. Harmondsworth and Baltimore, Md.: Penguin, 1971.
—and Johnson, Philip. *The International Style.* Rev. ed. New York: Norton, 1966.
Jacobus, John M. *20th-Century Architecture: The Middle Years, 1940-65.* London: Thames and Hudson; New York: Praeger, 1966.
Jencks, Charles. *Modern Movements in Architecture.* Harmondsworth: Penguin, 1973.
—and Baird, George (eds.). *Meaning in Architecture.* London: Barrie und Jenkins; New York: Braziller, 1970.
Joedicke, Jürgen. *A History of Modern Architecture.* New York: Praeger, 1960.

Klotz, Heinrich, and Cook, John W. *Conversations with Architects.* New York: Praeger; London: Lund Humphries, 1973.
Kopp, Anatole. *Town and Revolution.* London: Thames and Hudson; New York: Braziller, 1970.
Kultermann, Udo. *New Directions in African Architecture.* London: Studio Vista; New York: Braziller, 1969.
—*New Japanese Architecture.* Rev. ed. New York: Praeger, 1967.
Landau, Royston. *New Directions in British Architecture.* London: Studio Vista; New York: Braziller, 1968.
Lane, Barbara M. *Architecture and Politics in Germany. 1918–45.* Cambridge, Mass.: Harvard University Press, 1968.
Lissitzky, Lazar. *Russia: An Architecture for World Revolution.* Rev. ed. Cambridge, Mass.: MIT Press, 1970.
Mumford, Lewis. *Roots of Contemporary American Architecture.* New York: Grove Press; London: Chapman and Hall, 1952.
Pawley, Martin. *Architecture Versus Housing.* London: Studio Vista; New York: Praeger, 1971.
Richards, James Maude. *An Introduction to Modern Architecture.* Rev. ed. Harmondsworth and Baltimore, Md.: Penguin, 1971.
Sharp, Dennis. *Modern Architecture and Expressionism.* London: Longmans; New York: Braziller, 1966.
Stern, Robert A. *New Directions in American Architecture.* London: Studio Vista; New York: Braziller, 1969.
Temple, Egon. *New Finnish Architecture.* New York: Praeger, 1968.
—*New Japanese Architecture.* New York: Praeger, 1970.
Venturi, Robert. *Complexity and Contradiction in Architecture.* New York: Museum of Modern Art, 1967.
Whittick, Arnold. *European Architecture in the 20th Century.* London: Crosby Lockwood, 1950–53.

INDEX

Descriptions of the illustrations are listed in boldface type